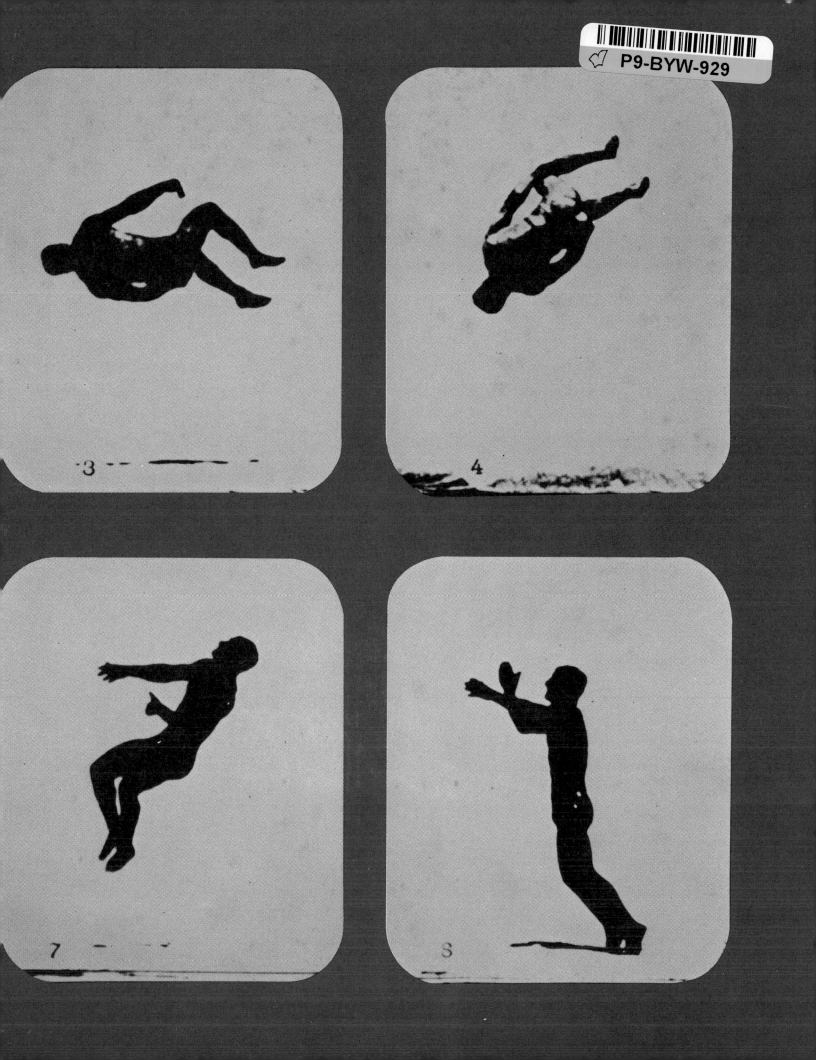

1977

PIONEERS OF PHOTOGRAPHY

For Dad on his birthday
I hope you enjoy this
book!

Love,
Mike

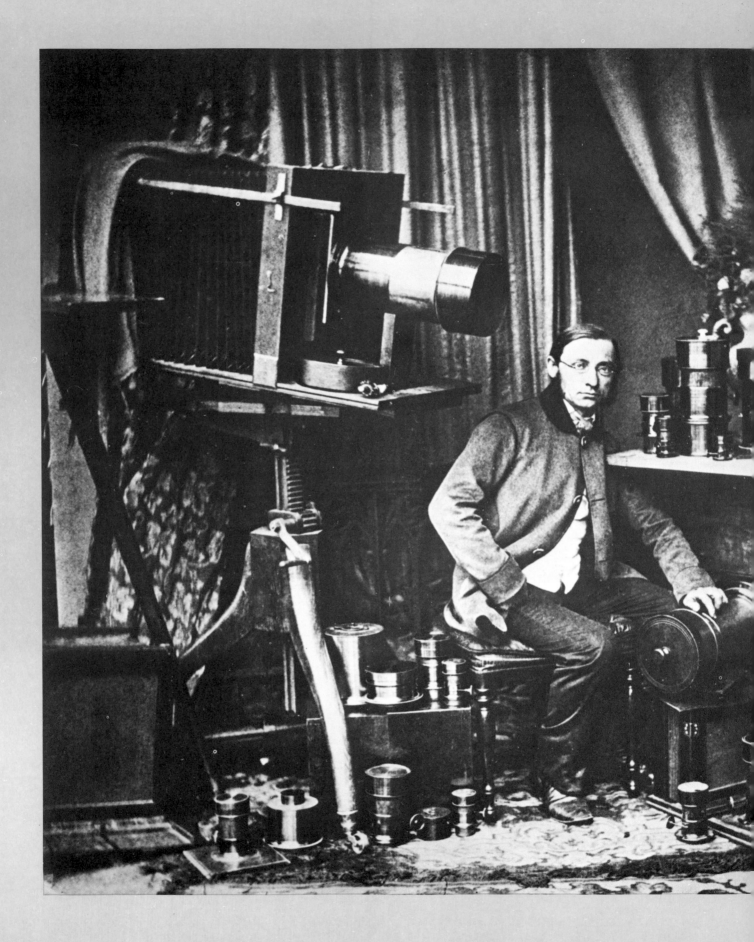

PIONEERS OF PHOTOGRAPHY

AN ALBUM OF
PICTURES AND WORDS
WRITTEN AND COMPILED
BY AARON SCHARF

HARRY N. ABRAMS, INC., PUBLISHERS, NEW YORK
By arrangement with the British Broadcasting Corporation

PREVIOUS PAGE Herman Krone: self portrait with his
photographic equipment

RIGHT Samuel A. Cooley, his assistants and photographic
waggons

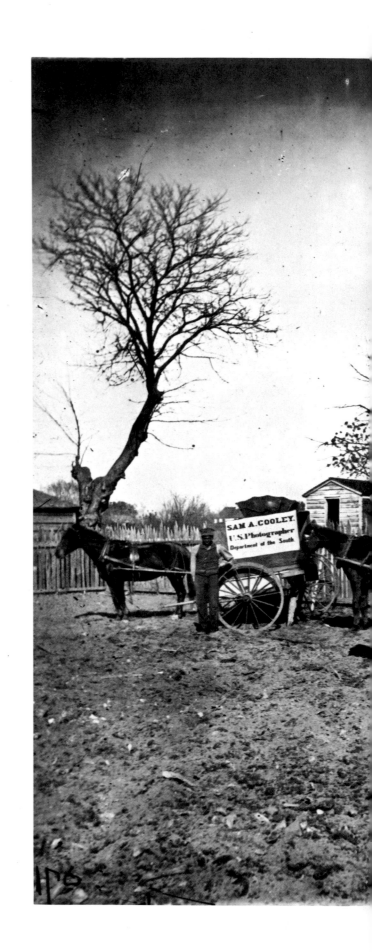

Library of Congress Cataloging in Publication Data

Scharf, Aaron, 1922-
 Pioneers of photography.

 Bibliography: p.
 1. Photography—History. 2. Photographers.
I. British Broadcasting Corporation. II. Title.
TR15.S34 770'.9'034 75-42216
ISBN 0-8109-0408-X

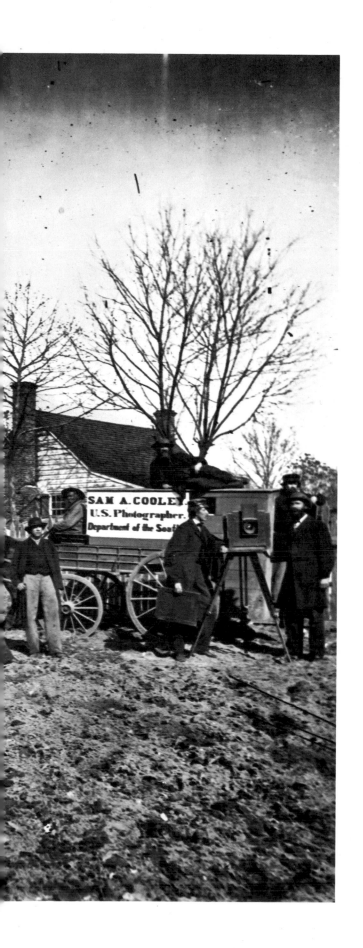

CONTENTS

FOREWORD

As I began working on the background research for the television programmes 'Pioneers of Photography' it became obvious to me – no specialist in the subject – that it was not always easy for the general reader to find some of the key documents and first-hand statements by the photographers themselves. There exists, for instance, a recent facsimile publication of Henry Fox Talbot's book, *The Pencil of Nature*, yet copies are difficult to track down for those who are not specialists. I hope, therefore, that by supplying a small number of carefully chosen documents, both images and texts, culled from the first hundred years of the experience of photography, this album will answer a real need.

The more I assembled together, the more fascinated I became – not only by the statements themselves but also by the personalities involved: Nicéphore Niépce communicating the lucid and detailed accounts of his experiments to his brother Claude; the first reports in English magazines of Daguerre's discovery and the responses of Talbot and others to them; Mrs Talbot complaining to her mother-in-law of Henry being discouraged; the impulsiveness of Julia Margaret Cameron who couldn't resist rushing into her family at dinner and ruining the tablecloths with chemicals. Nadar had no end of trouble photographing the Paris sewers by artificial light – the steam from bath water created a fog. And Samuel Bourne, in a glacial pass in the Himalayas, complained that no one who had not actually experienced it could realise the agony of pouring photographic chemicals with chapped hands.

The later chapters (as also the programmes) deal not so much with individuals as they do with the larger considerations of new developments in photography: the photography of movement by Muybridge and Marey; the magazine, *Camera Work*, the 'art' print, the arrival of a practicable natural-colour process. But even in these sections of the book, one cannot escape the enthusiasm of those extraordinary people whose words give a feeling of immediacy to everything they describe.

Of course, these writers are often trying to prove something either to themselves or to an audience and, as with any evidence of this kind, their personalities and circumstances have to be borne in mind. When Nicéphore Niépce wrote to Claude in 1816 to say that he had succeeded in getting negative images on paper, I personally believe him. But the evidence he sent with the letter has not survived. Like Thomas Wedgwood before him, he was not yet able to fix an image permanently and no reply of Claude's has been traced which would tell us of the condition of these first negatives by the time they reached Paris. Nadar was writing his memoirs long after the events he described and it must be remembered that he, like Julia Margaret Cameron, couldn't resist a good story and was a little hazy about dates. Nevertheless, that does not detract from the vividness of both their narratives.

Some of the most interesting material has come from chance meetings, and I could easily spend a lifetime following up the clues that I've been given by many kind and helpful people. But there is a limit to what only one producer and one hard-worked researcher can achieve on a series with a modest budget; time costs money and we have programmes to produce. So here, with an introduction and guidelines from Aaron Scharf, the photographers can speak for themselves. But readers must play their own part, use this book as a kind of quarry, and follow up for themselves anything they find intriguing.

Perhaps the most fascinating item, part of which is reproduced here for the first time, is the small red morocco album of calotypes by Dr John Adamson and his brother Robert, which they sent to Fox Talbot with a letter on

9 November 1842 to show the kind of work they had been doing with his process in St Andrews, Fife. This was six months before Robert opened his studio in Edinburgh and started his partnership with D. O. Hill. In the front of the album, carefully cut into an oval vignette, is the Adamsons' portrait of Sir David Brewster, the optical scientist who was the link between Talbot and the Scottish calotypists. He had certainly known of Talbot's photogenic drawings as early as 1836, two-and-a-half years before the announcement by Daguerre which prompted Talbot finally to publish his own process. What is more, in 1836 Brewster and Talbot were already considering 'taking a picture' of such an imposing building as Warwick Castle. I am grateful to Harold White who first drew my attention to the little album, and who generously gave me an intensive briefing on Fox Talbot's work. Further readings of some of the microfilms of the Lacock Abbey papers have filled the gaps. The great-great-grandchildren of Fox Talbot, Janet and Anthony Burnett Brown, have kindly given us permission to quote from the correspondence and to reproduce the album; (they were also very kind hosts to the film unit at Lacock Abbey).

Other new material which came to light includes the daguerreotype of Dorothy Draper by Dr John Draper which has recently been donated by his family to the Smithsonian Institution in Washington, and which Eugene Ostroff, the Curator of the Division of Photographic History, kindly contributed to our series. Previously this very early daguerreotype was known only by a late nineteenth-century reproduction of a duplicate portrait sent by Draper to Sir John Herschel in 1840 and which had unfortunately been damaged by cleaning in the 1930s. This new daguerreotype is either a copy of the original or a duplicate of the same pose. As it was kept by Draper himself, it seems likely that this was the original; it would only be human nature to send the second version rather than the first to England to show that portraits were possible with the new art.

Our concern with colour photography has provided some interesting images not reproduced before as far as I know. There is, for example, an early autochrome, a study of Beatrice Webb, by her friend the enthusiastic amateur photographer, George Bernard Shaw. There is also the rather more professional work of Alfred Stieglitz and Frank Eugene from the collection of The Art Institute of Chicago.

All this history is comparatively recent. Nothing has brought the shortness of time home to me more than my research on Samuel Bourne, one of the least known but most important of British landscape photographers. He was trekking through the Himalayas in the 1860s, yet his daughter, who was 100 years old in 1974, was still living when I began to write my scripts. Unfortunately she hasn't survived to see this book, but she and the rest of Bourne's family have been able to give valuable information.

Despite this strange compression of time, many of our inquiries have ended in a blank; papers have been lost and negatives junked as being of no further interest. Luckily there is now a growing awareness that photographs *are* important, often as important as written documents in the history of any country. As a television producer who has worked mainly in the fields of art and history, I should like to encourage anyone with photographs which they think are of biographical, historic, or even of local importance, to show them to a librarian or museum curator and allow them to be copied for reference, before they sell or give away the originals. But please don't send them to me!

The series of programmes on which this book is based would never have materialised without the help and kindness of many people who have contributed so much interest and information to the project. I would like to acknowledge here the debt I owe to Aaron Scharf for compiling and writing this book and advising on the series; to Brian Coe, Curator of the Kodak Museum; to the staff of the Science Museum, and in particular Dr D. B. Thomas and John Ward; and at the Royal Photographic Society, Professor Margaret Harker, Mrs Gail Buckland, Kenneth Warr, Arthur T. Gill and Leo de Freitas.

Apart from those mentioned in my foreword, others who have given particular assistance are Mrs Katherine Michaelson, Mrs Marion Smith, Mrs Anita V. Mozley, Mesdames Henriette and Janine Niépce, Madame Christiane Roger, Colin Ford, David Travis, Dr P. Génard, René André, E. Noel-Bouton, Professor A. Fessard, and the staff of the Archives Photographiques, the Print Room of the Bibliothèque Nationale, the National Galleries of Scotland, the Royal Scottish Museum, the Special Collections of the Library of the University of Glasgow, and the London Library.

I must also thank in the BBC Paris office, Maud Vidal and Gilda Jacob; and in my own office in London, the researcher for the series, Joy Curtiss, and three hard-worked assistants: Jennie Batchelor, Sara Ling and Sandy Vere-Jones. All six have had to gather up the huge number of photographs and I am very grateful for their patient help. My thanks, too, to Roynon Raikes, our staff photographer, and to the members of the film unit, in particular Peter Sargent, cameraman, and Alan J. Cumner-Price, film editor, both of whose professional knowledge and interest has filtered through into this book.

Ann Turner

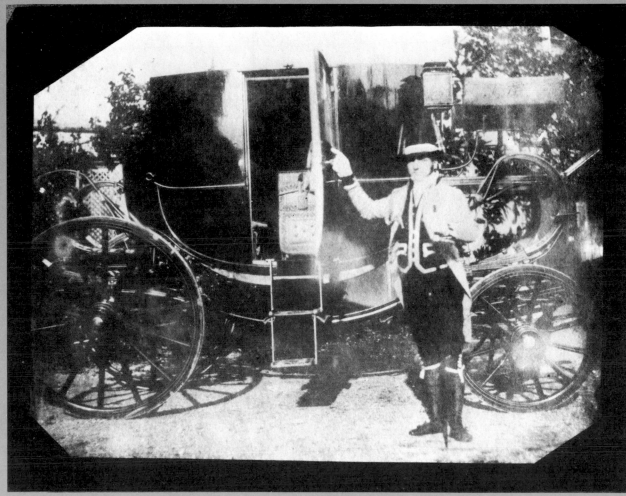

HENRY FOX TALBOT: THE FAMILY COACH AND FOOTMAN AT LACOCK ABBEY

INTRODUCTION

Though the invention of photography made news in 1839, it had its beginnings as early as 1816 in the experiments of Joseph Nicéphore Niépce. But the principles of photography were known earlier than that – long before it became a working reality. The dream of fixing an image of nature on some surface and then carrying it away was a necessary stimulus to the invention.

The practical knowledge required for the realisation of photography was there in its inchoate form in the distant past. The famous alchemist, Fabricius, had already

known, in 1552, that the sun's rays turned a certain silver compound from white to black. Aristotle before him knew that light passing through a small hole will project an image of the natural world onto the side of a dark box or the wall of a darkened room. That is to say, he already understood the principle of the camera obscura, the precursor of our modern photographic camera. And that other essential ingredient in photography's discovery, the urge to draw the picture out of the mirror or to extract the delicate image from the dark interior of the camera obscura, is ancient too.

To turn the fugitive image into a permanent physical reality was to enhance memory itself. The magical notion of being able to fix the mirror's image, to lay hold of it, is the expression no doubt of a primitive instinct going back to the first troglodyte who cast an incredulous eye on his reflection in some primeval puddle.

Writers in the eighteenth century, an impressionable period for all its reputation as the age of reason, let their fancies run wild as they indulged themselves in this re-vivification of the ancient tale of Narcissus. The most often cited is a proto-science-fiction writer, Tiphaigne de la Roche, whose book *Giphantie* appeared in Paris in 1760. It deals with the experiences of a voyager who finds himself on a mysterious island somewhere in Africa. In the home of the Governor he gazes out of the window only to behold a thoroughly incongruous scene of a wild sea. He is flabbergasted to discover that he is looking at a picture. That image, the same as would appear on any polished surface, or on water or glass, or on the retina of the eye, had been fixed, he is told, by some mysterious means. A heavy, quick-drying liquid had been employed, which formed a picture of the object it reflected in an instant:

They coat a piece of canvas with this material, and hold it in front of the objects they want to paint. The first effect on this canvas is like that produced in a mirror. One can see there all objects, far and near, the images of which can be transmitted by light. But what a mirror cannot do, the canvas does by means of its viscous matter; it retains the images . . . This impression of the image is instantaneous, and the canvas is carried away at once into some dark place. An hour later the prepared surface has dried, and you have a picture all the more precious in that no work of art can imitate it, nor can it be destroyed by time . . . [in this way nature] with a precise and never-erring hand, draws upon our canvasses images which deceive the eye.

This astonishing piece of prescience seems supernatural itself, and it no doubt echoes the age-old pleasure in prophesying that by some fabulous means it would one

Camera obscura

day be possible to peel off the image on a looking-glass and freeze the evanescent reflection on the surface of water.

Throughout the history of the camera obscura and the many other like devices, that effigy on the retinal glass, or in the prism or the viewfinder, has never entirely ceased to generate a reverence for its magical character, and a possessiveness for the image itself. One of the most vivid appreciations I know, of the beauty of nature thus reduced, was written by Horace Walpole in 1777, only sixteen years after *Giphantie* appeared in an English edition. From the beginning of the great age of inventions, all manner of mimetic devices appeared, some of them contraptions of such incredible construction that one becomes convinced that the means must have been quite as important as the end. The avowed purpose of all these viewing- or drawing-instruments was to render in projection or in reproduction a vision of nature virtually indistinguishable from the real thing.

Walpole falls in love with a newly invented modification of the camera obscura called the 'delineator'. According to him, that little magic box not merely duplicated nature, but exceeded it in the way the best art of the past had augmented the real world. 'Arabian tales', he called those images and their heightened effects. Even the exquisite rooms of his beloved Strawberry Hill, with all their marvellous textures and perspectives, were miraculously enhanced, he said, by that camera: 'It will perform more wonders than electricity . . . I could play with it for forty years.' And if that tiny image in the glass appeared as the work of some benevolent and obliging genie, so later the latent photographic image, materialising as if by magic in the developing fluid, fascinated photographers. So much so that witnessing the gradual generation of that

phantom image in the dark room was probably more often than not the most profound reason for taking the photograph in the first place.

To grasp the real quality of the response to the actuality of photography, we must try to comprehend the almost maniacal frenzy of activity among inventors and every manner of would-be inventor. All were united in an irrepressible determination to perfect a mechanical means for achieving pictorial verisimilitude. This was ultimately to be realised in the photographic process. In an age of invention, he who got there first most often, though not always, reaped substantial rewards in fame and fortune. But frequently there was an aesthetic motivation, if we may use that term loosely – a passion to provide a way through which the reproduction of a natural image could be rendered indistinguishable from the view of nature herself.

Soon an avalanche of delineating machines was tumbling out of the workshops and garden sheds of enthusiasts. The names of the contraptions themselves had an aura of the poetic about them. Thus in the high period of industrialisation we have a large number of improvements on, or alternatives to, the camera obscura, such as the Delineator, so-called. Another Delineator, Copier and Proportionometer, a tracing device in this case, was patented in 1806. Wollaston's well-known Camera Lucida appeared in 1807. This instrument, frequently used by artists, was simply a prism in a holder through which could be seen an image of nature apparently deposited on the drawing paper. Charles's Solar Megascope (1780) and Chrétien's Physionotrace (1790) were widely known at the time. There were later versions too of yet other physionotraces. Varley's invention of a Graphic Telescope was announced in 1812. Then followed an unend-

Camera lucida

ing stream of other instruments: The Agatograph, the Diagraph, the Hyalograph, Quarreograph, Pronopiograph, and Cayeux's Eugraph – another modification of the camera obscura. There were in addition the Graphic Mirror and the Periscope Camera, the Meniscus Prism and the Universal Parallel, this last a kind of pantographic implement which appeared in 1819. In France one such device was advertised, in this feverish stampede to ape nature, as 'Pantographe ou singe perfectionné'. During this period a Monsieur Soleil (most appropriately named) produced no less than ten variations on the camera obscura. Added to this torrent of visual devices were of course the Panoramas and Phantasmagorias of the time; the Eidophusikon, the Dioramas and other such late eighteenth- and early nineteenth-century means for providing illusionist entertainments and special effects on a large scale. They were, in spirit, the precursors of the cinema.

What else but this fascination for illusion, coupled with a belief in the efficacy of the machine, could account for so many contrivances before the coming of photography? And all these culminated in the invention of the photographic process itself. Artists, whatever their views as to the relation between actuality and poetry, the outer world of nature and the inner one of the mind, could hardly ignore such a barrage of instruments for drawing. For these machines not only facilitated the delineation of correct perspective and guaranteed the accuracy of scale and contour but were enchanting in themselves. These devices, employing lenticular means and treated glasses, made possible a more uniform, or enriched, range of tones, or gave tonal guidance for better creating the semblance of rotundity or sculptural form. Most of these instruments were for drawing or painting; some just for looking. And there were others, their details obscured by time, which apparently employed light-responsive chemical means to produce what may be considered as forerunners of even the earliest and inconclusive experiments with photography. Reynolds, Crome, Cotman and Turner, to mention only the best known, were part of a legion of artists who at least toyed with one or another of these devices.

Perhaps we can now better understand the vitriol of Thomas Carlyle's despair when he wrote in 1829 of the mania for mechanical devices to strengthen every aspect of life in that mechanical age. But Carlyle's booming pessimism perhaps obscured the poetic content in the inventive enterprises even of an era obsessed with machinery and material wealth.

The romance of a technical vocabulary, so evident in the captivating lexicography of drawing- and viewing-machines, also cast its spell on those who sought an appropriate verbal description for the new process of

photography. There is a manuscript in the hand of Nicé-phore Niépce, now universally credited with being, if not the father, then the grandfather of photography – the earliest surviving photograph, taken in 1827, is his. We reproduce this page here, with its play of permutations from Greek roots; Niépce naming the art.

Among the names used to describe the earliest photographic processes were 'Heliograph', 'Daguerreotype', and 'Calotype'. Other methods existed also, each with its own name, but these were on the whole inconsequential; not intrinsically so, but because vagaries of notoriety and then of history made them so. Some of the major processes were described in relation particularly to the distinctive kind of image each produced.

The differences between the two most widely acknowledged photographic processes, the daguerreotype and the calotype (an improvement of Fox Talbot's earlier process, photogenic drawing) are lucidly set out by Sir David Brewster, a contemporary thoroughly immersed in the goings-on about photography. There is an extract from this extraordinary document on page 52.

The daguerreotype had its own kind of beauty. Here, each image was unique, a direct, positive picture, laterally reversed, which could only be reproduced by rephotographing the original plate – with the consequent loss of sharpness in detail and tone. The beauty of the daguerreotype was that embodied in the magical content of high illusionism, the beauty of an utter realism so uncompromising that it seems to exceed in its descriptive detail even that which the unassisted eye could possibly take in. The physical structure of the daguerreotype image is a great quantity of minuscule globules of mercury, concentrated more heavily in the light areas and more sparsely in the dark. It is because of that delicate structure, literally a microscopic coalescence of spherical mirrors, that one can evoke the ghost in a daguerreotype by turning the image away from the direct frontal view and allowing a myriad of shadows to transform it into a negative image, not least enhancing its poetic content by endowing it with a fugitive and mysterious presence.

From a utilitarian point of view, the calotype was superior, for not only was it cheaper and easier to produce, as it was made on paper, but it could be multiplied any number of times for it depended on a negative. This negative, made also of paper, was rendered translucent (though not transparent) by oiling or waxing. And it was precisely this translucency, this shortcoming in the method, which gave the calotype its much acclaimed broad, beautiful, artistic effects. For the fibrous structure of the paper negative interceded, softening all contours of the image, diffusing the light, and imbuing all forms with a suggestive power.

How very provident it was of science and technique, and of fate, to reincarnate in photography two essential and timeless conditions in art manifested on the one hand in the poetry of ambiguity, and on the other in the attractiveness of the concrete. Notwithstanding the meaning of colour in this centuries-old controversy in which Vasari first argued the merits of Michelangelo over Titian, soon after the coming of photography it was once again to be manifested in the opposition of the Turner-esque and Pre-Raphaelite styles.

This little book is not intended to be an encapsulated history of photography, nor is its purpose to elaborate on the techniques employed. Both these elements are subordinated to one major consideration, which is to make the mystery of photography come alive through the enthusiasm and even the eccentricities of some of its early practitioners. Not least, I hope to convey the perils encountered in this hazardous occupation during its pioneer days, and the trials and tribulations which dog the footsteps of almost all the photographers I deal with. Where the opportunity has arisen I have tried to present those slightly peripheral events and personal musings which give to the history of photography a more human and intimate touch.

I concentrate largely on contemporary documents, particularly those which reveal the less obvious motivations of the photographers themselves. In this way, I hope to give greater insight to what superficially appears to be a commonplace activity, but which often has a more profound meaning.

The illustrations ought to predominate in a book of this kind. The photographs chosen are not only stylistically revealing, but tell us something of the photographer's or the subject's thought processes, or convey some particular situation or experiment in an inimitable way. I have avoided, wherever possible, those photographs which, through their frequent reproduction, have become pictorial stereotypes, and have included instead a large number of photographs which to my knowledge have either seldom or never before been published. I have made no attempt here to present a comprehensive picture of photography in its pioneer stage, but, in using as a guide the subjects as they appear in the television series, there is a kind of historical unravelling of the process of photography.

I should like most sincerely to thank both Ann Turner and Peter Campbell for putting in my path copious amounts of visual and textual material. I am furthermore grateful to them for the unflagging energies they expended on my behalf, for their friendly acquiescence to all (or most of) my demands, and for the great sensitivity of their criticisms.

THE PENCIL OF NATURE

"...how charming it would be if it were possible to cause these natural
images to imprint themselves durably, and remain fixed upon the paper!
"And why should it not be possible? I asked myself."

William Henry Fox Talbot (1844)

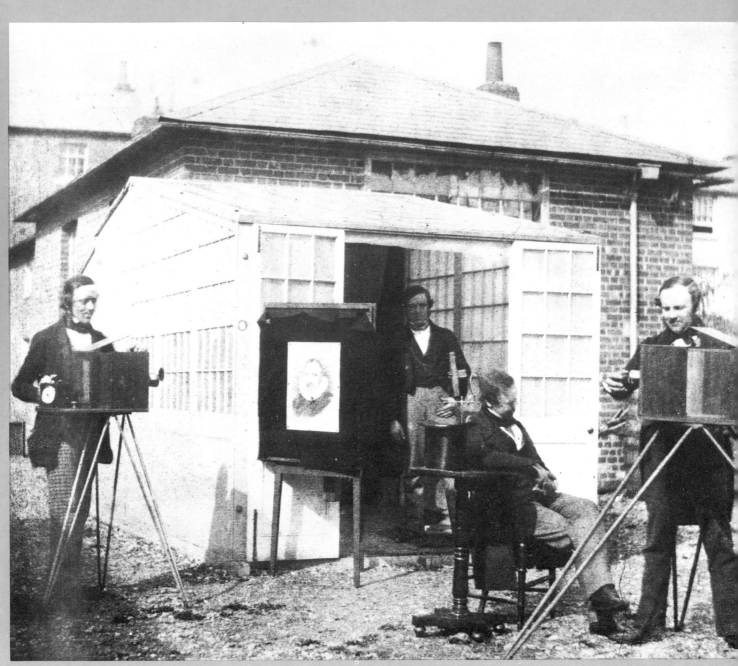

HENRY FOX TALBOT: THE READING PHOTOGRAPHIC ESTABLISHMENT

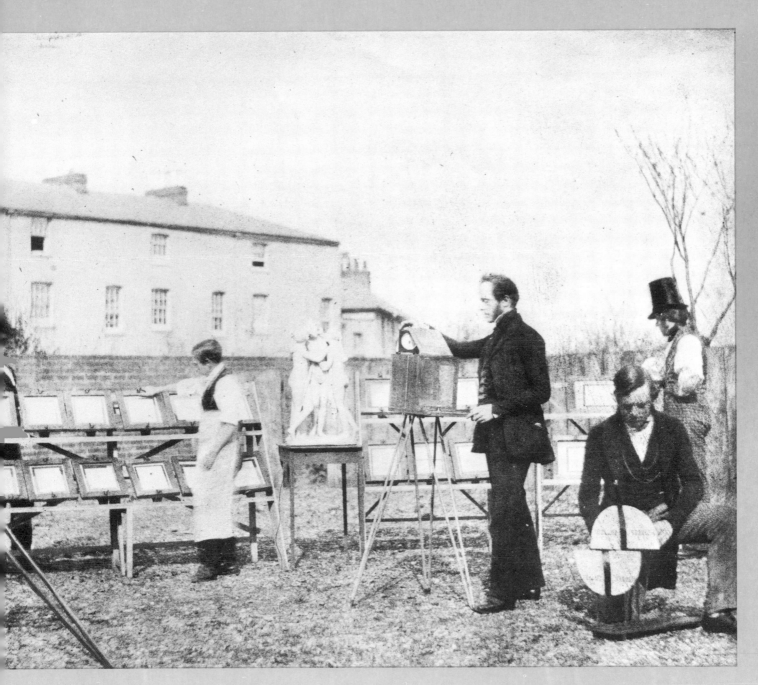

THE PENCIL OF NATURE

William Henry Fox Talbot (1800–77) has the distinction of being the first person, on 31 January 1839, to announce his discovery of photography to the world and at the same time to make the process known. He is also distinguished for inventing the first practicable negative-positive photographic process, and for discovering, in 1840, the efficacy of the latent image by which exposure times were reduced to a fraction of what they had been. Talbot was a country gentleman of comfortable means, this allowing him to pursue his twin passions for lin-

guistics and scientific experiment. He was a Fellow of the Royal Society and for a time a Member of Parliament.

In the autumn of 1833, after producing some disappointing sketches while using Wollaston's camera lucida at Lake Como in Italy, he resolved, as others had before him, to find a way of fixing the image he saw in the prism without recourse to the artist's pencil. To this end he turned, as he had once before, to the camera obscura, to capture on a piece of paper in its focus those magical, evanescent images. A year later, on 12 December 1834 Laura Mundy, Fox Talbot's sister-in-law, wrote to Talbot about his photographs. Though he was obviously still having great difficulties in fixing these images, the document establishes that at this early date, effectively several years before the process was officially made public, some kind of photography was possible, the 'beautiful shadows' no doubt referring to Talbot's contact prints of leaf and lace form:

Thank you very much for sending me such beautiful shadows, the little drawing I think quite lovely, and the verses particularly excite my imagination. I had no idea the art could be carried to such perfection. I had grieved over the gradual disappearance of those you gave me in the summer and am delighted to have these to supply their place in my book.[1]

We also know that by early 1835 Talbot had already hit upon the negative–positive process, however primitive the results at the time:

28 February 1835

In the photogenic or sciagraphic process, if the paper is transparent, the first drawing may serve as an object to produce a second drawing in which the lights and shadows would be reversed.[2]

In the autumn of the following year, there is evidence to show that the process could already accommodate an itinerant photographer with a portable camera. At the end of August or early September 1836 Talbot's wife Constance writes to her mother-in-law, Lady Elizabeth Fielding:

You are perfectly right in supposing Sir D[avid] B[rewster] to pass his time pleasantly here. He wants nothing beyond the pleasure of conversing with Henry discussing their respective discoveries and various subjects connected with science . . . Henry seems to possess new life and I feel certain that were he to mix

more frequently with his own friends we should never see him droop in the way which now so continually annoys us. I am inclined to think that many of his ailments are nervous for he certainly does not look ill. . . He has almost promised to go next week to Leamington and take a picture of Warwick Castle with Sir David.[1]

In the spring of 1839 after the public announcement, it is already clear that Talbot's photogenic contact prints have reached a new stage of refinement. Talbot states:

This paper, if properly made, is very useful for all ordinary photogenic purposes. For example, nothing can be more perfect than the images it gives of leaves and flowers, especially with a summer sun: the light passing through the leaves delineates every ramification of their nerves.[2]

In his notebook, under the date 23 September 1840, Talbot records his experiment with gallic acid, mixed with a solution of silver nitrate and acetic acid, as a sensitiser. Now he hits upon a further refinement of his technique; it is a landmark in the history of photographic processes. Talbot's new photo-sensitive mixture, 'an exciting liquid' he called it, developed the latent image which reduced the required exposure time to a considerable degree. He called his new technique the Calotype:

Some very remarkable results were obtained. Half a minute suffices for the Camera, the paper when removed is often perfectly blank but when kept in the dark the picture begins to appear *spontaneously*, and keeps improving for several minutes, after which it should be washed and fixed with iod. pot [iodine of potassium]. Exposure to moderate light also brings out the picture and more quickly. The same exciting liquid *restores* or *revives* old pictures on w. [Whatman] paper which have worn out, or become too faint to give any more copies. Altho' they are apparently reduced to the state of yellow iodide of silver of uniform tint, yet there is really a difference and there is a kind of latent picture which may be then brought out.[3]

On 8 February 1843 Lady Elizabeth Fielding, jealous of her son's discovery, writes to Talbot's wife from Paris where she hears of another inventor of photography:

I want him to know that there is a M. Bayard who makes photographs on *paper* and by and by he will be

1 Extracted from the Lacock Papers. Source: Harold White.
2 Lacock Papers.

1 Lacock Abbey Papers (LA 36–58) Sc. Mus. Microfilm.
2 *The Saturday Magazine*, 13 April 1839.
3 Lacock Papers notebook 1840.

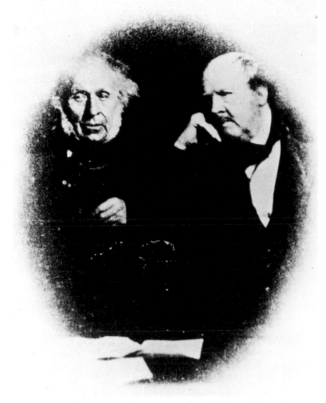

John Moffat: Photograph taken by artificial light in 1865 of Sir David Brewster (left) and Fox Talbot. Wet collodion.

pretending he has *invented* it. It is true that he does it very badly and the paper fritters away almost immediately owing to the chemical preparation he employs. But all that will not prevent his asserting he was the Inventor of it if Hy does not take some means to prevent it. The people here have adopted the name of Talbotype and think it only a foolish modesty [*not?*] to do so universally. This has been often suggested in England by various people, and it would seem that *this* is the precise moment in which it ought to be adopted as a *new aera* is about to commence. I wish therefore it should be adopted at *once* in England as it is already here. Kalotype it is objected ne veut rien dire a ceuz quie ne comprennent pas le Grec.[1]

The particular situation which provoked that flash of insight which led Fox Talbot to the invention of the first negative–positive photographic process, is compellingly set out in his book, *The Pencil of Nature*, which appeared in 1844 and was the first of its kind available for purchase by the general public. This publication, its title so revealing, had a text illustrated with pasted-in

1 Lacock Papers. See Bayard, p. 50.

photographs or, more accurately, pasted-in photographs with an accompanying text. Talbot writes with the charming decorum of the stilted style typical of that period.

Here, in his historical sketch recalling the invention of the new art, Talbot despairs at the frailty of his drawings made from the images in the camera obscura and camera lucida. But why? Gentlemen travellers of the time, as well as distinguished artists, did not use such instruments only for utilitarian purposes – to save time or to guarantee a great degree of accuracy. One suspects that the more profound reasons had to do with the fascination for toys, and more particularly for that irresistible little image in the prism or registered on the ground glass or paper. There, all the forms and colours in view were transformed, coalesced in reduction, and richer to the point of looking more like art than nature. Yet nature it unquestionably was, and all the more provocative for that. A sweet miniature, snatched from its larger context; a tiny window on the world. Talbot called such images 'fairy pictures', 'All looked beautiful in the prism', and he sickened of those insipid little drawings which he, an amateur artist, managed to extract from those magically delicate images he saw:

THE PENCIL OF NATURE

Introductory Remarks
The little work now presented to the Public is the first attempt to publish a series of plates or pictures wholly executed by the new art of Photogenic Drawing, without any aid whatever from the artist's pencil.

The term 'Photography' is now so well known, that an explanation of it is perhaps superfluous; yet, as some persons may still be unacquainted with the art, even by name, its discovery being still of very recent date, a few words may be looked for of general explanation.

It may suffice, then, to say, that the plates of this work have been obtained by the mere action of Light upon sensitive paper. They have been formed or depicted by optical and chemical means alone, and without the aid of any one acquainted with the art of drawing. It is needless, therefore, to say that they differ in all respects, and as widely as possible, in their origin, from plates of the ordinary kind, which owe their existence to the united skill of the Artist and the Engraver.

They are impressed by Nature's hand; and what they want as yet of delicacy and finish of execution arises chiefly from our want of sufficient knowledge of her laws. When we have learnt more, by experience, respecting the formation of such pictures, they will doubtless be brought much nearer to perfection; and

though we may not be able to conjecture with any certainty what rank they may hereafter attain to as pictorial productions, they will surely find their own sphere of utility, both for completeness of detail and correctness of perspective.

The Author of the present work having been so fortunate as to discover, about ten years ago, the principles and practice of Photogenic Drawing, is desirous that the first specimen of an Art, likely in all probability to be much employed in future, should be published in the country where it was first discovered. And he makes no doubt that his countrymen will deem such an intention sufficiently laudable to induce them to excuse the imperfections necessarily incident to a first attempt to exhibit an Art of so great singularity, which employs processes entirely new, and having no analogy to any thing in use before. That such imperfections will occur in a first essay, must indeed be expected. At present the Art can hardly be said to have advanced beyond its infancy – at any rate, it is yet in a very early stage – and its practice is often impeded by doubts and difficulties, which, with increasing knowledge, will diminish and disappear. Its progress will be more rapid when more minds are devoted to its improvement, and when more of skilful manual assistance is employed in the manipulation of its delicate processes; the paucity of which skilled assistance at the present moment the Author finds one of the chief difficulties in his way.

Brief Historical Sketch of the Invention of the Art
It may be proper to preface these specimens of a new Art by a brief account of the circumstances which preceded and led to the discovery of it. And these were nearly as follows.

One of the first days of the month of October 1833, I was amusing myself on the lovely shores of the Lake of Como, in Italy, taking sketches with Wollaston's Camera Lucida, or rather I should say, attempting to take them: but with the smallest possible amount of success. For when the eye was removed from the prism – in which all looked beautiful – I found that the faithless pencil had only left traces on the paper melancholy to behold.

After various fruitless attempts, I laid aside the instrument and came to the conclusion, that its use required a previous knowledge of drawing, which unfortunately I did not possess.

I then thought of trying again a method which I had tried many years before. This method was, to take a Camera Obscura, and to throw the image of the objects on a piece of transparent tracing paper laid on a pane of glass in the focus of the instrument. On this paper the objects are distinctly seen, and can be traced on it with a

pencil with some degree of accuracy, though not without much time and trouble.

I had tried this simple method during former visits to Italy in 1823 and 1824, but found it in practice somewhat difficult to manage, because the pressure of the hand and pencil upon the paper tends to shake and displace the instrument (insecurely fixed, in all probability, while taking a hasty sketch by a roadside, or out of an inn window); and if the instrument is once deranged, it is most difficult to get it back again, so as to point truly in its former direction.

Besides which, there is another objection, namely, that it baffles the skill and patience of the amateur to trace all the minute details visible on the paper; so that, in fact, he carries away with him little beyond a mere souvenir of the scene – which, however, certainly has its value when looked back to, in long after years.

Such, then, was the method which I proposed to try again, and to endeavour, as before, to trace with my pencil the outlines of the scenery depicted on the paper. And this led me to reflect on the inimitable beauty of the pictures of nature's painting which the glass lens of the Camera throws upon the paper in its focus – fairy pictures, creations of a moment, and destined as rapidly to fade away.

It was during these thoughts that the idea occurred to me ... how charming it would be if it were possible to cause these natural images to imprint themselves durably, and remain fixed upon the paper!

And why should it not be possible? I asked myself.

The picture, divested of the ideas which accompany it, and considered only in its ultimate nature, is but a succession or variety of stronger lights thrown upon one part of the paper, and of deeper shadows on another. Now Light, where it exists, can exert an action, and, in certain circumstances, does exert one sufficient to cause changes in material bodies. Suppose, then, such an action could be exerted on the paper; and suppose the paper could be visibly changed by it. In that case surely some effect must result having a general resemblance to the cause which produced it: so that the variegated scene of light and shade might leave its image or impression behind, stronger or weaker on different parts of the paper according to the strength or weakness of the light which had acted there.

Such was the idea that came into my mind. Whether it had ever occurred to me before amid floating philosophic visions, I know not, though I rather think it must have done so, because on this occasion it struck me so forcibly. I was then a wanderer in classic Italy, and, of course, unable to commence an inquiry of so much difficulty: but, lest the thought should again escape me between that time and my return to England,

I made a careful note of it in writing, and also of such experiments as I thought would be most likely to realise it, if it were possible.

And since, according to chemical writers, the nitrate of silver is a substance peculiarly sensitive to the action of light, I resolved to make a trial of it, in the first instance, whenever occasion permitted on my return to England.

But although I knew the fact from chemical books, that nitrate of silver was changed or decomposed by Light, still I had never seen the experiment tried, and therefore I had no idea whether the action was a rapid or a slow one; a point, however, of the utmost importance, since, if it were a slow one, my theory might prove but a philosophic dream.

Such were, as nearly as I can now remember, the reflections which led me to the invention of this theory, and which first impelled me to explore a path so deeply hidden among nature's secrets. And the numerous researches which were afterwards made – whatever success may be thought to have attended them – cannot, I think, admit of a comparison with the value of the first and original idea.

In January 1834, I returned to England from my continental tour, and soon afterwards I determined to put my theories and speculations to the test of experiment, and see whether they had any real foundation.

Accordingly I began by procuring a solution of nitrate of silver, and with a brush spread some of it upon a sheet of paper, which was afterwards dried. When this paper was exposed to the sunshine, I was disappointed to find that the effect was very slowly produced in comparison with what I had anticipated.

I then tried the chloride of silver, freshly precipitated and spread upon paper while moist. This was found no better than the other, turning slowly to a darkish violet colour when exposed to the sun.

Instead of taking the chloride already formed, and spreading it upon paper, I then proceeded in the following way. The paper was first washed with a strong solution of salt, and when this was dry, it was washed again with nitrate of silver. Of course, chloride of silver was thus formed in the paper, but the result of this experiment was almost the same as before, the chloride not being apparently rendered more sensitive by being formed in this way.

Similar experiments were repeated at various times, in hopes of a better result, frequently changing the proportions employed, and sometimes using the nitrate of silver before the salt, &c. &c.

In the course of these experiments, which were often rapidly performed, it sometimes happened that the brush did not pass over the whole of the paper, and of course this produced irregularity in the results. On some occasions certain portions of the paper were observed to blacken in the sunshine much more rapidly than the rest. These more sensitive portions were generally situated near the edges or confines of the part that had been washed over with the brush.

After much consideration as to the cause of this appearance, I conjectured that these bordering portions might have absorbed a lesser quantity of salt, and that, for some reason or other, this had made them more sensitive to the light. This idea was easily put to the test of experiment. A sheet of paper was moistened with a much weaker solution of salt than usual, and when dry, it was washed with nitrate of silver. This paper, when exposed to the sunshine, immediately manifested a far greater degree of sensitiveness than I had witnessed before, the whole of its surface turning black uniformly and rapidly: establishing at once and beyond all question the important fact, that a lesser quantity of salt produced a greater effect. And, as this circumstance was unexpected, it afforded a simple explanation of the cause why previous inquirers had missed this important result, in their experiments on chloride of silver, namely, because they had always operated with wrong proportions of salt and silver, using plenty of salt in order to produce a perfect chloride, whereas what was required (it was now manifest) was, to have a deficiency of salt, in order to produce an imperfect chloride, or (perhaps it should be called) a *subchloride* of silver.

So far was a free use or abundance of salt from promoting the action of light on the paper, that on the contrary it greatly weakened and almost destroyed it: so much so, that a bath of salt water was used subsequently as a fixing process to prevent the further action of light upon sensitive paper.

This process, of the formation of a subchloride by the use of a very weak solution of salt, having been discovered in the spring of 1834, no difficulty was found in obtaining distinct and very pleasing images of such things as leaves, lace, and other flat objects of complicated forms and outlines, by exposing them to the light of the sun.

The paper being well dried, the leaves, &c. were spread upon it, and covered with a glass pressed down tightly, and then placed in the sunshine; and when the paper grew dark, the whole was carried into the shade, and the objects being removed from off the paper, were found to have left their images very perfectly and beautifully impressed or delineated upon it.

But when the sensitive paper was placed in the focus of a Camera Obscura and directed to any object, as a building for instance, during a moderate space of time, as an hour or two, the effect produced upon the paper was not strong enough to exhibit such a satisfactory

picture of the building as had been hoped for. The outline of the roof and of the chimneys, &c. against the sky was marked enough; but the details of the architecture were feeble, and the parts in shade were left either blank or nearly so. The sensitiveness of the paper to light, considerable as it seemed in some respects, was therefore, as yet, evidently insufficient for the purpose of obtaining pictures with the Camera Obscura; and the course of experiments had to be again renewed in hopes of attaining to some more important result.

The next interval of sufficient leisure which I found for the prosecution of this inquiry, was during a residence at Geneva in the autumn of 1834. The experiments of the previous spring were then repeated and varied in many ways; and having been struck with a remark of Sir H. Davy's which I had casually met with – that the *iodide* of silver was more sensitive to light than the *chloride*, I resolved to make trial of the iodide. Great was my surprise on making the experiment to find just the contrary of the fact alleged, and to see that the iodide

Henry Fox Talbot: Photogenic drawing of leaves (undated)

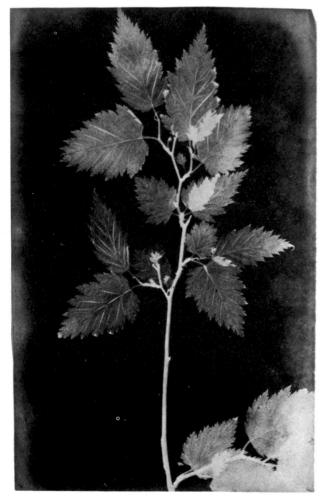

was not only less sensitive than the chloride, but that it was not sensitive at all to light; indeed that it was absolutely insensible to the strongest sunshine: retaining its original tint (a pale straw colour) for any length of time unaltered in the sun. This fact showed me how little dependance was to be placed on the statements of chemical writers in regard to this particular subject, and how necessary it was to trust to nothing but actual experiment: for although there could be no doubt that Davy had observed what he described under certain circumstances – yet it was clear also, that what he had observed was some exception to the rule, and not the rule itself. In fact, further inquiry showed me that Davy must have observed a sort of subiodide in which the iodine was deficient as compared with the silver: for, as in the case of the chloride and subchloride the former is much less sensitive, so between the iodide and subiodide there is a similar contrast, but it is a much more marked and complete one.

However, the fact now discovered, proved of immediate utility; for, the iodide of silver being found to be insensible to light, and the chloride being easily converted into the iodide by immersion in iodide of potassium, it followed that a picture made with the chloride could be *fixed* by dipping it into a bath of the alkaline iodide.

This process of fixation was a simple one, and it was sometimes very successful. The disadvantages to which it was liable did not manifest themselves until a later period, and arose from a new and unexpected cause, namely, that when a picture is so treated, although it is permanently secured against the *darkening* effect of the solar rays, yet it is exposed to a contrary or *whitening* effect from them; so that after the lapse of some days the dark parts of the picture begin to fade, and gradually the whole picture becomes obliterated, and is reduced to the appearance of a uniform pale yellow sheet of paper. A good many pictures, no doubt, escape this fate, but as they all seem liable to it, the fixing process by iodine must be considered as not sufficiently certain to be retained in use as a photographic process, except when employed with several careful precautions which it would be too long to speak of in this place.

During the brilliant summer of 1835 in England I made new attempts to obtain pictures of buildings with the Camera Obscura; and having devised a process which gave additional sensibility to the paper, viz. by giving it repeated alternate washes of salt and silver, and using it in a moist state, I succeeded in reducing the time necessary for obtaining an image with the Camera Obscura on a bright day to ten minutes. But these pictures, though very pretty, were very small, being quite miniatures. Some were obtained of a larger size,

but they required much patience, nor did they seem so perfect as the smaller ones, for it was difficult to keep the instrument steady for a great length of time pointing at the same object, and the paper being used moist was often acted on irregularly.

During the three following years not much was added to previous knowledge. Want of sufficient leisure for experiments was a great obstacle and hindrance, and I almost resolved to publish some account of the Art in the imperfect state in which it then was.

However curious the results which I had met with, yet I felt convinced that much more important things must remain behind, and that the clue was still wanting to this labyrinth of facts. But as there seemed no immediate prospect of further success, I thought of drawing up a short account of what had been done, and presenting it to the Royal Society.

However, at the close of the year 1838, I discovered a remarkable fact of quite a new kind. Having spread a piece of silver leaf on a pane of glass, and thrown a particle of iodine upon it, I observed that coloured rings formed themselves around the central particle, especially if the glass was slightly warmed. The coloured rings I had no difficulty in attributing to the formation of infinitely thin layers or strata of iodide of silver; but a most unexpected phenomenon occurred when the silver plate was brought into the light by placing it near a window. For then the coloured rings shortly began to change their colours, and assumed other and quite unusual tints, such as are never seen in the 'colours of thin plates'. For instance, the part of the silver plate which at first shone with a pale yellow colour, was changed to a dark olive green when brought into the daylight.

This change was not very rapid: it was much less rapid than the changes of some of the sensitive papers which I had been in the habit of employing, and therefore, after having admired the beauty of this new phenomenon, I laid the specimens by, for a time, to see whether they would preserve the same appearance, or would undergo any further alteration.

Such was the progress which I had made in this inquiry at the close of the year 1838, when an event occurred in the scientific world, which in some degree frustrated the hope with which I had pursued, during nearly five years, this long and complicated, but interesting series of experiments – the hope, namely, of being the first to announce to the world the existence of the New Art – which has been since named Photography.

I allude, of course, to the publication in the month of January 1839, of the great discovery of M. Daguerre, of the photographic process which he has called the Daguerreotype. I need not speak of the sensation created in all parts of the world by the first announcement of this splendid discovery, or rather, of the fact of its having been made (for the actual method made use of was kept secret for many months longer). This great and sudden celebrity was due to two causes: first, to the beauty of the discovery itself: secondly, to the zeal and enthusiasm of Arago, whose eloquence, animated by private friendship, delighted in extolling the inventor of this new art, sometimes to the assembled science of the French Academy, at other times to the less scientific judgment, but not less eager patriotism, of the Chamber of Deputies.

But, having brought this brief notice of the early

Henry Fox Talbot: The earliest surviving negative taken in the south gallery, Lacock Abbey, with Talbot's inscription, August 1835. Photogenic drawing.

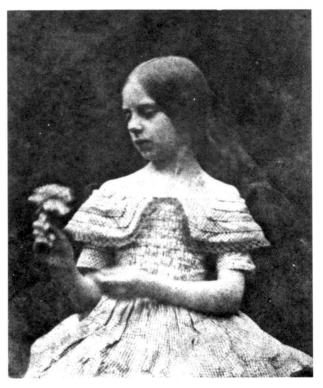

Henry Fox Talbot: Calotypes of his wife, Constance (above), 10 October 1840, taken within days of discovering the faster process, his daughter, Rosamund (above right), and an unknown man (below). All taken with a 'mousetrap' camera.

days of the Photographic Art to the important epoch of the announcement of the Daguerreotype, I shall defer the subsequent history of the Art to a future number of this work.

Some time previously to the period of which I have now been speaking, I met with an account of some researches on the action of Light, by Wedgwood and Sir H. Davy, which, until then, I had never heard of. Their short memoir on this subject was published in 1802 in the first volume of the Journal of the Royal Institution. It is curious and interesting, and certainly establishes their claim as the first inventors of the Photographic Art, though the actual progress they made in it was small. They succeeded, indeed, in obtaining impressions from Wedgwood, yet the improvements were so great in all respects, that I think the year 1839 may fairly be considered as the real date of the birth of the Photographic Art, that is to say, its first public disclosure to the world.

There is a point to which I wish to advert, which respects the execution of the following specimens. As far as respects the design, the copies are almost facsimiles of each other, but there is some variety in the tint which they present. This arises from a twofold cause. In the first place, each picture is separately formed by the light of the sun, and in our climate the strength of the sun's rays is exceedingly variable even in serene weather.

Henry Fox Talbot: The milliner's window. Calotype, c. 1845

Henry Fox Talbot: Photomicrograph of plant sections, c. 1839

When clouds intervene, a longer time is of course allowed for the impression of a picture, but it is not possible to reduce this to a matter of strict and accurate calculation.

The other cause is the variable quality of the paper employed, even when furnished by the same manufacturers – some differences in the fabrication and in the *sizing* of the paper, known only to themselves, and perhaps secrets of the trade, have a considerable influence on the tone of colour which the picture ultimately assumes.

These tints, however, might undoubtedly be brought nearer to uniformity, if any great advantage appeared likely to result: but, several persons of taste having been consulted on the point, viz. which tint on the whole deserved a preference, it was found that their opinions offered nothing approaching to unanimity, and therefore, as the process presents us spontaneously with a variety of shades of colour, it was thought best to admit whichever appeared pleasing to the eye, without aiming at an uniformity which is hardly attainable. And with these brief observations I commend the pictures to the indulgence of the Gentle Reader.

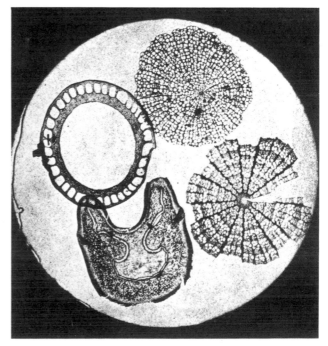

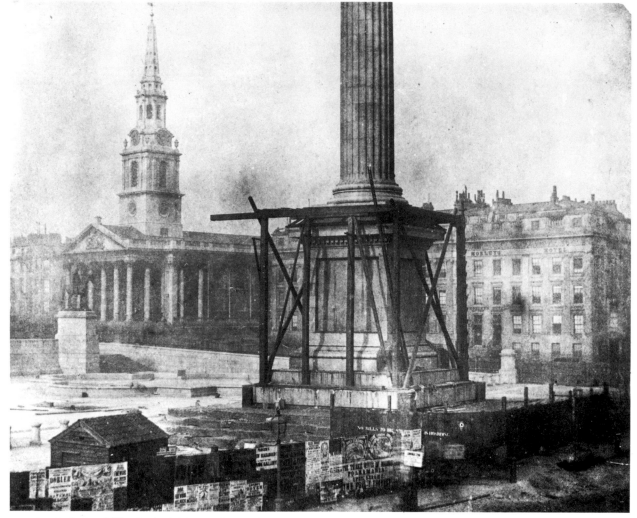

1.1 HENRY FOX TALBOT: NELSON'S COLUMN BEING CONSTRUCTED

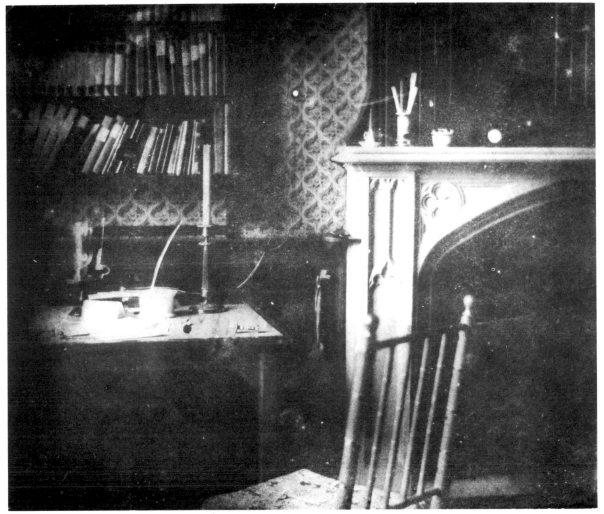

1.2 HENRY FOX TALBOT: INTERIOR, LACOCK ABBEY

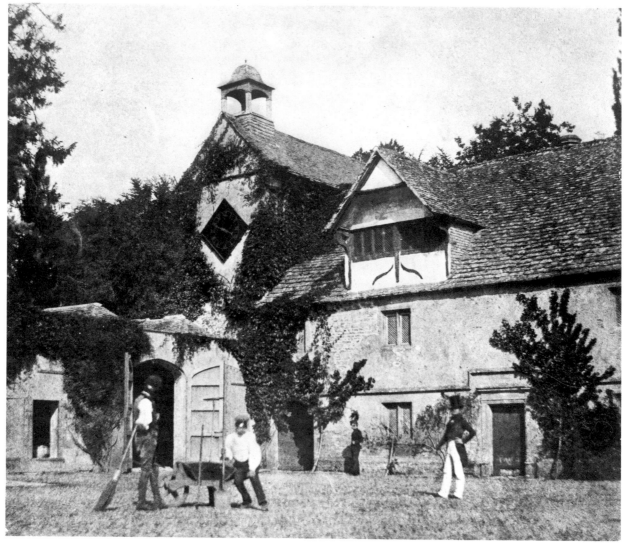

1.3 HENRY FOX TALBOT: THE COURTYARD, LACOCK ABBEY

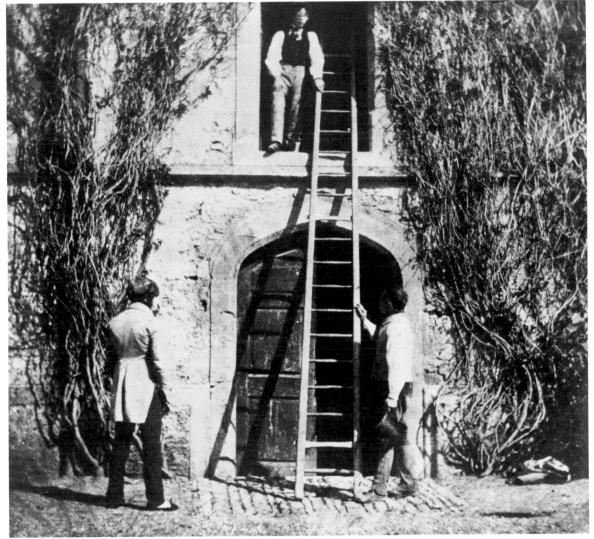

1.4 HENRY FOX TALBOT: THE LADDER

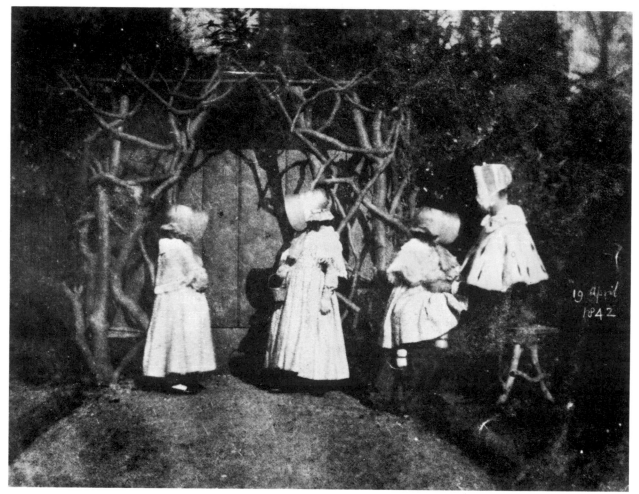

1.5 HENRY FOX TALBOT: MRS TALBOT AND THEIR THREE DAUGHTERS

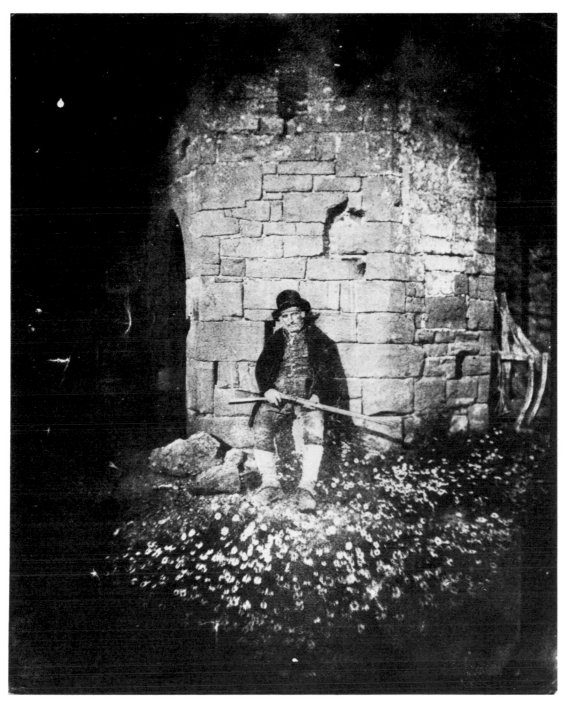

1.6 HENRY FOX TALBOT: A GAMEKEEPER

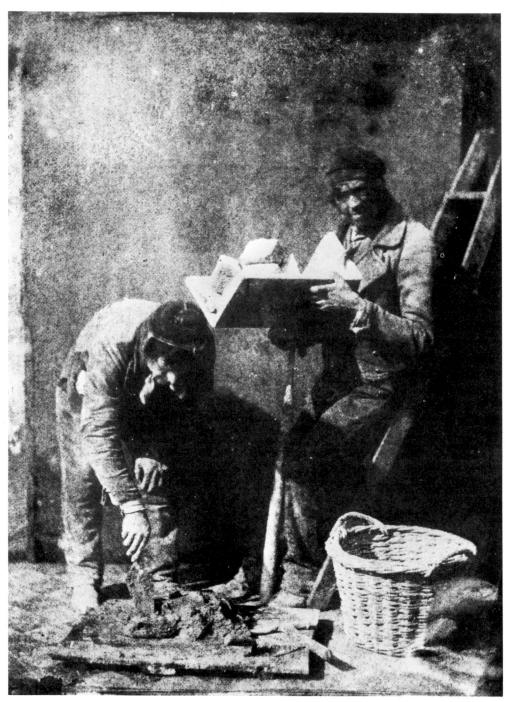

1.7 HENRY FOX TALBOT: BRICKLAYERS

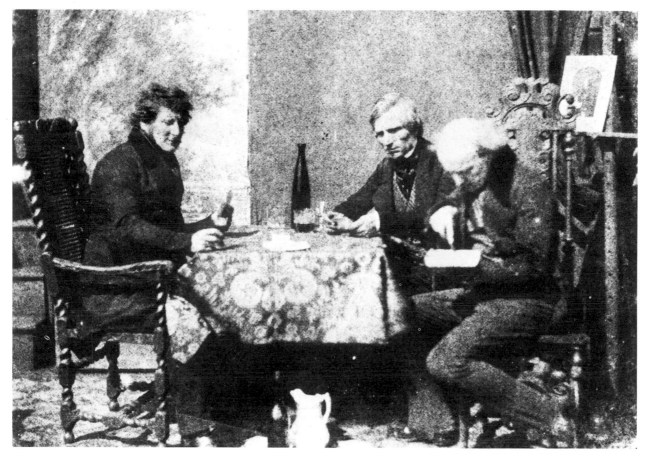

1.8 HENRY FOX TALBOT: BOHEMIAN PARTY

THE MIRROR WITH A MEMORY

"I am going to concentrate on three things:—1) to give greater precision to the representation of the objects; 2) to transpose the tones; 3) and finally, to fix them, which is not going to be the least easy; but as you rightly said, Mon cher ami, we are not lacking in patience, and with patience, one succeeds in the end."
 Joseph-Nicéphore Niépce (1816)

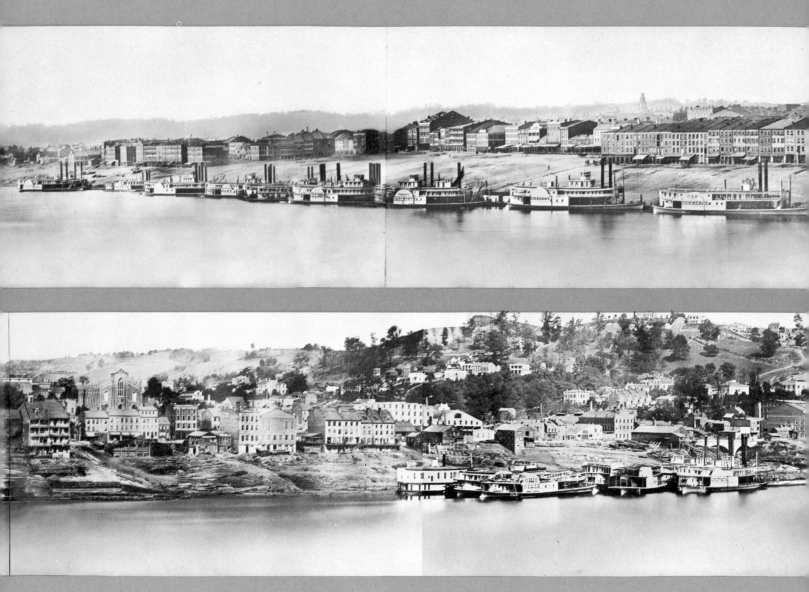

CHARLES FONTAYNE AND W. S. PORTER: PANORAMA OF EIGHT DAGUERREOTYPES OF THE CINCINNATI WATERFRONT

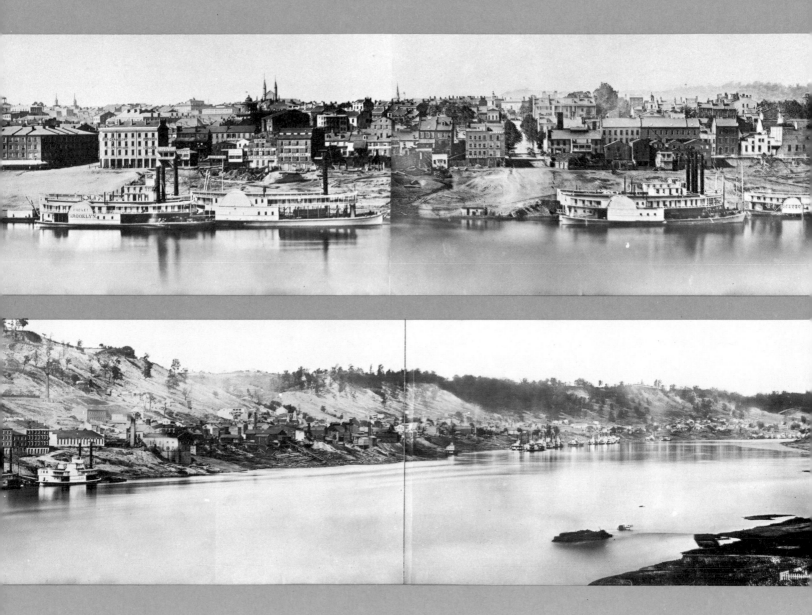

THE MIRROR WITH A MEMORY

One of the most startling pieces of information about the early daguerreotype and its rapid dissemination around the world is that, in the opening up of Japan in the early 1850s, Admiral Perry had on board a professional daguerreotypist. The illustration overleaf is a copy of an extraordinary recording executed by a Japanese printmaker. It appears in the famous *Black Ship Scroll*. It shows Perry's daguerreotypist and two assistants taking the portrait of a courtesan at Daian-ji temple in Shimoda. This was an extremely daring act on the part of the sitter,

for it was profoundly believed that a portrait of any kind was an inducement to the soul to shift its abode from the reality to the representation, and portrait photography particularly was soon considered by the superstitious tantamount to murder.

Considering the excitement caused in 1839 by the invention of photography, it may come as a surprise that a primitive, but workable, photographic process using a camera was devised as early as 1816 and what is even more astonishing is that it had been attempted to produce those photographs in natural colour.[1] We know that other photographic techniques had been evolved by more than one experimenter even earlier than that. But they neither involved the use of a camera, nor were they in any way conclusive. So Joseph Nicéphore Niépce (1765–1833), a dilettante inventor (dilettante in the best nineteenth-century sense), who lived a rural existence in provincial

France, can take the credit for being the true inventor of the first practicable, though problematical, photographic process, twenty-three years before photography was officially invented.

Niépce wrote a great many letters, mostly to his brother Claude who lived first in Paris then, till his death in 1827, with a bargebuilder in Hammersmith. This correspondence, which can only be touched upon here, presents a somewhat tragic picture of a family of good standing, struggling through the vicissitudes of revolution and restoration to wrest from an unstable world whatever security the commercial exploitation of their inventions could provide.

1 April 1816. Nicéphore writes to Claude in Paris:

The experiments I have done up till now make me believe that, as far as the principal effect, my process will work well; but I need to arrive at some way of fixing the colour: this is what is concerning me at the moment, and it's the thing which is the most difficult. Without that it wouldn't be worth anything, and I would have to tackle it another way.[1]

22 April. He breaks his lens and waits for another before continuing with his experiments.

5 May 1816. During a visit to Chalons he gets another lens and adapts his camera obscura to take it (Isidore is his son):

1 It is astonishing, but quite possible, that Niépce attempted to produce those photographs in natural colour. In a later letter to his brother Claude, after visiting Daguerre in 1827, he describes Daguerre's partial success in registering natural colours chemically, but holds out both for Daguerre and himself little hope of overcoming such an intractable process. See Victor Fouqué, *La Vérité sur l'invention de la photographie*, Paris 1867.

Illustration by E. Morin from 'The Legend of the Daguerreotype' by Champfleury.

1 Niépce Letters 1816, Originals in *Chalon-sur-Saône Public Library*. Published.

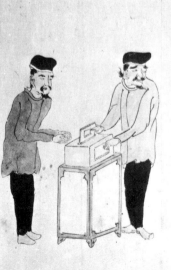

Unknown Japanese Artist: The Black Ship Scroll – photographers from Commodore Perry's expedition to Japan taking a Daguerreotype of a courtesan, 1853–4.

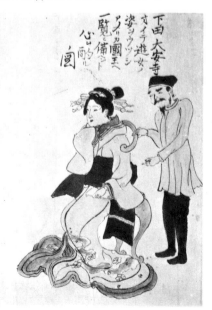

We returned here on Wednesday evening; but since then the time has always been fully occupied which hasn't left me free to follow up my experiments, and I'm maddened because they interest me a great deal, and one's got to drop it from time to time to go the rounds or receive people here: It's a bore; I would prefer, I can tell you, to be in the wilderness. Not being able to use my camera obscura when my lens was broken, I made an artificial eye with Isidore's Baguier, which is a little box with 16 or 18 lines in a grid. Luckily I had a lens from a solar microscope, which, as you know, belonged to our grand-father Barrault. I found one of these little lenses was exactly the right focal length, and the image of the objects defined itself in a very sharp and precise way on a field of 13 lines in diameter. I put the apparatus in the room where I work; opposite the pigeon-cote, and with the sash wide open. I made the experiment by the method you know, Mon cher ami; and I saw on the white paper all the part of the pigeon-cote which can be seen from the window, and a faint picture of the sash-bars which were lit less brilliantly than the objects outside. You can see the effects of the light in the representation of the pigeon-cote and as far as the frame of the window. This is a test piece which is still very unfinished; but the object glass picture is extremely small. The possibility of drawing in this way, seems to me to be pretty well proved; and if I succeed in perfecting my process, I will rush to let you know in return for the lively interest you wish so much to show me. I have no illusions; there are great difficulties, above all in fixing the colours; [but with] work and a great deal of patience one could win through. What you foresaw has happened: the ground of the picture is black, and the objects are white, or rather lighter than the background. I believe such a method of painting is not unknown, and that I have seen engravings done in this way; for the rest it would not be impossible to change the ordering of the tones; even on that point I have several theories which I am curious to check.

19 May 1816.

I am hastening to reply to your letter of the 14th which we received the day before yesterday; and which gave us a great deal of pleasure. I am writing you on a single half-sheet because Mass this morning and a visit made this evening to M. and Madame de Morteuil have left me hardly any time; and secondly, not to increase the weight of my letter too much, as I am adding to it two prints made by the process you know about. The smallest was from the Baguier, and the other from the Box which I have described to you, which is half-way between the Baguier and the big Box. To get the best idea of the effect, you must put yourself in shadow. (Place the print on something opaque and put yourself against the light.) I expect this type of print will alter in course of time if it's not kept from contact with light, because of the action of the nitric acid which is not neutralised. I'm afraid, too, that it will have been damaged by the jostlings of the coach. This is nothing but a test: but if the results were a little stronger (which I hope to get), and above all if the ordering of the tones was reversed, I believe that the illusion would be complete. These two prints were made in the room where I work, and the field was no bigger than the size of the window sash. I have read in Abbé Nollet that to be able to produce a greater number of distant objects, one needs lenses of a greater focal length, and to put one more glass in the lens housing. Although they are hardly worth it, if you want to keep these two prints you have only to wrap them in grey paper and put the whole thing in a book. I am going to concentrate on three things :— 1) to give greater precision to the representation of the objects; 2) to transpose the tones; 3) and finally, to fix them, which is not going to be the least easy; but as you rightly said, Mon cher ami, we are not lacking in patience, and with patience, one succeeds in the end. If I am lucky enough to perfect this same process, I shan't forget to send you new samples as a return for the lively interest you would certainly take in something which could be so useful to the arts, and from which we would reap great advantage.

28 May 1816.

I am hastening to send you four new prints, 2 big and 2 little that I have made which are sharper and more precise due to a very simple method which consists of reducing the diameter of the lens with a disc of pierced cardboard. In this way as the inside of the box receives less light, the image becomes sharper, and its outlines as well as its lights and darks are much stronger. You can appreciate this from the roof of the pigeon-cote, by the angle of its wall, by the window sashes – you can see the sash bar – even the windows seem transparent in some places. In short the paper records exactly the picture of the object depicted; and if you cannot see it all that distinctly, it's because the image of the object represented is very small, the object appears as it would if it were viewed from a distance. It follows from this, as I told you, that one would need two glasses in the lens to record distant objects conveniently and to project a wide area on the 'retina'; but this is something else again. The pigeon-cote has been taken in reverse, the barn, or rather the roof of the barn is on the left instead of being

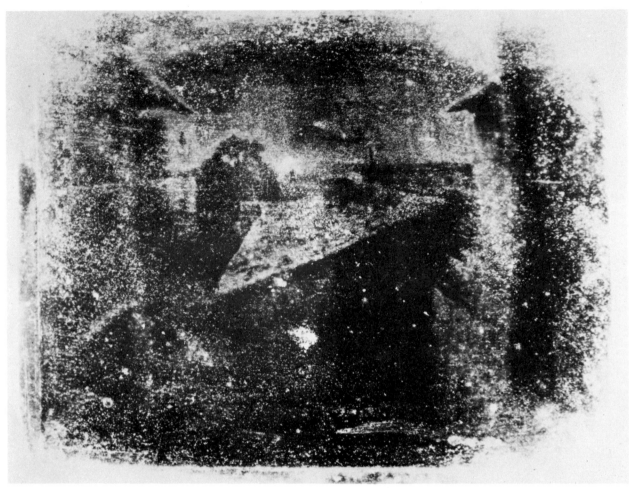

Joseph Nicéphore Niépce: View from his study window (Summer 1827). The first view from nature through a camera obscura to be fixed permanently.

on the right. The white mass to the right of the pigeon-cote above the light track which one can only see partially (but this is the way it is depicted on the paper by the reflexion of the image), that's the tree of white butter-pears which is a good deal further off; and the black splodge at the top of the peak, is an opening that can be seen between the branches. That shadow on the right marks out the roof of the bake-house which seems lower than it ought to be, because the Boxes are placed at about 5 feet above the floor. Finally, Mon cher ami, those little white spots dotted in above the roof of the barn, are the branches of trees in the orchard which are visible, and so are represented on the retina. The effect would be all the more striking, if, as I told you, or rather, as I have no need to tell you, if the order of the darks and lights could be reversed; this is what I must concentrate on before trying to fix the colours, and it is not easy. Up till now I have only taken the picture of the pigeon-cote in order to make a comparison between the prints. You will find that one of the large ones and the two small ones are fainter

than the two others where the outlines of the objects are very well developed; this is a result of my having closed the hole in the card covering the lens too much. There would seem to be ratios from which one must not stray, and I have not yet been able to find the best. When the lens is left clear, the print one gets seems very misty, and the picture recorded takes on that kind of look because the objects are not so sharp and seem in some way to lose themselves in the haze.

From 1826, until his death on 5 July 1833, Niépce took part in an edgy and clandestine correspondence with his most obvious competitor, Louis Jacques Mandé Daguerre (1787–1851). So fearful were they that the secret of their processes might be purloined while they struggled to perfect a more efficient method, that they made use of a cryptic numerology, a prearranged code, which ludicrously punctuates their letters. After Niépce died, Daguerre carried on, mostly by himself, ultimately to hit upon his own, chemically idiosyncratic, technique.

Daguerre was a well-known scenic painter of large-

scale illusionist entertainments, for which he frequently employed the camera obscura. He hit upon the idea of photography about eight years after Niépce's first experiments, devoting himself almost obsessively to the difficult task of making his process workable. About 1826 he got wind of Niépce's activities and succeeded, though not without difficulty, in elbowing his way into the confidence of the inventor from Chalon. Thus, on 14 December 1829, began the uneasy partnership which terminated with the death of Niépce, leaving Daguerre to carry on in ineffectual consultation with Niépce's son, Isidore. Daguerre's first letters to Niépce were treated with the greatest suspicion. These letters have not survived, but here is part of Niépce's letter of early February 1827, addressed to an engraver named Lemaître, inquiring whether or not Daguerre is known to him:

Having been told, I have no idea how, of the object of my experiments, this gentleman wrote to me last year in January, to let me know that he himself had been occupied with the same object for a considerable time. He asked me if I had been more successful than he in these efforts. On the one hand, if one is to believe what he says, he has already obtained some very surprising results. On the other, he asks me whether I believe the thing is possible. I need not tell you that I was surprised by this incoherence of thought, to say the least. I was therefore all the more careful and reserved in what I told him, but still I wrote him in a civil manner so as to elicit a reply. This I've received only today, which is to say after an interval of over a year, and he writes only to find out how much I've progressed and asks if I would send him a picture . . .[1]

But eventually, due largely to Daguerre's persistence, Niépce's suspicions faded and a legal partnership was formed. By 1832 victory seemed so near that Niépce sat down and played with a number of Greek compounds in a game of devising an appropriate designation for the new art:[2]

		French phonetic equivalent	Niépce's translation
a	φίσις	(phusis)	nature
b	αὐτή	(aute)	·itself
c	γραφη	(graphe)	writing; painting; picture
d	τύπος	(typos)	[esbarque]; sign; imprint; trace; image; effigy; model

1 Fouqué, op. cit.·
2 Kravets, Niépce Papers, Moscow 1944.

		French phonetic equivalent	Niépce's translation
e	εἰχών	(eikon)	image, symbol, representation; description; portrait
f	παράστασις	(parastasis)	representation, show, the act of showing as representing
g	ἀληθής	(alethes)	true; real –

This makes *with*
1 Physautographie a b c Phusis, aute, graphe –
2 Physautotype a b d Phusis, aute, Typos –
3 Iconotauphyse – (sic) e b a Eikon, aute, Phusis –
4 Paratauphyse – (sic) f b a Parastasis, aute, Phusis
5 Alethophyse – g a alethes, Phusis –
6 Phusalethotype – a g d Phusis, alethes, Typos –

That's to say
1 Painting by nature herself
2 Copy by nature herself
3 Portrait by nature herself
4 To show nature herself } Roughly
5 Real nature
6 True copy from nature

physaute }
phusaute } Nature herself

Autophuse }
Autophyse } Copy by nature

Here is one of Daguerre's last letters to Niépce, persisting in the truncated style of a conspiratorial communiqué. Niépce died only a few months later:

Paris 19 April 1833

Mon cher Monsieur Niépce,

You will consider me very slack but it was impossible for me to reply earlier, my painting hasn't left me a free moment, I have been so busy I haven't even had time to uncork the bottles you sent me. I am amazed that you could only get the 54th part as residue, but if this stuff works out a little expensive you have to take into account that only very little is needed to cover a plate. You will have been surprised not to have got the glass things back earlier but as the awful weather persisted I guessed they would not be urgently needed; also apart from that I was thinking of rigging something for the 13,[1] but the idea is to simplify; besides it's only applicable to very small sized plates.

1 For '13' read camera obscura; for '18', silver plate.

It consists of completely rearranging the copper fitting of the 13; it's the plate that holds the tube that has to be screwed on the other way so that the tube goes into the 13; the glass which is not touched will turn back naturally with the whole fitting; the concave part stays on the side of the aperture which itself is between the glass and the 18 and the convex part of the lens is facing the subject. By this arrangement the intensity of the light is increased at least by half as much again, and in consequence the speed [of exposure], but as there is only the centre clear you do not need more than a 5 inch deep case to get a range more or less like that of the smallest drawing boxes. I think that the case of 6 inch size, rearranged, will take the biggest ones, though less easily than the 5 inch size for the small.[1]

The news of the invention of photography was first made public at the beginning of 1839. A vast amount of cover-

1 Niépce Papers, op. cit., Moscow.

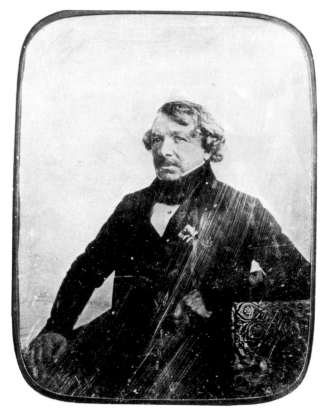

RIGHT J. Sabatier-Blot: Louis Jacques Mandé Daguerre. Daguerreotype.

BELOW L. J. M. Daguerre: Fossils. Daguerreotype.

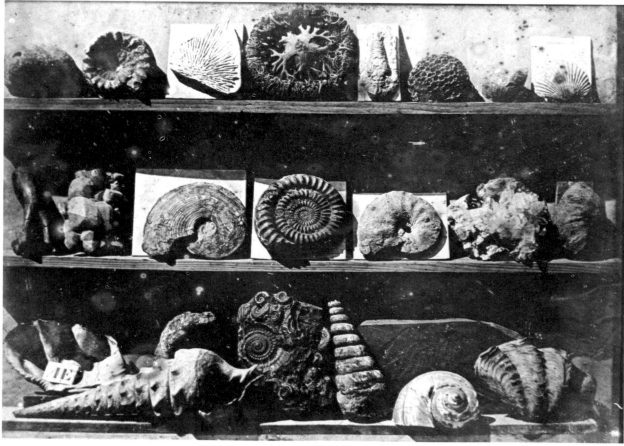

age was given to this modern miracle. The following is an excerpt from *The Literary Gazette* in London for 12 January, citing the *Gazette de France*, and printed under the heading 'Fine Arts':

FINE ARTS

The Daguerotype

Paris, 6th January, 1839

We have much pleasure in announcing an important discovery made by M. Daguerre, the celebrated painter of the Diorama. This discovery seems like a prodigy. It disconcerts all the theories of science in light and optics, and, if borne out, promises to make a revolution in the arts of design.

M. Daguerre has discovered a method to fix the images which are represented at the back of a camera obscura; so that these images are not the temporary reflection of the object, but their fixed and durable impress, which may be removed from the presence of those objects like a picture or an engraving.

Let our readers fancy the fidelity of the image of nature figured by the camera obscura, and add to it an action of the solar rays which fixes this image, with all its gradations of lights, shadows, and middle tints, and they will have an idea of the beautiful designs, with a sight of which M. Daguerre has gratified our curiosity. M. Daguerre cannot act on paper; he requires a plate of polished metal. It was on copper that we saw several points of the Boulevards, Pont Marie, and the environs, and many other spots, given with a truth which Nature alone can give to her works. M. Daguerre shews you the plain plate of copper: he places it, in your presence, in his apparatus, and, in three minutes, if there is a bright summer sun, and a few more, if autumn or winter weaken the power of its beams, he takes out the metal and shews it to you, covered with a charming design representing the object towards which the apparatus was turned. Nothing remains but a short mechanical operation – of washing, I believe – and the design, which has been obtained in so few moments, remains unalterably fixed, so that the hottest sun cannot destroy it.

Messrs. Arago, Biot, and Von Humboldt, have ascertained the reality of this discovery, which excited their admiration; and M. Arago will, in a few days, make it known to the Academy of Sciences.

I add some further particulars. Nature in motion cannot be represented, or at least not without great difficulty, by the process in question. In one of the views of the Boulevards, of which I have spoken, all that was walking or moving does not appear in the design; of two horses in a hackney coach on the stand, one unluckily moved its head during the short operation; the animal is without a head in the design. Trees are very well represented; but their colour, as it seems, hinders the solar rays from producing their image as quickly as that of houses, and other objects of a different colour. This causes a difficulty for landscape, because there is a certain fixed point of perfection for trees, and another for all objects the colours of which are not green. The consequence is, that when the houses are finished, the trees are not, and when the trees are finished, the houses are too much so.

Inanimate nature, architecture, are the triumph of the apparatus which M. Daguerre means to call after his own name – *Daguerotype*. A dead spider, seen in the solar microscope, is finished with such detail in the design, that you may study its anatomy, with or without a magnifying glass, as if it were nature itself; not a fibre, not a nerve, but you may trace and examine. For a few hundred francs travellers may, perhaps, be soon able to procure M. Daguerre's apparatus, and bring back views of the finest monuments, and of the most delightful scenery of the whole world. They will see how far their pencils and brushes are from the truth of the Daguerotype. Let not the draughtsman and the painter, however, despair – the results obtained by M. Daguerre are very different from their works, and, in many cases, cannot be a substitute for them. The effects of this new process have some resemblance to line engraving and mezzotinto, but are much nearer to the latter: as for truth, they surpass everything.

I have spoken of the discovery only as it regards art. If what I have heard is correct, M. Daguerre's discovery tends to nothing less than a new theory on an important branch of science. M. D. generously owns that the first idea of his process was given him, fifteen years ago, by M. Nieps, of Chalons-sur-Saone; but in so imperfect a state, that it has cost him long and persevering labour to attain the object.

H. Gaucheraud.[1]

1 From the *Gazette de France* of 6 January 1839, which pre-empted the official announcement made by François Arago at a meeting of the Académie des Sciences on 7 January.

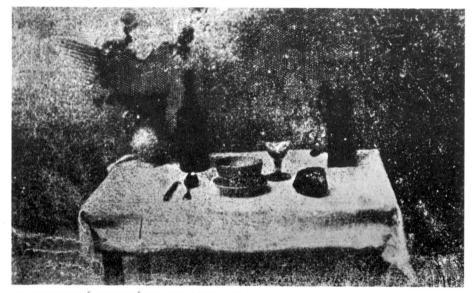

2.1 JOSEPH NICÉPHORE NIÉPCE: STILL LIFE ON GLASS

2.2 L. J. M. DAGUERRE: BOULEVARD DU TEMPLE

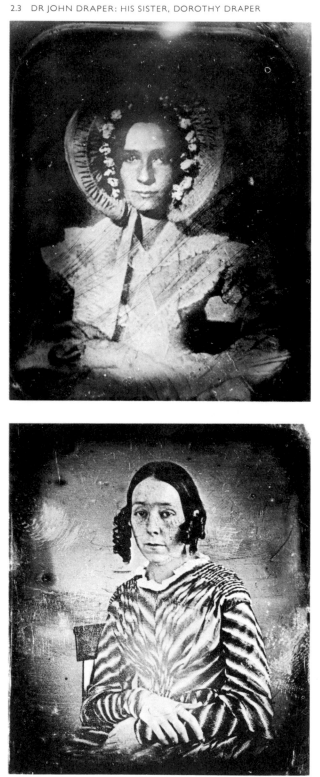

2.4 HENRY FITZ JUNIOR: SUSAN FITZ

2.6 SOUTHWORTH AND HAWES: CHIEF JUSTICE LEMUEL SHAW

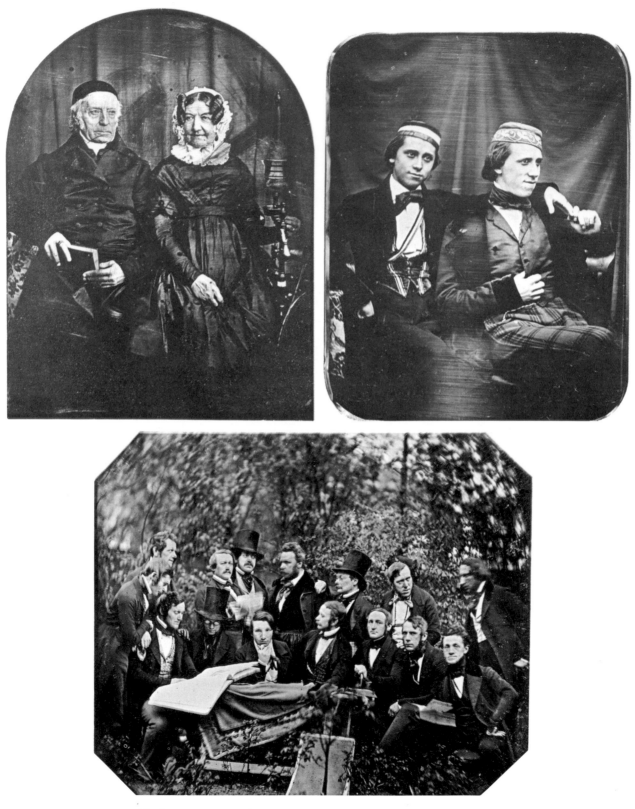

2.7 CARL FERDINAND STELZNER: DANIEL RUNGE AND HIS WIFE
WILHELMINA (ABOVE LEFT), W. A. KRÜSS AND E. J. KRÜSS (ABOVE
RIGHT), AND THE OUTING OF THE HAMBURG SKETCH CLUB (BELOW).

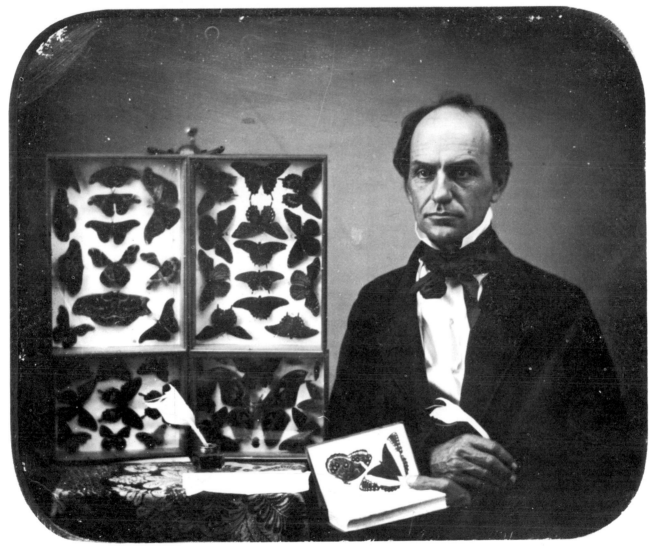

2.8 UNKNOWN PHOTOGRAPHER : THE BUTTERFLY COLLECTOR

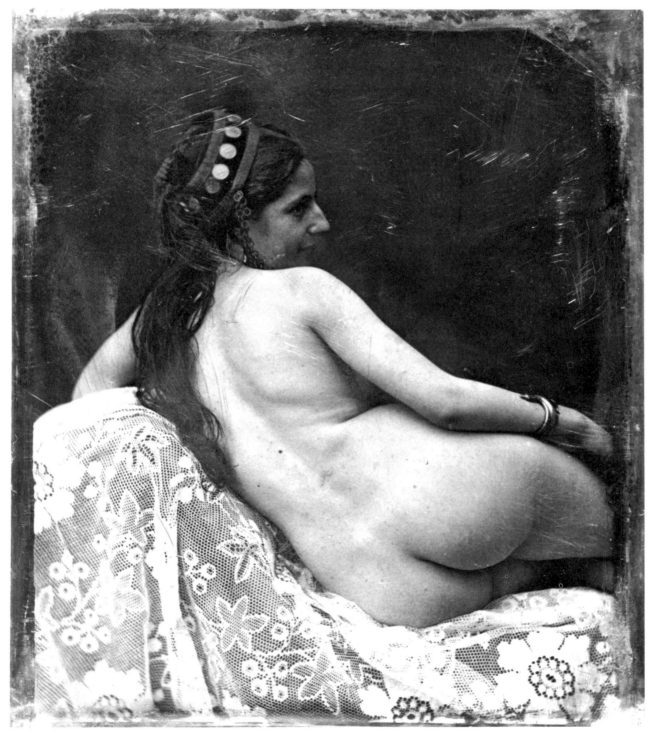

2.9 UNKNOWN PHOTOGRAPHER: NUDE

2.10 HUBERT: CLASSICAL STILL LIFE

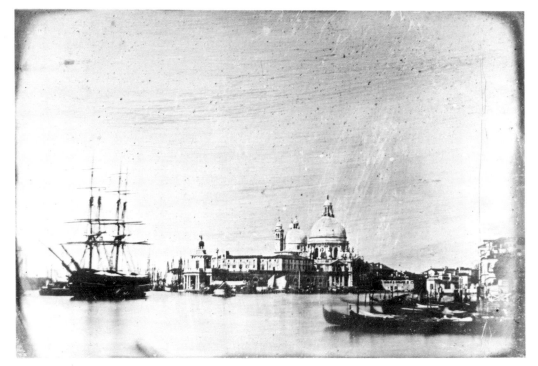

2.11 DR ALEXANDER JOHN ELLIS: VENICE

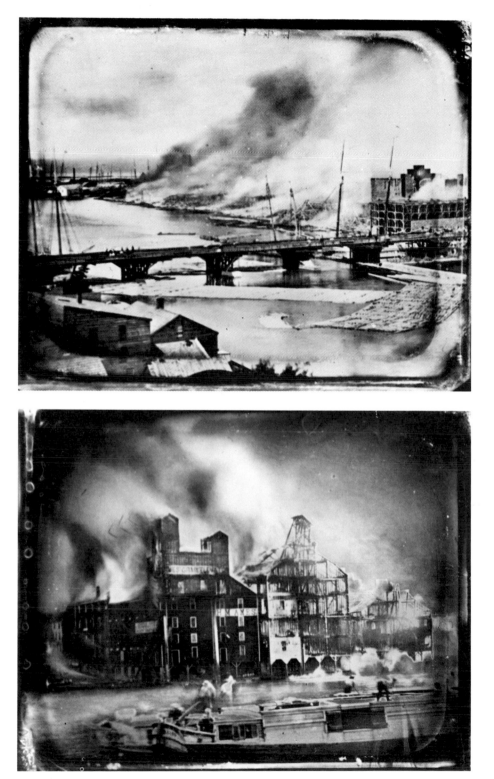

2.12 G. N. BARNARD: BURNING MILLS AT OSWEGO, NEW YORK, 1853

SUN PICTURES

"The photographic picture enclosed was made on 24 October 1839 in 18 minutes—from 11 o'clock in the morning to 11:18, by the following process: Dip the paper in a weak solution of sodium chloride; when it is completely dry, brush this paper with silver nitrate dissolved in six times its weight of water. With the paper almost dry and protected from all action of light, expose it to the fumes of iodine, then in the camera obscura, then to mercury, as in M. Daguerre's process, and finish by washing it in a solution of hyposulphite of soda."
Hippolyte Bayard (1839)

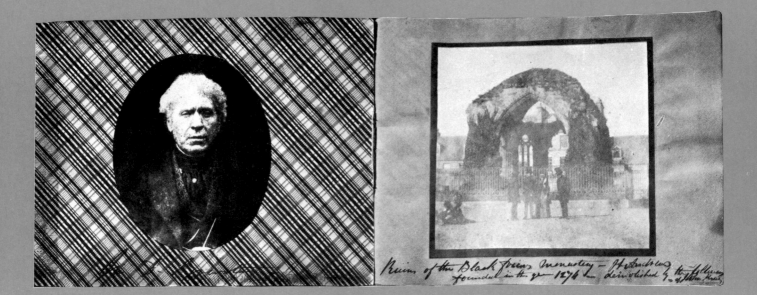

DR JOHN ADAMSON AND ROBERT ADAMSON: PAGES FROM AN ALBUM OF CALOTYPES TAKEN AT ST ANDREWS, FIFE

SUN PICTURES

The *idea* of photography occurred to many people more or less at the same time. In the mêlée to establish priority for its invention, a torrent of claims poured forth, some entirely without foundation, some half-baked, and others quite legitimate. Among this last group, their voices drowned by the trumpeting of others, was one of the forgotten men of 1839, Hippolyte Bayard, inventor of the direct positive process. He provided an ironic caption to his self-portrait, the image of a 'Drowned Man':

Hippolyte Bayard: Self-portrait as a drowned man. 18 October 1840. Positive paper process.

The corpse of the gentleman you see above this, is that of Monsieur Bayard, inventor of the process, the marvellous results of which, you are about to see, or you are going to see. To my certain knowledge, this ingenious and indefatigable experimenter has devoted about three years to perfecting this invention. The Academy, the King, and all those who have seen his drawings (which he himself considers tentative) have admired them, just as you yourselves are enjoying them at this moment. The Government which has been only too generous to Monsieur Daguerre, has said it can do nothing for Monsieur Bayard, and the poor wretch has drowned himself. Oh! the vagaries of human life! Artists, intellectuals, the newspapers have been interested in him for some time and yet today – when he has already been on show at the Morgue for several days – no one has recognised or claimed him. Ladies and gentlemen, pass on to other things for fear that your sense of smell be offended because, as you can see, the face of the gentleman and his hands begin to decompose.

Bayard continued his pathetic efforts to establish a claim to being the inventor of one of the first photographic processes. He sent the following letter to the Academy of Science in France, on the subject of his direct positive on paper method:

24 February 1840

Until today I have held back from giving to the public the photographic process of which I am the inventor, first wishing to make this process as perfect as possible; but as I have not been able to prevent some information

about it being communicated and that from this it would be possible, more or less to make use of my researches, and to detract from the honour of my discovery, I don't think I should delay any longer in making known the method which I have found successful.

There is no time for me to give the necessary details, but if the Academy will permit me, I will complete the account at another session. Here briefly is what my process consists of: ordinary writing-paper having been prepared according to M. Talbot's method, and blackened by exposure to light, I dip it for several seconds in a solution of potassium iodide; then, spreading it on a slate, I put it in the back of a camera obscura. When the drawing has taken shape, I wash the paper in a solution of hyposulphite of soda, and then in warm clean water, and dry it in darkness.[1]

Having heard of Talbot's discovery of the latent image (p. 14), Bayard even laid claim to that, and may indeed have had a right to it:

At the last session of the Academy [8 February 1841], M. Biot read a letter of M. Talbot, in which this physicist speaks of a method, which he doesn't divulge, to make a photographic impression visible which is invisible when it leaves the camera obscura. For some time I have known of three ways which lead to this result. Permit me, Sir, to make one known, and when time has permitted me to try the two others, I will have the honour to communicate them to you.

Having prepared a paper with potassium bromide and then silver nitrate, it is exposed in the camera obscura *still wet* for several minutes. Taken out and looked at by the light of a candle, one can see no trace on this paper of the image which is nevertheless printed on it; to make it appear all that is required is to expose the paper to vapour of mercury as in M. Daguerre's process. It soon blackens everywhere the light has worked on the preparation. It is hardly necessary to remark that as far as possible, one must avoid exposing the prepared paper to any other light source than that of the camera obscura. The description above and one or two proofs obtained by this process were sent to the Academy, which, in its session of 11 November 1839, had kindly acknowledged their receipt. Kindly open this packet, Monsieur, if you think it is relevant.[2]

The packet was opened and found to contain two photographs on paper and the following note:

1 *Mémoirs Originaux des Créateurs de la Photographie*, R. Colson, ed., Paris, 1898.
2 Ibid.

Photographic process on paper

The photographic picture enclosed was made on 24 October 1839 in 18 minutes – from 11 o'clock in the morning to 11.18, by the following process:
Dip the paper in a weak solution of sodium chloride; when it is completely dry, brush this paper with silver nitrate dissolved in six times its weight of water. With the paper almost dry and protected from all action of light, expose it to the fumes of iodine, then in the camera obscura, then to mercury, as in M. Daguerre's process, and finish by washing it in a solution of hyposulphite of soda.

At the time the paper is taken out of the camera obscura, you can hardly see traces of the drawing; but as soon as the mercury vapour condenses on the paper, you can see pictures forming as happens with the metal plates, but with this difference, that the pictures are produced in reverse as in M. Talbot's process.

Paris, 8 November 1839[1]

The race was on with a vengeance. Talbot received a letter from his mother in Paris, dated 11 February 1843:

It seems this M. Bayard has *not* taken his invention from yours and he takes extreme pains to bring it to perfection . . . I really wish you would bring this business to bear, and strike while the iron is hot, for if once M. Bayard succeeds, *yours* will diminish, and there is at this moment an enthusiasm for *Talbotype* which may vanish particularly in such a volatile country as this . . . I have never seen before so good a chance for your fame, don't let it slip thro' your fingers.[2]

Bayard's process is described later, in a letter to Talbot from the Rev. C. R. Jones, 2 March 1843. With critical delicacy, Jones intimates a preference for Bayard's, over Talbot's, images:

March 2nd 1843
. . . I am afraid that you imagine I either underrate or have not fairly tried your beautiful discovery, neither of which, I assure you is the case; I admire it beyond anything and tried it at Paris with M. Regnault & M. Bayard. (The latter succeeded in making an excellent portrait of myself) the only thing which delayed me from doing much more was the apparent want of a more perfect and sure medium of transmission in the way of paper. As we found it continually playing tricks in the form of blotches & spots. If you could refer me to any means of avoiding these I shd. be very much obliged.

1 Ibid.
2 Lacock Papers (LA 43–24).

Hippolyte Bayard: Moulin de la Galette, Montmartre, 1848

M. Bayard's process is quite different from yours. He blackens the paper in the light before putting it in the camera previously to which he dips it in a certain liquid, which renders it sensitive to light which then produces a *positive* picture; although therefore you are obliged to have a separate process for each picture (though I should conceive they might be repicted [sic] by your sensitive paper) the effect produced is wonderfully sharp and powerful.

With respect to the time required it is much inferior to the Calotype as it requires 10 minutes even in sunlight to make a good picture and is therefore inapplicable to portraits.

M. Bayard succeeded while I was in Paris last May in making the pictures, after setting, perfectly impervious to light; and some days after I saw him receive from the Société d'Encouragement 4000 frs.

[Jones goes on to describe that in the case of Bayard's death his secret process had been deposited with Baron Séguier who told Jones that it was wonderfully simple.] . . . Have you never tried any positive paper? Or has Sir J. Herschel succeeded in fixing his?

I tried to apply your method to the French Isinglass paper, but found it shrunk and spoilt by the immersion.[1]

1 Ibid.

The following is an extract from an extremely comprehensive analysis of photography purporting to be a review of four books on the subject published between 1839 and 1842. It appeared in *The Edinburgh Review*, January 1843. The writer, Sir David Brewster, is an important figure in the early history of photography. A Scottish physicist, he was particularly concerned with optics and light, and had long been involved in the gestation period preceding the birth of photography. He was, in a way, the man behind both Talbot and David Octavius Hill (1802–70) and Robert Adamson (1821–48). It was he who encouraged Talbot in his first photographic experiments, and who brought Hill, the artist, and Adamson, the photographer, together in 1843:

In thus stating the peculiar advantages of Photography, we have supposed the Daguerreotype and Calotype to be the same art. Our readers have already seen in what the difference really consists; but it is still necessary that we should attempt to draw a comparison between them, as sister arts, with advantages peculiar to each.

In doing this, our friends in Paris must not suppose that we have any intention of making the least deduction from the merits of M. Daguerre, or the beauty of his invention; which cannot be affected by the subsequent discovery of the Calotype by Mr Talbot. While a Daguerreotype picture is much more sharp and accurate in its details than a Calotype, the latter possesses the advantage of giving a greater breadth and massiveness to its landscapes and portraits. In the one, we can detect hidden details by the application of the microscope; in the other, every attempt to magnify its details is injurious to the general effect. In point of expense, a Daguerreotype picture vastly exceeds a Calotype one of the same size. With its silver plate and glass covering, a quarto plate must cost five or six shillings, while a Calotype one will not cost as many pence. In point of portability, permanence, and facility of examination, the Calotype picture possesses a peculiar advantage. It has been stated, but we know not the authority, that Daguerreotype pictures have been effaced before they reached the East Indies; but if this be true, we have no doubt that a remedy will soon be found for the defect. The great and unquestionable superiority of the Calotype pictures, however, is their power of multiplication. One Daguerreotype cannot be copied from another; and the person whose portrait is desired, must sit for every copy that he wishes. When a pleasing picture is obtained, another of the same character cannot be produced. In the Calotype, on the contrary, we can take any number of pictures, within reasonable limits, from a negative; and a whole circle of friends can procure, for a mere trifle, a copy of a successful and pleasing portrait. In the Daguerreotype the landscapes are all reverted, whereas in the Calotype the drawing is exactly conformable to nature. This objection can of course be removed, either by admitting the rays into the camera after reflection from a mirror, or by total reflection from a prism; but in both these cases, the additional reflections and refractions are accompanied with a loss of light, and also with a dimunition, to a certain extent, of distinctness of the image. The Daguerreotype may be considered as having nearly attained perfection, both in the quickness of its operations and in the minute perfection of its pictures; whereas the Calotype is yet in its infancy – ready to make a new advance when a proper paper, or other ground, has been discovered, and when such a change has been made in its chemical processes as shall yield a better colour, and a softer distribution of the colouring material.

Brewster's somewhat circumspect message is clear. However much the daguerreotype had reached perfection in its delineation of detail, the many advantages of the calotype would ultimately give it a greater ascendancy. At that date the daguerreotype still reigned supreme, with the calotype generally relegated to an inferior position. To put things in their proper perspective, Brewster may have felt obliged to state the case for his friend Talbot. History has proven him right.

The article appeared just before the auspicious meeting of Hill and Adamson took place in Edinburgh. Brewster was Principal of United College, University of St Andrew's, and had been in close touch with Adamson and his brother John, a doctor in the town. Brewster encouraged Robert Adamson to take up photography as a profession. Indeed, in the same article he announced that Mr Robert Adamson, 'whose skill and experience in photography is very great, is about to practise the art professionally in our northern metropolis'. No doubt that article, with its sensitive analyses of the two types of photography, hastened, or even generated, the fruitful partnership of Hill and Adamson later that year and confirmed them in their choice of the calotype medium.

Because Hill was a distinguished painter, his photographs were inevitably to be compared with the works of earlier masters of portraiture: Rembrandt, Reynolds, Raeburn. No doubt Adamson's role in producing these portrait photographs was more than merely technical, yet the compositions, and particularly the positive use of the many elegant random effects intrinsic in the medium, point to the sensitivities of a highly trained artist. Hill's preference for the calotype rather than the daguerreotype medium was most likely determined by his predilection for a broader kind of handling and for soft, evanescent

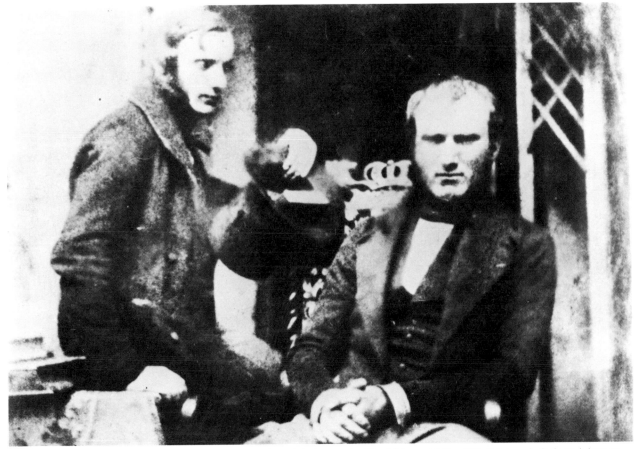

D. O. Hill: Robert Adamson and Dr John Adamson (right) outside the porch of Rock House, Calton Hill, Edinburgh. Robert Adamson was only 22 when he went into partnership with D. O. Hill. Rock House was their studio: the porch faced south and photographs were made in the open air, various props being added to simulate indoor locations. Calotype.

effects – an early indication of the expressive range of photography. J. Craig Annan, a Glasgow photographer largely responsible for reviving Hill's reputation at the beginning of this century, quotes perceptively from one of Hill and Adamson's sitters, comparing their photographs with paintings by Raeburn:

There is the same broad freedom of touch; no nice miniature stripplings, as if laid in by the point of a needle – no sharp edged strokes; all is solid, massy broad: more distinct at a distance than when viewed near at hand. The arrangements of the lights and shadows seem rather the result of a happy haste, in which half the effect was produced by design, half by accident, than of great labour and care; and yet how exquisitely true the general aspect! Every stroke tells, and serves, as in the portraits of Raeburn, to do more than relieve the features: it serves also to indicate the prevailing mood and predominant power of the mind. [1]

Oddly enough, Hill would certainly have been offended had he been remembered only as a photographer. This is confirmed by the fact that his obituary makes no reference to his photographic activities. Ironically, though, Hill has emerged from an undoubted obscurity as a painter to become a brilliant figure in the history of photography. He seems to have treated photography as a secondary artistic activity, according to it the same status painters of the time gave to print-making, and taking advantage of the extra income it could provide. This is suggested in Hill's letter of 25 October 1848 to John Scott of Colnaghi's, London, that highly reputable firm of print publishers:[1]

My dear Mr Scott,
I have been very long in fulfilling the promise I volunteered when in London – of sending you some specimens of the Calotypes I made in conjunction with my lamented friend Mr Robert Adamson.[1] I have now

1 *Camera Work*, No. 11, July 1905, quoting Hugh Miller, 'Leading Articles on Various Subjects', ed. Davidson, 1870.

1 Adamson died in January 1848.

D. O. Hill: Eyewitness sketch made May 1843 at the first General Assembly of the Free Church of Scotland at Cannonmills, Edinburgh. Hill and Adamson's first Calotypes were made to help Hill with his painting of the scene (see 3.8).

the pleasure of sending you a hundred specimens (pray gratify me by accepting them) and have selected them with some care in the hope that you may be induced to mount and bind them in a way similar to that in which Eastlakes and Stanfields volumes are got up. Let me shortly describe these. The Calotypes are mounted on half colombier stone plate paper. This is done by a copper plate printer in the same way that indice proofs are printed – and perhaps using a weak solution of gum – to ensure adhesion – but the thin paste is not used – & don't keep them long in a damp state. In binding them up I have adopted a somewhat extravagant style of binding – morocco gilt – each leaf mounted on a guard of satin ribbon for strength as well as appearance – between the leaves a leaf of thin glazed paper – as tissue paper – the binding of each of our volumes cost about 5 guineas – on the title page – one of the Calotypes should be used as a vignette – this may be the Greyfriars Tomb – with the artist sitting sketching & the girls looking on – & the lettering turns etc. done in faint sepia or gold liquid with a hair pencil. The portrait of my amiable friend Adamson – who did much for the art – cut to a smallish oval – might be on a preliminary title – I forget what binders call it. Thus and my own large portrait might be opposite to his – on the larger title page – I have written the names in pencil on all the subjects they might be if you cared for it printed in faint sepia letters on the mounting paper, under each picture. Please excuse all this minuteness on a subject you may consider very unworthy of it – although 'tis one on which I feel somewhat warmly. I would like

they appear in their better attire in taking up their residence with you.

An artist tonight tells me he finds mounting the Calotypes on faintly tinted Crayon papers gives a value to the lights which they do not possess on white paper. But follow your own taste in this matter. The white spots must be carefully stippled out – with water colours of the same tint.

If you should come across any lover of the Calotype who shall express a desire to possess any of our work – or a similar volume – of course I shall be happy to supply them or it direct – or through you as a matter of business. I regret seeing so little of Mr Mackay – I have been since he came to Scotland continually in & out of town – & am not yet living in my own house. I trust his Whiskey escaped the fangs of the guager.

I beg to be kindly & gratefully remembered to Miss Scott, & that Mrs Morton & Mr Colnaghi will accept of my kind regards I am just starting again for Ayrshire where I have yet some field work to do.

Believe me My dear Sir Yours entirely
D. O. Hill[1]

This letter, for all its imperfections, is worth careful scrutiny, for it tells us of Hill's attitude to the new art, of his position vis-à-vis Adamson, and of the tender care and respect given to the presentation and conservation of objects which we, in our profligate world, habitually dismiss as ephemera.

1 Letter in collection of the National Library of Scotland.

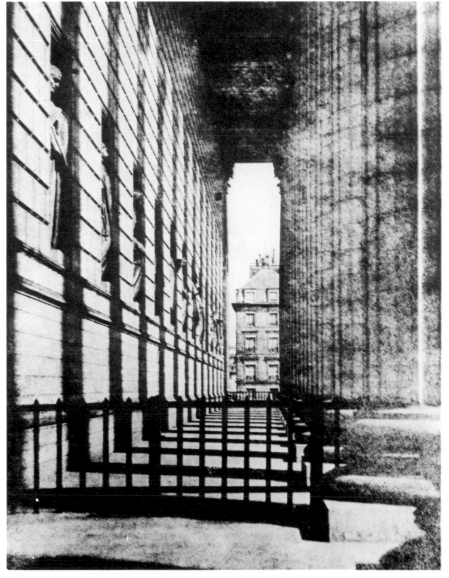

3.1 HIPPOLYTE BAYARD: PERSPECTIVE

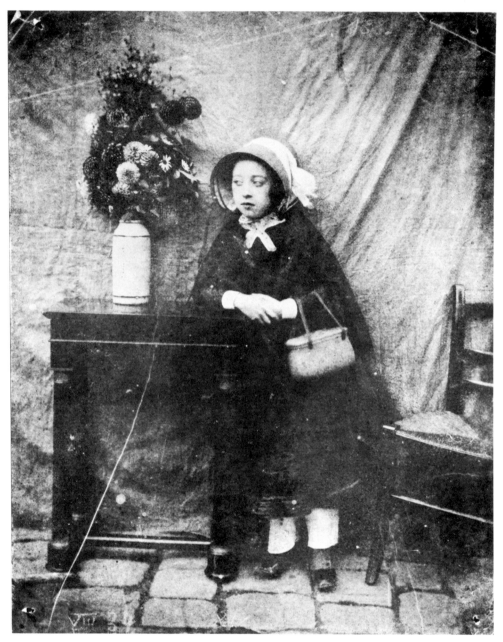

3.2 HIPPOLYTE BAYARD: LA PETITE BOUDEUSE

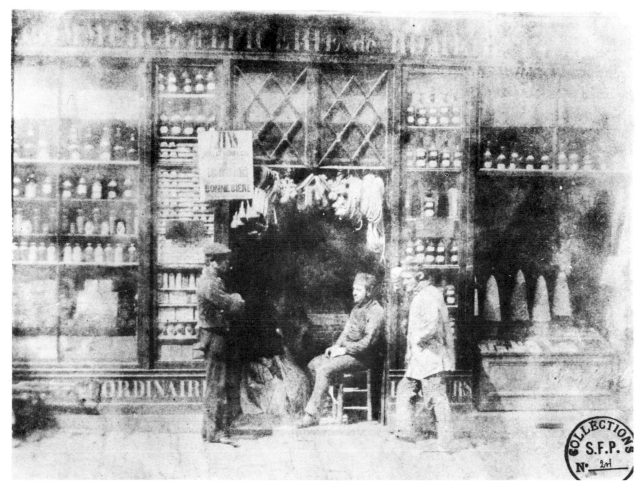

3.3 HIPPOLYTE BAYARD: L'ETALAGE DE L'EPICIER

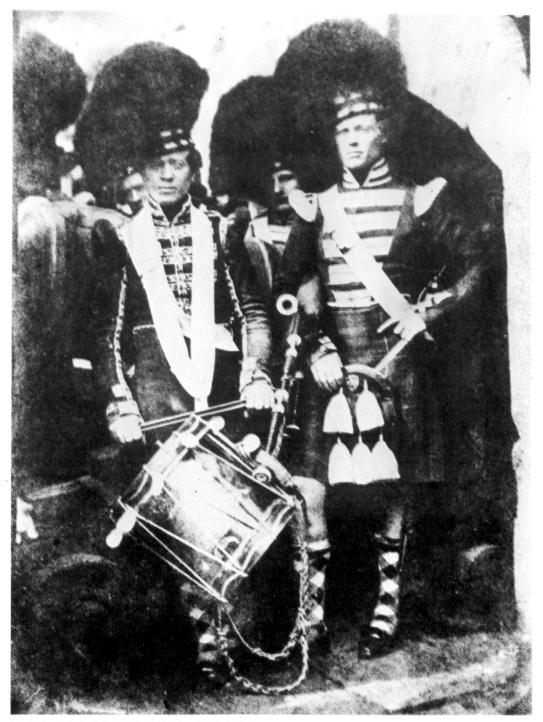

3.4 D. O. HILL AND ROBERT ADAMSON: PIPER AND DRUMMER OF THE 92ND HIGHLANDERS

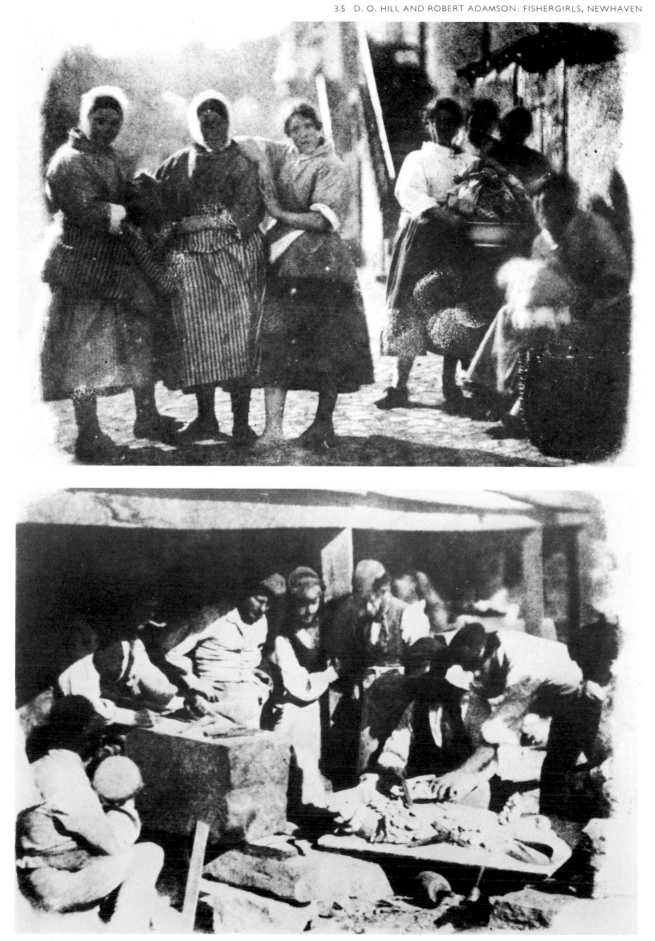

3.7 D. O. HILL AND ROBERT ADAMSON: DURHAM CATHEDRAL

3.8 D. O. HILL AND ROBERT ADAMSON: ROBERT CADDELL,
GRAHAM FYVIE AND SHERRIFF GRAHAM SPIERS

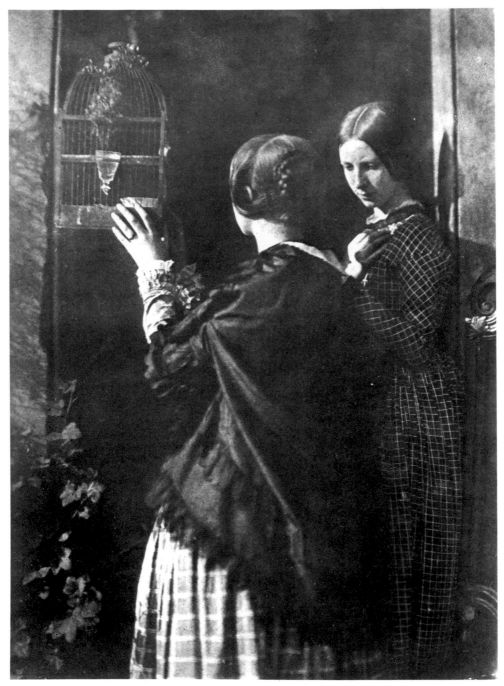

3.9 D. O. HILL AND ROBERT ADAMSON: THE BIRDCAGE

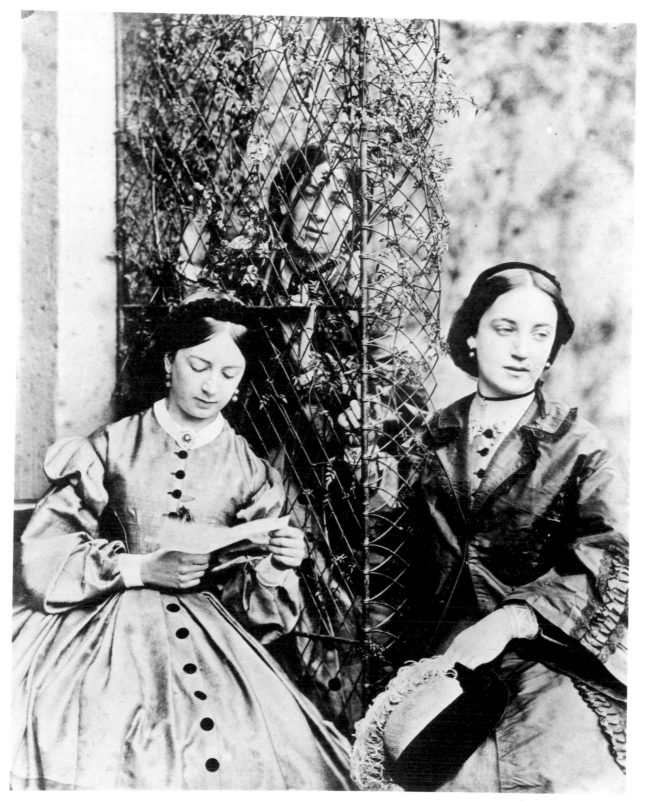

3.10 D. O. HILL AND A. MCGLASHAN: THROUGH THE TRELLIS

FAMOUS MEN AND FAIR WOMEN

"I longed to arrest all beauty that came before me, and at length the longing has been satisfied."
Julia Margaret Cameron (1874)

"The studio, I remember, was very untidy and very uncomfortable. Mrs Cameron put a crown on my head and posed me as the heroic queen. This was somewhat tedious, but not half so bad as the exposure."
A Lady Amateur who sat for Mrs Cameron (1886)

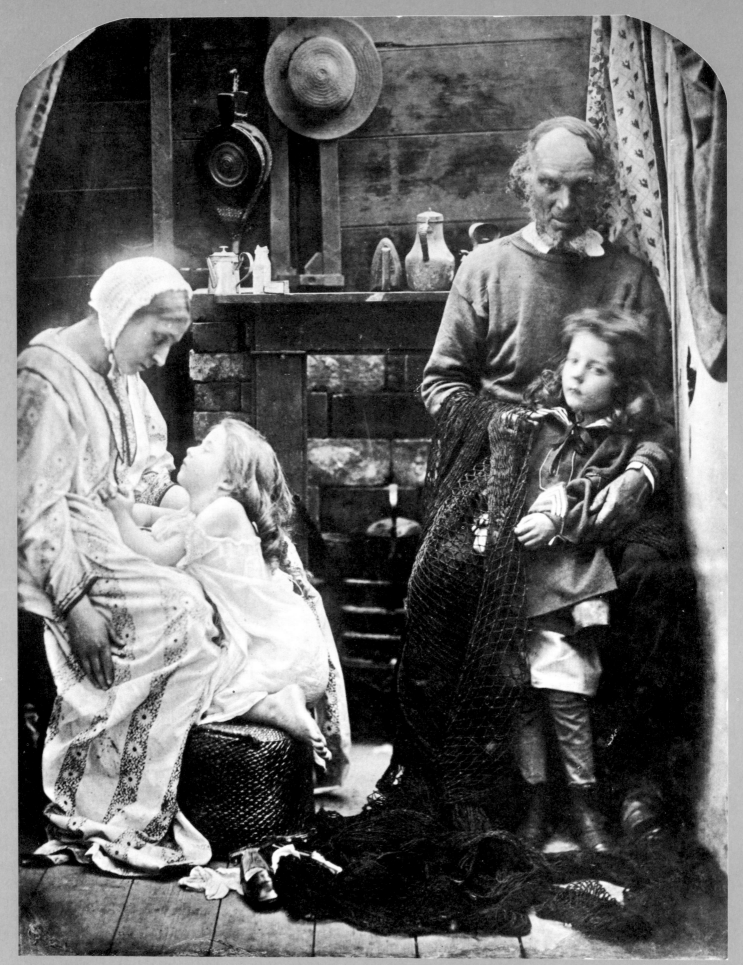

JULIA MARGARET CAMERON: PRAY GOD BRING FATHER SAFELY HOME

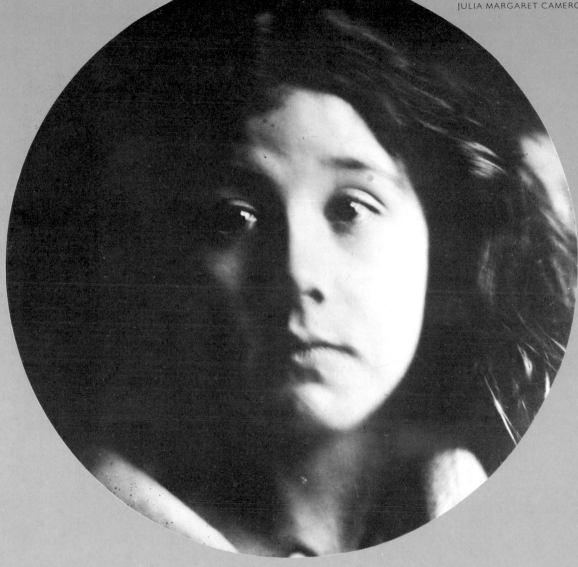

FAMOUS MEN AND FAIR WOMEN

It is not merely fortuitous that the earliest criticisms of the photographs of that Victorian lady, Julia Margaret Cameron (1815–79), coincide almost exactly with those meted out in France against those 'abominable' canvasses produced by the young Impressionists:

Mrs Cameron's photographs are only inferior because her artistic knowledge is inferior. . . .[1]

1 *The Photographic Journal*, 15 August 1864.

Mrs Cameron exhibits her series of out of focus portraits of celebrities. We must give this lady credit for daring originality but at the expense of all other photographic qualities.[1]

At the German Gallery in Bond Street, Mrs Cameron exhibits a very extensive collection of her studies and portraits. Our own opinion of this style of work has already been recorded. There is, in many cases, much evidence of art feeling, especially in the light and shade, the composition, so far as form is concerned, often being awkward. The subjects of many of the portraits – such as Sir John Herschel, Henry Taylor, Holman Hunt, Alfred Tennyson, and others – are full of interest in themselves, and are often noble in form and appearance, a circumstance which alone gives value to the exhibition. Not even the distinguished character of some of the heads serve, however, to redeem the result of wilfully imperfect photography from being altogether repulsive: one portrait of the Poet Laureate presents him in a guise which would be sufficient to convict him, if he were charged as a rogue and vagabond, before any bench of magistrates in the kingdom.[2]

The following extract is from Benjamin Wyles, 'Impressions of the Photographic Exhibition', printed in *The British Journal of Photography*, 9 December 1870:

All photographers are enthusiasts, of course; they cannot help it if they would, and, being enthusiasts, it as naturally follows that they must see the concourse of pictures got together in Conduit-street, to mark off another year's progress . . . Once in the exhibition, and one's name entered in the porter's book, what a crowd of good things seem to claim one's attention from all quarters at once! – big pictures and little, portraits and views, reproductions and transparencies, carbon and silver, and nearly all above the average of excellence. Any one lot at home and by itself would be a source of enjoyment. A hasty run round by way of exploring soon shows that some exhibitors have quantity, some quality, and some have been happy enough to combine both. Mrs Cameron, Woodbury, Robinson, Col. Stuart Wortley, Blanchard, and Heliotype are all very much 'to the fore'. Many others are not less deserving if less conspicuous.

Taking the lady first, as in honour bound – and which good rule the hanging committee seems to have gone upon – one finds a large screen nearly filled with her works, and duplicates of the same are hung at intervals on the walls. Looked at *en masse* there is a sort of

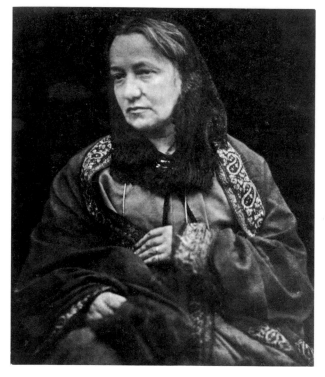
Julia Margaret Cameron by her son, Henry Herschel Hay Cameron in 1870. Wet collodion.

misty 'glamour' about Mrs Cameron's productions that is decidedly pleasing, but a closer examination is not nearly so satisfactory. There is a sort of feeling after art – a suggestiveness; but that is all. The beholder is left to work out the idea in his own imagination, if he can; but as nine out of ten *cannot* – not being blessed with the artistic faculty – it follows that the peculiar line this lady has chosen will never allow of her works being very popular.

Moreover, in working for the few it might be well to have some little respect for the proprieties. Art is not art *because* it is slovenly, and a good picture is not improved by having the film torn, or being in some parts a mere indistinguishable smudge. Of all departments in photographic art perhaps the style of Mrs Cameron's works is the easiest. A lens turned right out of focus, negatives not intensified, the upper part of the figure only taken usually, and when taken 'giving it a name' – this seems to be about the extent of the special means employed.

The hotly contested discussion between hard and soft focus, between scrupulous technique and the priority of expression, or sensation, certainly transcended photography at the time, and applied as well to painting. These comments, in the context of Impressionist painting, are not surprising, and though the first group exhibition of

1 *The Photographic Journal*, 15 February 1865.
2 *Photographic News*, 20 March 1868.

those 'depraved' Frenchmen (which, not altogether by chance, took place in Nadar's recently vacated photographic studios, see chapter 6) was not held till 1874, sufficient criticism of their paintings had made it across the Channel from 1863 (and the infamous Salon des refusés) to alert the Ruskin-dominated critics to the idea that soft focus, whether in painting or photography, was too crude both for the refined and for the hoi polloi. Understandably, then, Mrs Cameron's reputation was bound to improve towards the end of that century and certainly in the first quarter of this, after Impressionism had become respectable and accepted as a modern art form.

Mrs Cameron had a reputation for being sloppy with her technique, though there were some sensitive enough to understand that this was the inevitable result of an irrepressible enthusiasm mixed with a fervent desire to capture some deeper layer in the personality of her sitters, or to project her own personality on them.

This is made clear in her brief, unfinished, autobiographical manuscript, 'Annals of My Glass House', written in 1874 and intended, it seems, to serve as a corrective for the obtuseness of critics who teased and ridiculed Julia Cameron's photographs in their relentless advocacy of a hard-focus style. We reproduce the 'Annals' here in its entirety, just as it appeared in the *Photographic Journal*, July 1927, on the occasion of an exhibition of Mrs Cameron's work. The *Photographic Journal* is now contrite and apologetic about the indiscretions of its predecessors. The appearance of the 'Annals' in 1927 coincided with a publication by Virginia Woolf and the art critic, Roger Fry, in which Julia Margaret Cameron's portrait photographs were raised to the highest spheres of art. The 'Annals' were made available to *The Photographic Journal* by Mrs Cameron's grand-daughter, Mrs Trench. Mrs Cameron's excitement for her chosen means of expression, wrapped up in an impetuous nature, shine through in this poeticising estimation of her own worth:

ANNALS OF MY GLASS HOUSE

'Mrs Cameron's Photography', now ten years old, has passed the age of lisping and stammering and may speak for itself, having travelled over Europe, America and Australia, and met with a welcome which has given it confidence and power. Therefore, I think that the 'Annals of My Glass House' will be welcome to the public, and, endeavouring to clothe my little history with light, as with a garment, I feel confident that the truthful account of indefatigable work, with the anecdote of human interest attached to that work, will add in some measure to its value.

That details strictly personal and touching the affections should be avoided, is a truth one's own instinct would suggest, and noble are the teachings of one whose word has become a text to the nations –

'Be wise: not easily forgiven
Are those, who setting wide the doors that bar
The secret bridal chambers of the heart
Let in the day.'

Therefore it is with effort that I restrain the overflow of my heart and simply state that my first lens was given to me by my cherished departed daughter and her husband with the words, 'It may amuse you, Mother, to try to photograph during your solitude at Freshwater.'

The gift from those I loved so tenderly added more and more impulse to my deeply seated love of the beautiful, and from the first moment I handled my lens with a tender ardour, and it has now become to me as a living thing, with voice and memory and creative vigour. Many and many a week in the year '64 I worked fruitlessly, but not hopelessly –

'A crowd of hopes
That sought to sow themselves like winged lies
Born out of everything I heard and saw
Fluttered about my senses and my soul.'

I longed to arrest all beauty that came before me, and at length the longing has been satisfied. Its difficulty enhanced the value of the pursuit. I began with no knowledge of the art. I did not know where to place my dark box, how to focus my sitter, and my first picture I effaced to my consternation by rubbing my hand over the filmy side of the glass. It was a portrait of a farmer of Freshwater, who, to my fancy, resembled Bollingbroke. The peasantry of our island is very handsome. From the men, the women, the maidens and the children I have had lovely subjects, as all the patrons of my photography know.

This farmer I paid half-a-crown an hour, and, after many half-crowns and many hours spent in experiments, I got my first picture, and [this was the one I] effaced it when holding it triumphantly to dry.

I turned my coal-house into my dark room, and a glazed fowl-house I had given to my children became my glass house! The hens were liberated, I hope and believe not eaten. The profit of my boys upon new laid eggs was stopped, and all hands and hearts sympathised in my new labour, since the society of hens and chickens was soon changed for that of poets, prophets, painters and lovely maidens, who all in turn have immortalized the humble little farm erection.

Having succeeded with one farmer, I next tried two children; my son, Hardinge, being on his Oxford vacation, helped me in the difficulty of focusing. I was half-way through a beautiful picture when a

splutter of laughter from one of the children lost me that picture, and less ambitious now, I took one child alone, appealing to her feelings and telling her of the waste of poor Mrs Cameron's chemicals and strength if she moved. The appeal had its effect, and I now produced a picture which I called

'My First Success'

I was in a transport of delight. I ran all over the house to search for gifts for the child. I felt as if she entirely had made the picture. I printed, toned, fixed and framed it, and presented it to her father that same day: size 11 by 9 inches.

Sweet, sunny haired little Annie! No later prize has effaced the memory of this joy, and now that this same Annie is 18, how much I long to meet her and try my master hand upon her.

Having thus made my start, I will not detain my readers with other details of small interest; I only had to work on and to reap rich reward.

I believe that what my youngest boy, Henry Herschel, who is now himself a very remarkable photographer, told me is quite true – that my first successes in my out-of-focus pictures were 'a fluke'. That is to say, that when focusing and coming to something which, to my eye, was very beautiful, I stopped there instead of screwing on the lens to the more definite focus which all other photographers insist upon.

I exhibited as early as May '65. I sent some photographs to Scotland – a head of Henry Taylor, with the light illuminating the countenance in a way that cannot be described; a Raphaelesque Madonna, called 'La Madonna Aspettante'. These photographs still exist, and I think they cannot be surpassed. They did not receive the prize. The picture that did receive the prize, called 'Brenda', clearly proved to me that detail of table-cover, chair and crinoline skirt were essentials to the judges of the art, which was then in its infancy. Since that miserable specimen, the author of 'Brenda' has so greatly improved that I am content to compete with him and content that those who value fidelity and manipulation should find me still behind him. Artists, however, immediately crowned me with laurels, and though 'Fame' is pronounced 'The last infirmity of noble minds', I must confess that when those whose judgment I revered have valued and praised my works, 'my heart has leapt up like a rainbow in the sky' and I have renewed all my zeal.

The Photographic Society of London in their *Journal* would have dispirited me very much had I not valued that criticism at its worth. It was unsparing and too manifestly unjust for me to attend to it. The more lenient and discerning judges gave me large space upon

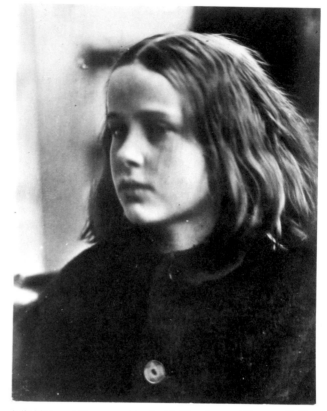

Julia Margaret Cameron: 'Annie, My First Success' (January 1865). Wet collodion.

their walls which seemed to invite the irony and spleen of the printed notice.

To Germany I next sent my photographs. Berlin, the very home of photographic art, gave me the first year a bronze medal, the succeeding year a gold medal, and one English institution – the Hartly Institution – awarded me a silver medal, taking, I hope, a home interest in the success of one whose home was so near to Southampton.

Personal sympathy has helped me on very much. My husband from first to last has watched every picture with delight, and it is my daily habit to run to him with every glass upon which a fresh glory is newly stamped, and to listen to his enthusiastic applause. This habit of running into the dining-room with my wet pictures has stained such an immense quantity of table linen with nitrate of silver, indelible stains, that I should have been banished from any less indulgent household.

Our chief friend [Sir Henry Taylor] lent himself greatly to my early efforts. Regardless of the possible dread that sitting to my fancy might be making a fool of himself, he, with greatness which belongs to unselfish affection, consented to be in turn Friar Laurence with Juliet, Prospero with Miranda, Ahasuerus with Queen

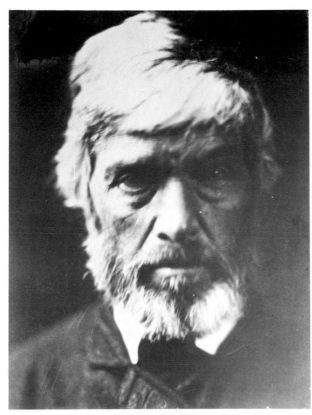

Julia Margaret Cameron: Thomas Carlyle, c. 1867. Taken at her sister's home, Little Holland House, Kensington. Wet collodion.

Esther, to hold my poker as his sceptre, and do whatever I desired of him. With this great good friend was it true that so utterly

'The chord of self with trembling
Passed like Music out of sight,'

and not only were my pictures secured for me, but entirely out of the Prospero and Miranda picture sprung a marriage which has, I hope, cemented the welfare and well-being of a real King Cophetua who, in the Miranda, saw the prize which has proved a jewel in that monarch's crown. The sight of the picture caused the resolve to be uttered which, after 18 months of constancy, was matured by personal knowledge, then fulfilled, producing one of the prettiest idylls of real life that can be conceived, and, what is of far more importance, a marriage of bliss with children worthy of being photographed, as their mother had been, for their beauty; but it must also be observed that the father was eminently handsome, with a head of the Greek type and fair ruddy Saxon complexion.

Another little maid of my own from early girlhood has been one of the most beautiful and constant of my models, and in every manner of form has her face been reproduced, yet never has it been felt that the grace

of the fashion of it has perished. This last autumn her head illustrating the exquisite Maud –

'There has fallen a splendid tear
From the passion flower at the gate.'

is as pure and perfect in outline as were my Madonna Studies ten years ago, with ten times added pathos in the expression. The very unusual attributes of her character and complexion of her mind, if I may so call it, deserve mention in due time, and are the wonder of those whose life is blended with ours as intimate friends of the house.

I have been cheered by some very precious letters on my photography, and having the permission of the writers, I will reproduce some of those which will have an interest for all.

An exceedingly kind man from Berlin displayed great zeal, for which I have ever felt grateful to him. Writing in a foreign language, he evidently consulted the dictionary which gives two or three meanings for each word, and in the choice between these two or three the result is very comical. I only wish that I was able to deal with all foreign tongues as felicitously:

'Mr —— announces to Mrs Cameron that he received the first half, a Pound Note, and took the Photographies as Mrs Cameron wishes. He will take the utmost sorrow* to place the pictures were good.

'Mr —— and the Comitié regret heavily† that it is now impossible to take the Portfolio the rooms are filled till the least winkle.‡

'The English Ambassade takes the greatest interest of the placement the Photographies of Mrs Cameron and M —— sent his extra ordinarest respects to the celebrated and famous female photographs. – Your most obedient, etc.'

The kindness and delicacy of this letter is self-evident and the mistakes are easily explained:
* Care – which was the word needed – is expressed by 'Sorgen' as well as 'Sorrow'. We invert the sentence and we read – To have the pictures well placed where the light is good.
† Regret – Heavily, severely, seriously.
‡ Winkel – is corner in German.

The exceeding civility with which the letter closes is the courtesy of a German to a lady artist, and from first to last, Germany has done me the honour and kindness until, to crown all my happy associations with that country, it has just fallen to my lot to have the privilege of photographing the Crown [Prince] and Crown Princess of Germany and Prussia.

This German letter had a refinement which permits one to smile *with* the writer, not *at* the writer. Less sympathetic, however, is the laughter which some

English letters elicit, of which I give one example:

'Miss Lydia Louisa Summerhouse Donkins informs Mrs Cameron that she wishes to sit to her for her photograph. Miss Lydia Louisa Summerhouse Donkins is a carriage person, and, therefore, could assure Mrs Cameron that she would arrive with her dress uncrumpled.

'Should Miss Lydia Lousia Summerhouse Donkins be satisfied with her picture, Miss Lydia Lousia Summerhouse Donkins has a friend who is *also* a Carriage person who would *also* wish to have her likeness taken.'

I answered Miss Lydia Louisa Summerhouse Donkins that Mrs Cameron, not being a professional photographer, regretted she was not able to 'take her likeness' but that had Mrs Cameron been able to do so she would have very much preferred having her dress crumpled.

A little art teaching seemed a kindness, but I have more than once regretted that I could not produce the likeness of this individual with her letter affixed thereto.

This was when I was at L.H.H., to which place I had moved my camera for the sake of taking the great Carlyle.

When I have had these men before my camera my whole soul has endeavoured to do its duty towards them in recording faithfully the greatness of the inner as well as the features of the outer man.

The photograph thus taken has been almost the embodiment of a prayer. Most devoutly was this feeling present to me when I photographed my illustrious and revered as well as beloved friend, Sir John Herschel. He was to me as a Teacher and High Priest. From my earliest girlhood I had loved and honoured him, and it was after a friendship of 31 years' duration that the high task of giving his portrait to the nation was allotted to me. He had corresponded with me when the art was in its first infancy in the days of Talbot-type and autotype, I was then residing in Calcutta, and scientific discoveries sent to that then benighted land were water to the parched lips of the starved, to say nothing of the blessing of friendship so faithfully evinced.

When I returned to England the friendship was naturally renewed. I had already been made godmother to one of his daughters, and he consented to become godfather to my youngest son. A memorable day it was when my infant's three sponsors stood before the font, not acting by proxy, but all moved by real affection to me and to my husband to come in person, and surely Poetry, Philosophy and Beauty were never more fitly represented than when Sir John Herschel, Henry Taylor and my own sister, Virginia Somers, were encircled round the little font of the Mortlake Church.

When I began to photograph I sent my first triumphs to this revered friend, and his hurrahs for my success I here give. The date is September 25th, 1866:

'My Dear Mrs Cameron –
'This last batch of your photographs is indeed wonderful, and wonderful in two distinct lines of perfection. That head of the "Mountain Nymph, Sweet Liberty" (a little farouche and egarée, by the way, as if first let loose and half afraid that it was too good), is really a most astonishing piece of high relief. She is absolutely alive and thrusting out her head from the paper into the air. This is your own special style. The other of "Summer Days" is in the other manner – quite different, but very beautiful, and the grouping perfect. Proserpine is awful. If ever she was "herself the fairest flower" her "cropping" by "Gloomy Dis" has thrown the deep shadows of Hades into not only the colour, but the whole cast and expression of her features. Christabel is a little too indistinct to my mind, but a fine head. The large profile is admirable, and altogether you seem resolved to out-do yourself on every fresh effort.'

This was encouragement eno' for me to feel myself held worthy to take this noble head of my great Master himself, but three years I had to wait patiently and longingly before the opportunity could offer.

Meanwhile I took another immortal head, that of Alfred Tennyson, and the result was that profile portrait which he himself designates as the 'Dirty Monk'. It is a fit representation of Isaiah or of Jeremiah, and Henry Taylor said the picture was as fine as Alfred Tennyson's finest poem. The Laureate has since said of it that he likes it better than any photograph that has been taken of him *except* one by Mayall; that '*except*' speaks for itself. The comparison seems too comical. It is rather like comparing one of Madame Tussaud's waxwork heads to one of Woolner's ideal heroic busts. At this time Mr Watts gave me such encouragement that I felt as if I had wings to fly with.

Certain aspects of the preservation of photographs were obviously of concern to Julia Cameron. But one suspects that the problems she encountered with the coatings on her glass negatives were to some extent due to a sub-conscious unwillingness to submit to any technical discipline, and even to an obscure desire to subvert technique. One wonders what her real feelings were when, in the early summer of 1869, she attended a meeting of the Photographic Society at which her problem with collodion-coating was discussed?

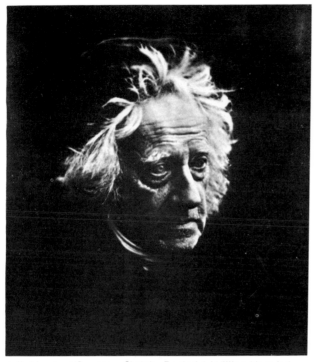

Julia Margaret Cameron: Sir John Frederick William Herschel, April 1869. 'Taken at his own residence, Collingwood'. A family friend of the Camerons, Herschel was himself one of the most distinguished early pioneers of photography, inventing the terms 'negative' and 'positive' for Fox Talbot. Wet collodion.

THE CHAIRMAN remarked that he had often regretted that ladies so seldom attended the meetings of the Society. He was glad to see that two ladies were present; and one of them, Mrs Cameron, wished to say a few words to the Members.

Mrs CAMERON said she was desirous of ascertaining the cause of the appearance of cracks in some of her negatives. In a large-sized portrait of Sir John Herschel, taken two years ago (exhibited), the whole face of the negative was covered with fine cracks, which, although they destroyed the continuity of the collodion film, did not seem to extend outwards to the coating of the varnish. Another, a large portrait of Tennyson, was similarly affected, and, altogether, about forty-five of her negatives had given way . . .

The negatives were passed round for examination, THE REV. J. B. READE suggesting that the binocular microscope would decide the question as to whether the fault lay with the collodion film or the superposed varnish . . .

Mr THOMAS felt called upon to make a few remarks on the subject of cracked films . . .

Mr BLANCHARD conceived that the marine residence of Mrs Cameron (Freshwater, Isle of Wight) might have to answer for the prevalence of this kind of injury; for the sea-air was often loaded with moisture, and sometimes held in suspension likewise appreciable quantities of common salt . . .

Mr HOOPER, and after him Mr F. ELIOT, expressed opinions favourable to the practice of wrapping the negatives in paper . . .

Mr DALLMEYER thought that the use of certain kinds of glass which were liable to what is technically known as 'sweating', might sometimes induce a want of permanence in the finished negative. The vitreous surface was then affected by the escape of alkali, the best remedy against which was the immersion of the glasses in diluted sulphuric acid.[1]

Such ponderous ruminations on technique must have been excruciating to Julia Cameron, and there is no indication that any of the suggestions were subsequently followed up. The spontaneous manner of her photographic procedures would seem to guarantee a deep-seated abhorrence for all the chemical fiddle-faddle which to some photographers assumed the proportions even of an aesthetic experience. Julia Cameron's overriding concern for her subjects superseded all the exigencies of technique. We may therefore conclude that this little episode at the Photographic Society was in large part initiated by Mrs Cameron to demonstrate that she was not quite so thoughtless or so brutal about technique as her critics supposed.

Here is a useful document which throws further light on Julia Cameron's work:[2]

A Reminiscence of Mrs Cameron by a Lady Amateur
I suppose the great majority of modern photographers – at least the younger ones – remember very little of the pictures of the late Mrs Julia Margaret Cameron. Twenty years ago Mrs Cameron's pictures occupied a place of honour at the Exhibitions of the Photographic Society, and a very large place, for the dear old lady believed in nothing less than plates of the very largest size she was able to manipulate. In those days, when I knew absolutely nothing of photography, I could never understand why Mrs Cameron affected such enormous pictures; I now know that with a large plate one can give a good margin for stains and other annoyances, though it seems rather wasteful to use a 15 by 12 plate in order to get a picture 9 by 6. Still, all Mrs Cameron's photographs were not failures, whole or partial, and a good many did not need to be cut down at all, because an imperfection at the corners, or near the edges, did not, according to the Rejlander school, in which Mrs Cameron studied, matter very much. Looking now at the finished productions of modern photographers,

1 *The Photographic Journal*, 15 May 1869.
2 *The Photographic News*, 1 January 1886.

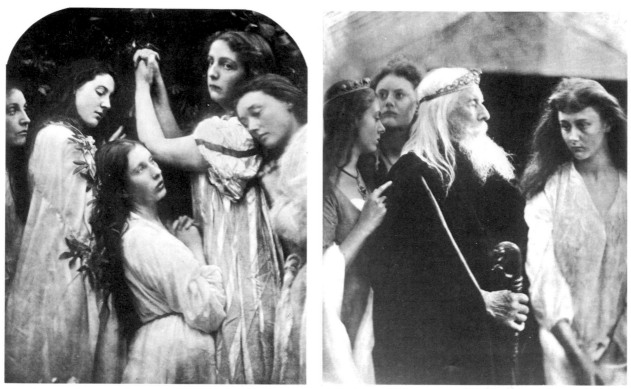

Julia Margaret Cameron: 'Too late, too late' (above left), 'King Lear and his daughters' (above right with Mr Cameron as Lear),
Zenobia (below), c. 1870.

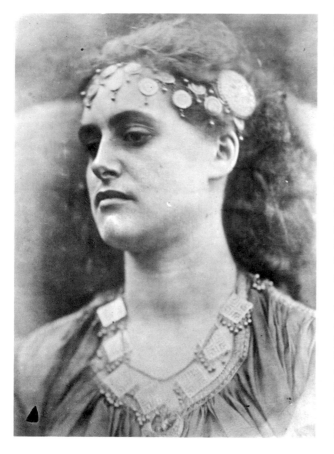

absolutely without the slightest blemish, the pictures of
Mrs Cameron, with their numerous imperfections, and
framed in a slap-dash, rough style, at which the hanging
committee must have shuddered, come back to me
with a *naïveté* which is quite refreshing.

It was after Mrs Cameron had become celebrated
that I made her acquaintance. Her contributions to the
Photographic Society's Exhibitions began in 1864, and
the *Photographic News* spoke as follows: 'As one of the
especial charms of photography consists in its
completeness, detail, and finish, we can scarcely
commend works in which the aim appears to have been
to avoid these qualities. The portraits are chiefly those
of men of mark, as artists or authors, and include Mr
Holman Hunt, Mr Henry Taylor, Mr G. F. Watts, and
some others, and, both from the subjects, and the mode
of treatment, interest, while they fail to please us.'

The non-photographic press, however, went into
raptures over Mrs Cameron's pictures, the *Illustrated
London News* putting them forward as models for
photographers to imitate, and speculating whether
their peculiar softness, or what some irreverent critics
of the time called 'fuzziness', was not produced by
something applied to the photograph. This of course
was nonsense, and so was a good deal of the extravagant
praise. Indeed, I think it did her more harm than good,
for it made her fancy photographers were hostile to her,

and led her into the speculation of taking a gallery in the West End for the exhibition solely of her works. This exhibition was a non-success, as it could scarcely fail to be.

The reference to the size of Julia Cameron's plates is important. Despite her rather primitive instincts she no doubt was yielding to a conscious desire to create a work of art, and it is difficult to convince people that a diminutive photograph could be sufficiently artful to compensate for the lack of nobility in scale. That, most likely, is a much more important factor than the advantages in being able to crop out marginal imperfections. But the larger the plates, the longer the exposure, and the Lady Amateur also presents us with a very graphic description of her ordeal while sitting for one of Mrs Cameron's subject pictures in Freshwater, on the Isle of Wight:

The studio, I remember, was very untidy and very uncomfortable. Mrs Cameron put a crown on my head and posed me as the heroic queen. This was somewhat tedious, but not half so bad as the exposure. Mrs Cameron warned me before it commenced that it would take a long time, adding, with a sort of half groan, that it was the sole difficulty she had to contend with in working with large plates. The difficulties of development she did not seem to trouble about. The exposure began. A minute went over and I felt as if I must scream; another minute, and the sensation was as as if my eyes were coming out of my head; a third, and the back of my neck appeared to be afflicted with palsy; a fourth, and the crown, which was too large, began to slip down on my forehead; a fifth – but here I utterly broke down . . . The first picture was nothing but a series of 'wabblings', and so was the second; the third was more successful, though the torture of standing for nearly ten minutes without a head-rest was something indescribable. I have a copy of that picture now. The face and crown have not more than six outlines, and if it was Mrs Cameron's intention to represent Zenobia in the last stage of misery and desperation, I think she succeeded.[1]

Thus the blurred character of Julia Cameron's photographs, and the Lady Amateur goes on to describe the Merlin which had moved so much during the exposure that 'at least fifty' of his images could be found in the print. Obviously, posing before Mrs Cameron's large camera, with its consequent prolongation of the exposure time, was a far more excruciating task than sitting for a portrait in oils where despite the much longer sessions it was not nearly so important to keep dead still. But it wasn't the technique that determined Julia Cameron's style, necessity masquerading as a virtue. That peculiarity of photographic form merely reinforced what she had already in mind.

1 *The Photographic News*, 1 January 1886.

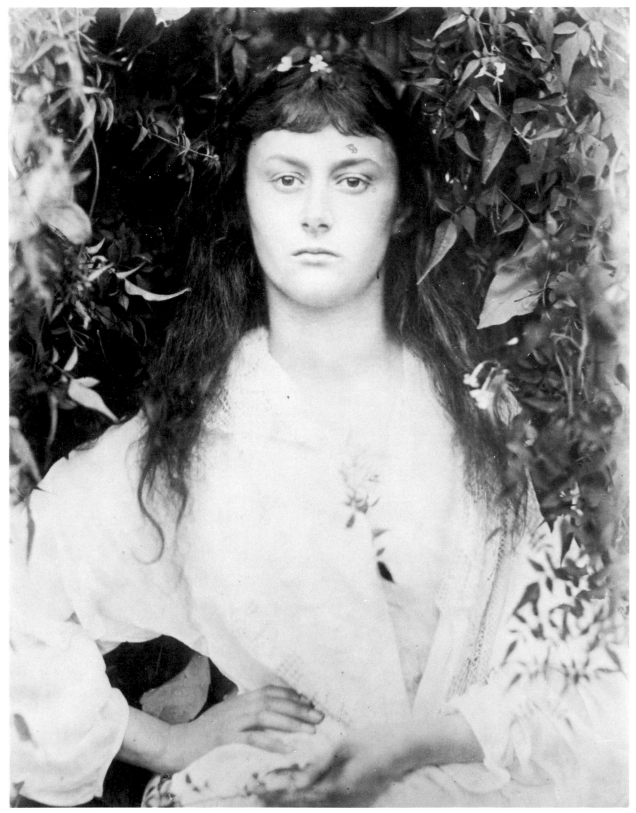

4.1 JULIA MARGARET CAMERON: ALICE LIDDELL

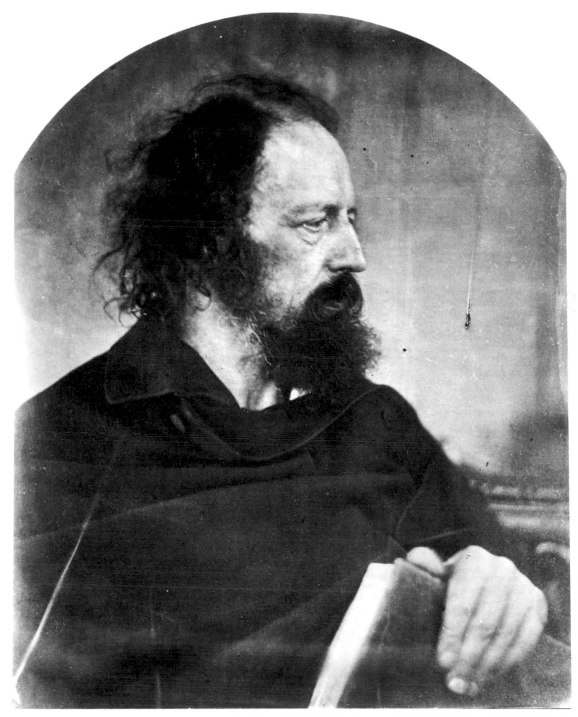

4.2 JULIA MARGARET CAMERON: ALFRED TENNYSON – THE DIRTY MONK

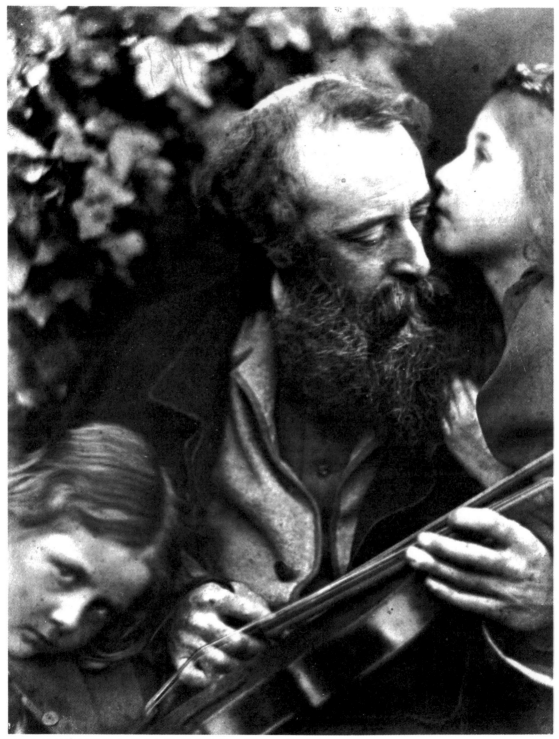

4.3 JULIA MARGARET CAMERON: 'THE WHISPER OF THE MUSE'

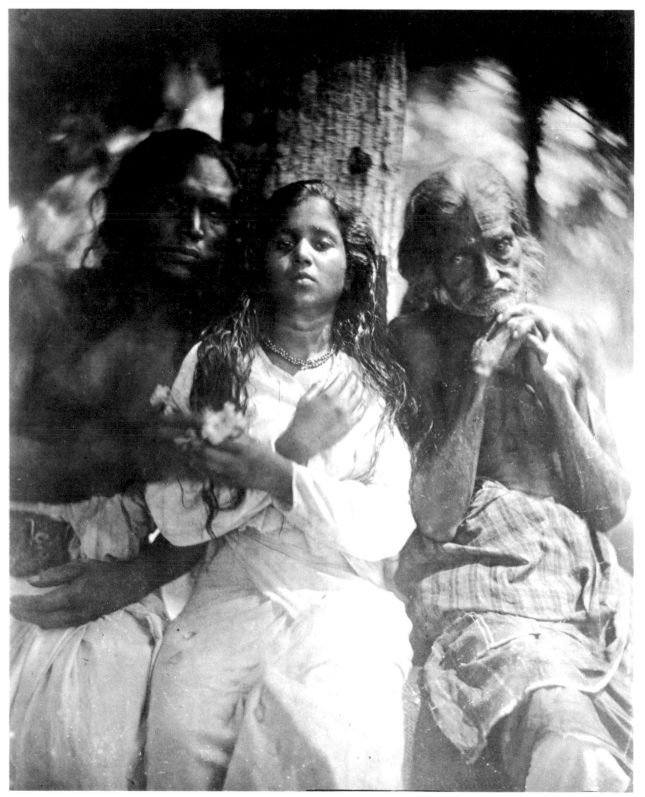

4.4 JULIA MARGARET CAMERON: A GROUP OF KALUTARA PEASANTS

TRAVELLING MAN

"For my own part, I may say that before I commenced photography I did not see half the beauties in nature that I do now, and the glory and power of a precious landscape has often passed before me and left but a feeble impression on my untutored mind; but it will never be so again."

Samuel Bourne (1864)

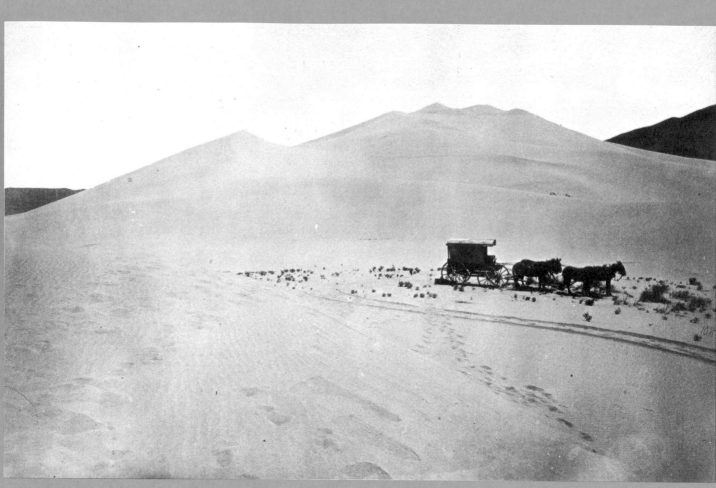

TIMOTHY O'SULLIVAN: HIS PHOTOGRAPHIC VAN ON A WESTERN SURVEY TRIP

BISSON FRÈRES: THE ASCENT OF MONT BLANC

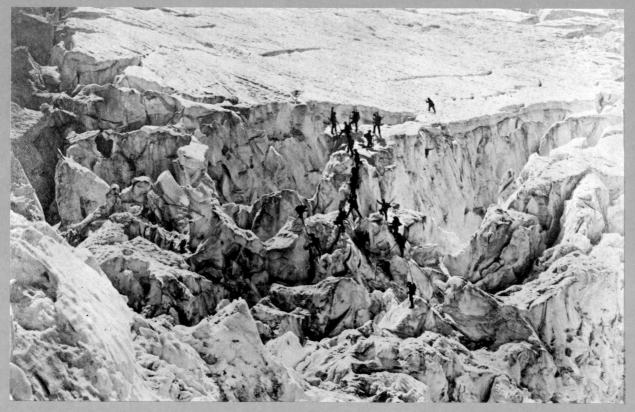

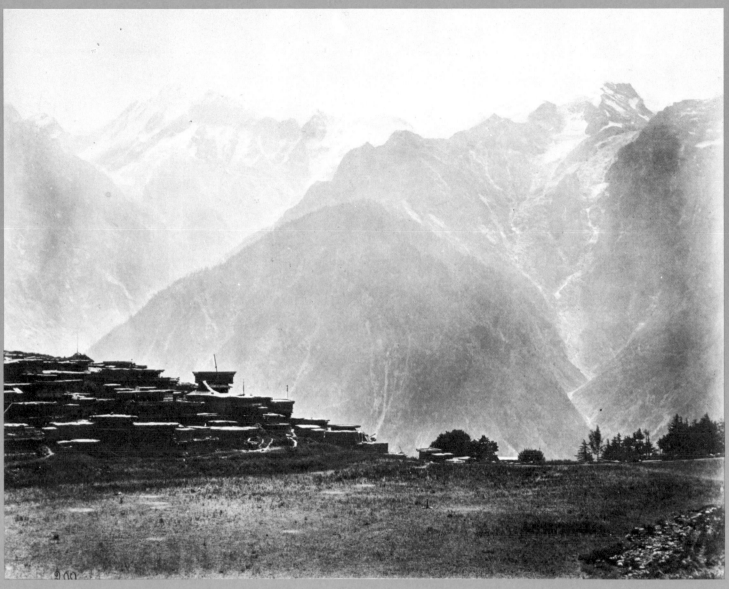

SAMUEL BOURNE: PANORAMIC VIEW AT CHINI

TRAVELLING MAN

Between 1863 and 1866 Samuel Bourne (1834–1912) made three trips to the Himalayas, which were in the best tradition of eighteenth-century gentlemen travellers. Bourne, however, was encumbered with an unbelievable cargo of photographic equipment and plates, not to mention the other necessities of life appropriate to the daily existence of an Englishman abroad: an ample supply of Hennessy's brandy, 'sporting requisites', books and odd pieces of furniture. To hoist that great load over one of the most perilous terrains on earth required an entourage

of at least thirty, and sometimes as many as sixty 'coolies' who, more often than not, were pressed – or, as Bourne writes, 'puckeroed' – into service. Additionally there was a staff of servants.

The son of a Staffordshire farmer, Bourne was closely aware of the seasons and the moods of nature, observations which in his youth he struggled to express in a kind of Wordsworthian poetry. Later he indulged this passion in his accounts of the Himalayan vistas. As an amateur enthusiast he was exhibiting photographs in Nottingham as early as 1859, and he soon abandoned his job as a bank clerk for the more congenial open-air life of the landscape photographer. Three years later his astonishing activities in India were to begin.

Bourne was the first European traveller to photograph the wilder parts of the Himalayan foothills, though there was one other photographer in the region, the Rajah of Chumba. Bourne was invited to visit him. His Highness was the proud possessor of the most exquisitely made photographic equipment. And much to the disgust of the utilitarian-minded traveller, these superb cameras and lenses were not kept primarily for taking photographs; they were valued for the sheer beauty of their design.

Bourne published three series of elegantly written accounts of his incredible journeys. Strange ordeals they were, undertaken more, it seems, in pursuit of that perverse pleasure in adversity, in solitude and in pain, than for the purported recording of the lofty grandeur of the magnificent Himalayan mountain ranges. These diaries appeared as instalments in *The British Journal of Photography*, reconstructed from notes soon after the completion of the expedition, and in one case over two years later. We can estimate, partly on Bourne's figures, that the total number of photographs taken on his three journeys must have been around 800 or 900. This out of more than 1,500 made in the three years or so he spent at that time in India, as his negative numbers indicate. His second journey, to Kashmir in 1864, lasted a full ten months during which time he made 546 negatives. Bourne was, in fact, very sparing with his camera, not only scrupulously selective, but conscious also of the great difficulties entailed in preparing the plates. Sometimes, after a ten- or fourteen-mile diversion, the photographer returned with only one or two negatives; sometimes with none.

Following his first journey, which took ten weeks, Bourne writes from Simla on 7 November 1863, describing the fantastic scenery he had seen 160 miles away on the road to Chini, near the Tibetan border. There, at an altitude of 9000 feet, he had in full view great mountain ranges reaching above him to heights of 22,000 feet. So overwhelming was the landscape that often it seemed beyond the capabilities of photography to convey:

With scenery like this it is very difficult to deal with the camera: it is altogether too gigantic and stupendous to be brought within the limits imposed on photography. Even the much-vaunted 'globe lens' would find itself unequal to extend its great divergence over these mighty subjects, and compress their rays on the few square inches of a collodion plate . . . But my anxiety to get views of some of these fine combinations of rocks and water often induced me to leave the regular track, and put myself and instruments in the greatest danger by attempting an abrupt descent to some spot below indicated by the eye as likely to command a fine picture. Though this was only accomplished with immense difficulty, sundry bruises, and great personal fatigue under a scorching sun, I was in every instance rewarded, always returning with pictures which the more contented gazer from above would scarcely believe obtainable. But this toiling is almost too much for me, and, I must confess, it at the time greatly outweighed the pleasure . . .[1]

Bourne returned to Chini and then struck off to the west in the direction of Spiti. Again, he is overwhelmed by the magnificence of the view, describing it with the adulation of the most confirmed romantic:

What a mighty upbearing of mountains! What an endless vista of gigantic ranges and valleys, untold and unknown! Peak rose above peak, summit above summit, range above and beyond range, innumerable and boundless, until the mind refused to follow the eye in its attempt to comprehend the whole in one grand conception.[2]

Bourne then pays great tribute to the power of photography to prepare the mind for what the eye may better behold:

. . . it must be set down to the credit of photography that it teaches the mind to see the beauty and power of such scenes as these, and renders it more susceptible of their sweet and elevating impressions. For my own part, I may say that before I commenced photography I did not see half the beauties in nature that I do now, and the glory and power of a precious landscape has often passed before me and left but a feeble impression on my untutored mind; but it will never be so again.[3]

1 Bourne, 'Ten Weeks with the Camera in the Himalayas', *The British Journal of Photography*, 1 February 1864.
2 Op. cit. 15 February 1864.
3 Ibid.

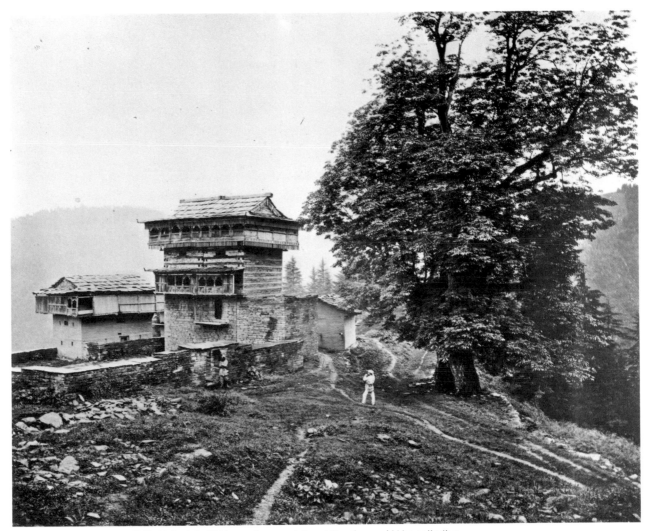

Samuel Bourne: Village of Kôt Kulu, July 1866. '. . . it was raining at the time. . .' Wet collodion.

Above the valley of the Sutlej, at an altitude of more than 15,000 feet. Bourne attempts to take a picture in the excruciating cold:

Everything wore an air of the wildest solitude and the most profound desolation, and while I looked upon it I almost shuddered with awe at the terrific dreariness of the scene. But the cold was too intense to permit me to look long upon its stern and desolate grandeur, and while at this elevation I was anxious, if possible, to try a picture; but to attempt it required all the courage and resolution I was possessed of. In the first place, having no water I had to make a fire on the glacier and melt some snow. In the next place, the hands of my assistants were so benumbed with cold that they could render me no service in erecting the tent, and my own were nearly as bad. These obstacles having at length been overcome, on going to fix the camera I was greatly disappointed after much trouble to find that half the

sky had become obscured, and that a snow storm was fast approaching . . . I managed to get through all the operations, and the finished negative – though rather weak, and not so good a picture as it would have been if the snow storm had not prevented my taking the view intended – is still presentable, and I keep it as a memento of the circumstances under which it was taken, and as being, so far as I am aware, a photograph taken at the greatest altitude ever yet attempted.[1]

Bourne was later to exceed even this height when on his last trip he photographed the Manirung Pass at 18,600 feet (5.4). Bourne's coolies were often frightened out of their wits at the lunatic persistence of this mad Englishman who undertook the most hazardous expeditions. Many of them consequently deserted, leaving their freight by the roadside. It is with amazement that we read

1 Ibid.

of the unmitigated cheek of this photographer in the face of mutiny or desertion, though in other circumstances he'd shown himself sensitive to the needs of his bearers:

I had not gone a quarter of a mile further when I came upon another load, and yet another, left by the road side as before. This was getting serious, and I vowed vengeance against the rascals who had placed me in this difficulty. I was told that these men had no doubt hidden themselves in a village which I saw at a little distance from the road. Taking a stout stick in my hand I set out in search of them, in a mood not the most amiable. After searching several houses unsuccessfully my attention was attracted to another, where two women stood at the door watching the proceedings. I fancied they looked guilty, and at once charged them with concealing my coolies. 'Nay sahib; koee admee nahe hy mera ghur pur; coolie nahe hy.' (No sir; there is no man in my house; there is no coolie.) Not satisfied with this answer I walked in, and soon discovered my friends hiding beneath a *charpoy* or bed, and dragging them forth made them feel the 'quality' of my stick. amid the cries and lamentations of the aforesaid females.[1]

In describing his ten-month Kashmir trip (1864) Bourne comments on the lack of the picturesque in Himalayan landscapes, however awe-inspiring they appear, and in this respect, both for painting and for photography in so far as it aspires to the conditions of painting, the romantic subject and scale of the Swiss alps is preferable:

The scenery in some places was grand and impressive. huge mountains, frequently clothed with forests of pine, towered aloft on every hand, my little path winding about them; sometimes ascending far up, only to dip again deep into the valleys; occasionally crossing a ravine in which a mass of snow still lay imbedded from the fall of last winter. And yet, with all its ponderous magnificence and grandeur, strange to say this scenery was not well adapted for pictures – at least for photography.
 I may here pause for a moment to remark that the character of the Himalayan scenery in general is not picturesque. I have not yet seen Switzerland, except in some of M. Bisson's and Mr England's photographs; but, judging from these, and from the numerous descriptions I have read of it, I should say that it is far more pleasing and picturesque than any part I have yet seen of the Himalayas. The mountains here are, no

doubt, greater, higher, and altogether more vast and impressive; but they are not so naked in their outline, not so detached, do not contain so much variety, have no such beautiful fertile valleys amongst them, no lakes, few waterfalls, and scarcely any of those fine-pointed peaks which rise from broader summits and lift their pyramids of snow to the skies. This striking and rugged character of the Alps is just what the artist loves, and which gives such a pleasing charm and variety to all well-chosen and well-executed views of that popular district. Here the mountains are all alike, all having the same general features and outlines, presenting in the aggregate, from their immense extent and size, a scene grand and impressive, doubtless, but wanting in variety.[1]

But Bourne was yet to explore the area in which lies the source of the Ganges, and he acknowledges that the reputed sublimity of its scenery may even surpass that of Switzerland. Indeed, only a few paragraphs later, he is already qualifying his previous remarks:

As I sat down to rest on a grassy mound contemplating this scene a feeling of melancholy seemed to steal over

1 Op. cit. 23 November 1866.

Samuel Bourne: From his own album c. 1870. This is not captioned but there is such a close resemblance to his photographs in later life that there can be little doubt that it is him. We⁺ collodion.

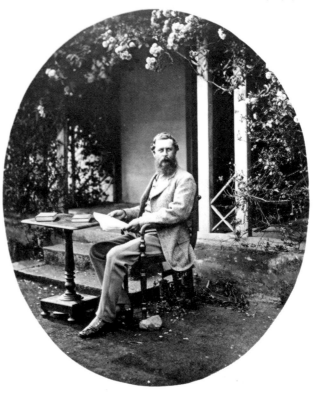

1 Bourne, 'Narrative of a Photographic Trip to Kashmir (Cashmere) and Adjacent Districts', *The British Journal of Photography*, 19 October 1866.

me, as it had done on several occasions when travelling among these tremendous hills. Here was I, a solitary lonely wanderer, going Heaven knew where, surrounded by the gloomy solitude of interminable mountains which seemed, in fact, to stretch to infinity on every hand. To attempt to grasp or comprehend their extent was impossible, and the aching mind could only retire into itself, feeling but an atom in a world so mighty . . .

It is of course totally impossible to give any notion of scenes and distances like these by the camera; the distances would run into each other and be lost in one indistinguishable hazy line, where the eye could trace that receding succession which conveys the idea of immense extent and distance. The photographer can only deal successfully with 'bits' and comparatively short distances; but the artist, who has colour as well as outline to convey the idea of distance, might here find something worth coming for. If our artists at home, who are crowding on the heels of each other and painting continually the same old scenes which have been painted a hundred times before, would only summon up courage to visit the Himalayas, they would find new subjects enough for a lifetime, or a hundred lifetimes . . . They would also furnish to people at home some idea of what the Himalayas are really like, which we of the camera can hardly do.

The effects which I have sometimes witnessed in the evening, just before sunset, have been such as will remain impressed on my memory for ever – effects which must be seen to be felt, since no description can conjure up to the reader the magic and almost dreamlike visions which the writer has witnessed . . . How often have I lamented that the camera was powerless to cope with these almost ideal scenes, and that with all its truthfulness it can give no true idea of the solemnity and grandeur which twilight in a vast mountainous region reveals partly to the sense and partly to the imagination.[1]

The trials and tribulations of the explorer-photographer were many. Here is Bourne's account of one of his mishaps after setting up his photographic tent on a narrow path poised high up on the slope of a mountain:

I was engaged in developing a plate when my servant informed me that twelve laden ponies were waiting to pass. I kept them waiting for some time, and had yet another picture to take, but the men getting impatient I allowed them to pass by going a little up the slope above my tent. I saw five or six pass over safely and went inside to prepare another plate. Eleven had crossed, and the twelfth was in the act of doing so when he lost his footing and came right down upon the tent and me ! Down went the table and smash went the bottles, collodion, developers, fixer, and measures ! As soon as I could extricate myself I rushed out and saw the pony get up and walk off uninjured; but how was I to replace my precious bottles and glasses? By turning the broken ones to account, and bringing two or three brandy bottles into use, I contrived to carry on my work.[1]

Mindful of the vastness of the Himalayan landscape, Bourne is proudly defiant about his use of large plates, and he speaks disdainfully of the trivial scale of small photographs. We detect a degree of conceit here in view of the Herculean obstinacy with which he lugged (or had lugged) those immense loads of photographic supplies up and down the precipitous paths of the High Himalayas. His comments on the aesthetic advantages of the large over the small contact print are rare in the early literature of photography. They belong to a period when the democratisation of the photographic process, in its greater availability and ease of operation, stiffened the determination of many photographers to hold out for Art:

If I might be allowed the digression, I would like to ask here if any photographer at home ever now works large plates of 12×10 and upwards? Judging from the journals, everyone seems to confine his attention to small plates – stereoscopic, or even smaller size – and 'satchel' or 'pocket' cameras seem to be all the 'go' . . . We all know that it is much easier to get faultless skies on small plates by any process than on large, and hence, I suppose, the reason why we seldom or never hear of large plates being worked by a dry process. But what is the use of these bits of pictures when they are obtained? Are they worth the trouble of preparing and developing, and travelling perhaps hundreds of miles to get? They are simply looked upon as *scraps*, however good they may be; they have no pretensions to *pictures*, and, making an exception in favour of stereoscopic views, which have a special interest of their own, one attaches little importance to these diminutive transcripts of nature, which really convey no impression of the grandeur and *effect* of the scenes they represent. I confess that if they could be enlarged *satisfactorily* there might be some reason for employing such small plates; but can they be? I have never yet seen or heard of any enlargements that were equal to photographs taken direct from nature, and till such can be produced commend me to *large* pictures taken direct in the camera; for when such

1 Ibid. 23 November 1866.

1 Op. cit. 8 February 1867, written from Simla, 27 June 1866.

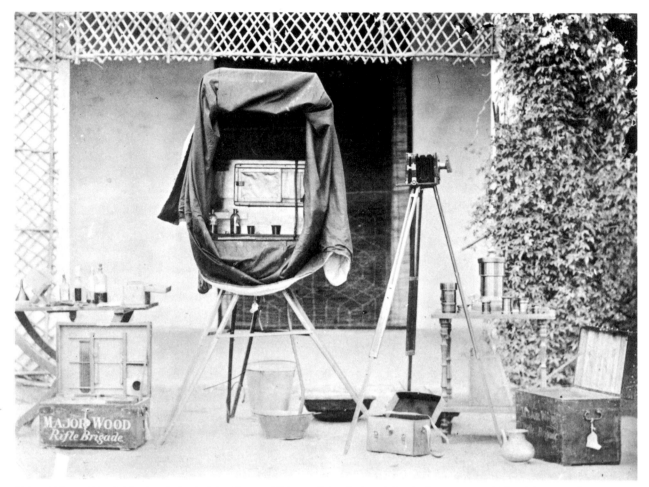

Colonel Henry Wood: His chemicals, dark tent for sensitising and developing plates, baths, camera and tripod, lenses and cases – the kind of equipment Bourne was using in India at much the same time.

pictures are artistically chosen, properly lighted, and cleanly and skilfully manipulated, they possess a charm which never tires, and when looking at them they almost make one feel as though one stood in the very presence of the scenes themselves. I admit that it is not an easy matter to manipulate large plates successfully, and that they involve considerable expense and trouble; but when people are blacking their fingers and spending their cash in photography, why not aim at something that shall be worth looking at when it is finished, and give themselves and friends some pleasure in beholding? I take it that *one* good large picture that can be framed and hung up in a room is worth a hundred little bits pasted in a scrap-book; and twenty such pictures taken on any given journey, of the best subjects only, would yield an amount of pleasure and satisfaction which whole boxes full of small negatives could never impart.[1]

Many photographers, before and after Bourne, saw the camera as a means of satisfying their curiosity about the outside world, and that also of a picture-minded public stimulated by a newly risen pictorial press. The story of travellers with a camera has not yet completely been told. From the very beginning, many determined men and women lugged photographic equipment, not infrequently as cumbersome as that of Bourne, to almost every explored and unexplored spot on this shrinking earth. What such images meant in terms of the present much vaunted 'global village', and what effect they most undoubtedly have had on the human psyche is yet to be determined.

1 Bourne, 'A Photographic Journey through the Higher Himalayas', *The British Journal of Photography*, 18 March 1870.

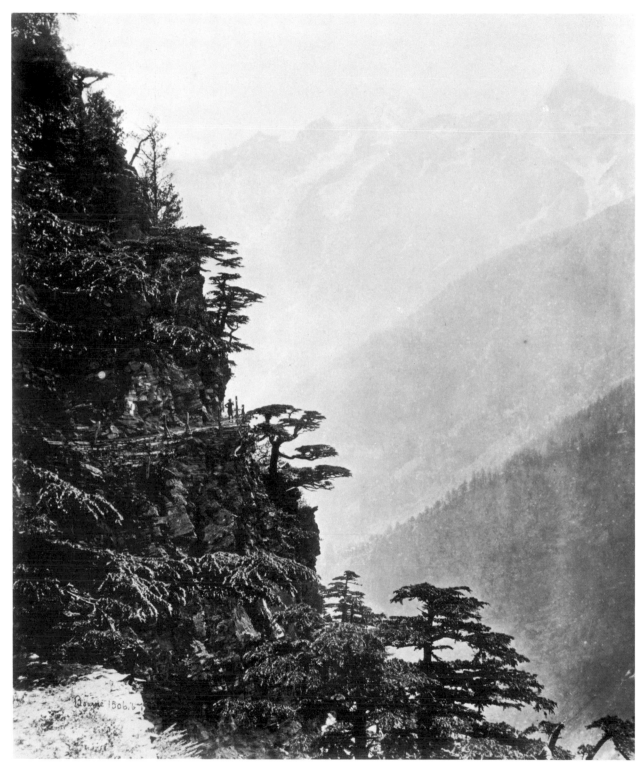

5.1 SAMUEL BOURNE: THE NEW ROAD NEAR ROGI

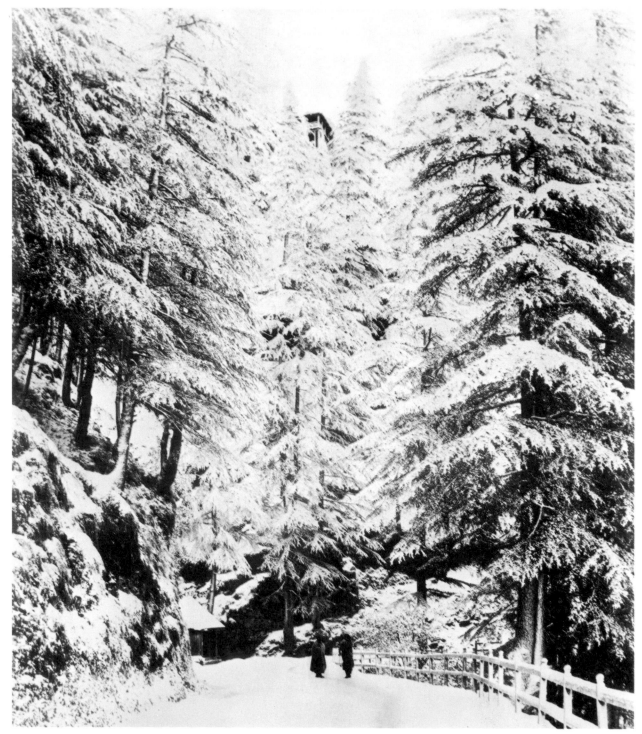

5.2 SAMUEL BOURNE: DEODARS IN THE SNOW, SIMLA

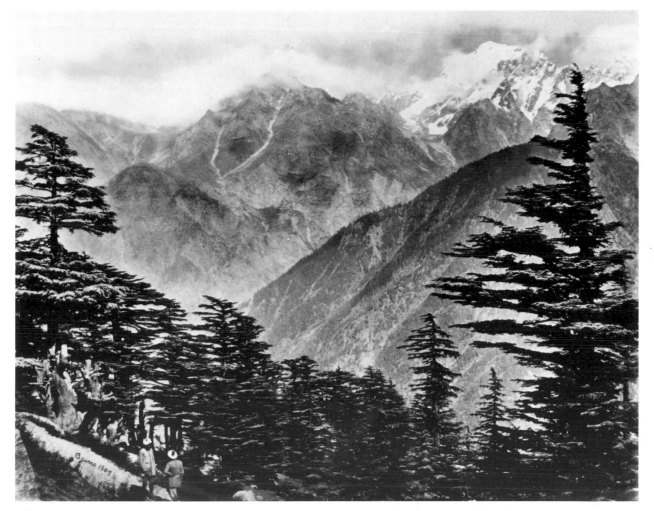

5.3 SAMUEL BOURNE: VIEW NEAR CHINI

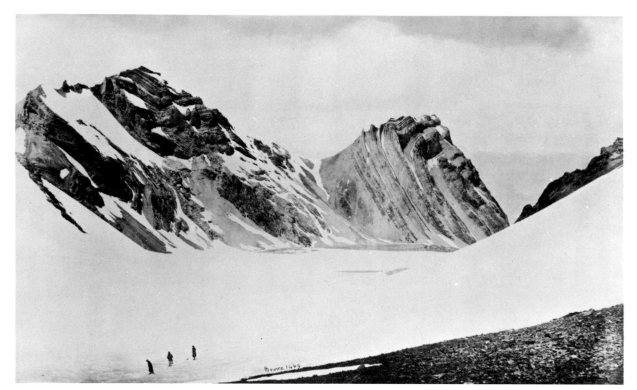

5.4 SAMUEL BOURNE: THE MANIRUNG PASS

5.5 BOURNE AND SHEPHERD: THE REVERSING STATION, BHON GHAT

5.6 JOHN THOMSON: CHAO-CHOW-FU BRIDGE

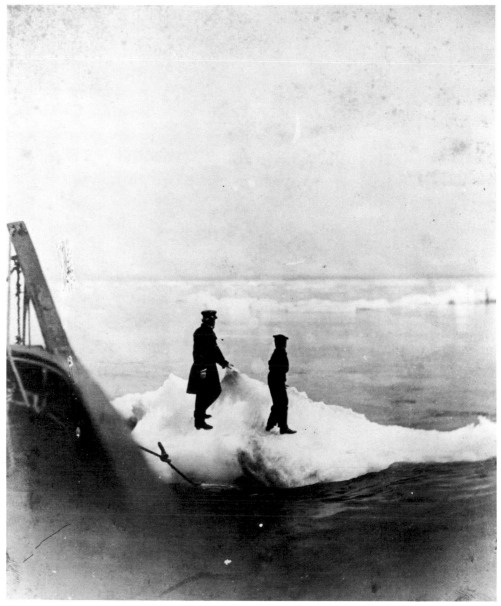

5.7 DUNMORE AND CRITCHERSON: MAN AND BOY ON FLOATING ICE, LABRADOR

WHEN I WAS A PHOTOGRAPHER

"The theory of photography can be learnt in an hour; the first ideas of how to go about it in a day....What can't be learnt...is the feeling for light—the artistic appreciation of effects produced by different or combined sources; it's the understanding of this or that effect following the lines of the features which requires your artistic perception." Nadar (1857)

NADAR'S STUDIO, 35 BOULEVARD DES CAPUCINES

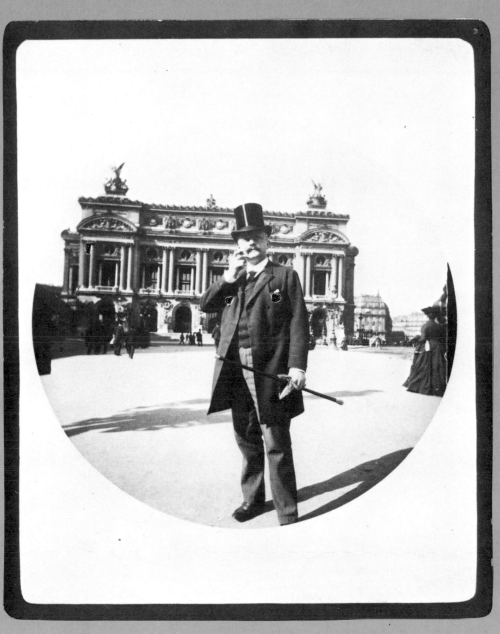

WHEN I WAS A PHOTOGRAPHER

Felix Tournachon (1820–1910), who called himself Nadar, became a legend in his own time. Indisputably, Nadar was the best known, indeed most notorious, photographer in France in the last half of the nineteenth century. He was a man of many parts; a man with 'double viscera' as his friends said. His career, from medical student and Montmartre Bohemian at nineteen, to spy, journalist, novelist, caricaturist of note, art critic, photographer, balloonist and pioneer in the advocacy of heavier than air flight, was as adventurous as that of Jules

Verne's hero in his *Journey from the Earth to the Moon*: Michel Ardan, the character inspired by Verne's admired friend, Nadar. Everyone knew Nadar. And most of the artistic and intellectual aristocracy of nineteenth-century France sat for his camera from 1853, when he opened his first photographic studio in Paris.

In a sardonic appraisal of photography in 1857, Nadar shows himself extremely sensitive to the possible aesthetic deterioration the widespread use of the medium could produce:

Photography is a miraculous discovery, a science which is pursued by the highest minds, an art which sharpens the wisest wits – and whose application is within the powers of the greatest. This wonderful art which makes something out of nothing, this miraculous invention after which one can believe in anything, this insoluble problem for which the learned men who solved it some 20 years ago are still looking for a name, this photography which, with applied electricity and chloroform, makes our 19th century the greatest of all centuries, this supernatural photography is practised each day in every house, by the first comer as well as the last, because it has created a meeting point for all the dead heads of all the professions. Everywhere you can see working at photography an artist who has never painted, a tenor without a contract, and I undertake to turn with one lesson your coachman and your concierge – and I speak in all seriousness – into yet another two photographic technicians. The theory of photography can be learnt in an hour; the first ideas of how to go about it in a day . . . What can't be learnt . . . is the feeling for light – the artistic appreciation of effects produced by different or combined sources; it's the understanding of this or that effect following the lines of the features which requires your artistic perception. What is taught even less, is the instinctive understanding of your subject – it's this immediate contact which can put you in sympathy with the sitter, helps you to sum them up, follow their normal attitudes, their ideas, according to their personality, and enables you to make not just a chancy, dreary, cardboard copy typical of the merest hack in the darkroom, but a likeness of the most intimate and happy kind, a speaking likeness . . .[1]

The bluff and down-to-earth Nadar would seem to have been the last person to find in photography a metaphysical meaning and he takes a certain poetic glee in his facetious assessment of photography's mysterious nature. Yet one suspects that he really delighted in the idea that,

of all the practical inventions the nineteenth century bequeathed to mankind, the miraculous one of photography, utilitarian though it was, partook at the same time in the impenetrable mysteries of the spirit world.

The following, an extract from one of Nadar's books, was written, we ought to note, in the high period of European spiritualism during which a number of eminent figures interested themselves in what we now call extra-sensory perception, psycho-kinesis and, not least, spirit photography. Nadar writes of Balzac's dread of the occult powers of photography, and it is tempting to think that both their attitudes conveyed a psychological expression of redress against the reality of the photograph and the consequent demystification of art (as it has felicitously been called). What could be better than to insinuate a metaphysical content into the actuality of the photograph itself?

But those many new miracles will have to wane before the most astonishing, the most disturbing of all: the one which seems finally to give to man the power to create, in his turn, by giving substance to the disembodied ghost which vanishes as soon as seen without leaving a shadow in the glass of the mirror, a ripple on the water of the pool. Could not man himself believe that he was creating in fact when he seized, caught, materialised the intangible, retaining the fugitive image, the light, etched by him today on the hardest metal? In truth Niépce and his fine friend were wise to wait to be born. The Church has always shown itself cool towards innovators – when she wasn't being a little too warm towards them – and the discovery of 1842 [sic] had doubtful attractions to the lord of all. This mystery smacks of the devil at his spells and stinks of the stake: the heavenly roasting-spit has been warmed up for much less . . . The night, dear to sorcerers, reigned alone in the murky depths of the camera obscura, the chosen place appointed for the Prince of Darkness . . . It isn't surprising then if, at first, admiration herself seemed uncertain; she appeared disturbed, as if she was scared; it took time before the Universal Animal pulled himself together and approached the Monster. In front of the Daguerreotype, this fear was shown 'from the lowest to the highest', as the popular saying goes, and the untutored or illiterate were not alone in showing this hesitation as distrustful as it was superstitious. More than one among the great minds suffered from this complaint of first refusal. To take an example from among the greatest: Balzac felt ill at ease before the new marvel, he could not get rid of a vague dread of the Daguerreotype operation. He had worked out an explanation for himself, as well as could be at that time, taking on here and there fantastical theorisings à la Cardan. I think I

1 Part of evidence presented to a tribunal when claiming his right to use the name 'Nadar', 12 December 1857. Bibliothèque Nationale Cat. des Estampes Na 163/41.

Possibly Gavarni and Silvy: Balzac, c. 1848. Daguerreotype.

can remember seeing his particular theory set out by him at length in some corner of the great spread of his works. I haven't the time to dig it out but my memory recalls very clearly the long-winded dissertation that he made when we once met and which he repeated another time (for he seemed to be obsessed with it), in that tiny flat hung round with purple in which he lived at the corner of the rue Richelieu and the Boulevard . . . So, according to Balzac, every body in its natural state was made up of a series of ghostly images superimposed in layers to infinity, wrapped in infinitesimal films . . . Man never having been able to create, that's to say make something material from an apparition, from something impalpable, or to make from nothing, an object – each Daguerrian operation was therefore going to lay hold of, detach and use up one of the layers of the body on which it focused. . . Was Balzac's fear of the Daguerreotype real or feigned? It was real. Balzac had more to gain than to lose, the amplitude of his paunch and the rest of his body making it possible for him to be prodigal of his 'ghosts' without having to count them. In any case it didn't prevent him from posing at least once for that unique Daguerreotype by Gavarni and Silvy which I owned, now handed over to M. Spoelberg de Louvenjoul.[1]

1 Nadar (Felix Tournachon), *Quand j'étais photographe* (Paris 1900).

Nadar's immense energies (as I have noted, he was an avid and accomplished aeronaut, writer and caricaturist as well), coupled with an insatiable curiosity, led him to explore the possibilities of photographing the unseen urban landscape from above – in a balloon – and from below, using new techniques in artificial lighting in the catacombs and sewers of Paris. With great relish he writes in retrospect of his adventures. On aerial photography about 1858:

Feverishly I set about organising the laboratory that I had to get into the basket, because at that date we hadn't yet reached those blessed days when our nephews could carry a whole laboratory in their pockets, and we had to do our own stuff [notre cuisine] up there on the spot. So everything was there, all the kit, in its place. And nothing could be forgotten for it wouldn't really be convenient to come up and down too often.

The basket was arranged as perfectly as could be; it was as spacious as the balloon would allow – six hundred cubic meters of this to lift nothing more than the attaching cables, my assistant and me.

Everything inside was neatly to hand, packed or hung in place. We were quite at home there, and Bertsch quickly changed his cubby-hole on the rue Fontaine-Saint-Georges for our aerial laboratory, a real umbrella cover from which he teased the stars.

In the space below the balloon was hung the tent, a double layer, black and orange, which kept out all the sunlight, with a very little window of a photogenic yellow glass which gave me just the amount of illumination I needed. It was hot underneath it for the worker and the work. But our collodion and our other materials were reliable, kept in their ice-buckets.

My camera, fastened vertically, was a Dallmeyer. That speaks for itself. And the triggering of the horizontal shutter that I had dreamed up – another patent! – for opening and closing it with a single continuous action – worked impeccably.

Finally I had anticipated as well as I could the vibrations of the basket. The force of our ascent was such that the holding cables – which came not from the basket but from the ring encircling the craft, were set so that they could allow the balloon to expand or shrink. Besides, I intended to fly only in calm weather, and if the elasticity of my rigging seemed strained at the desired height of 300 metres, I could descend to 200, or to 100 – it had to succeed.

On artificial light:

. . . at that time (1858) electricity was still far removed from the really useful simplifications that developed so

Nadar and assistant: Four aerial views of Paris from an eight part negative processed in a balloon basket, 1868. (Altitude 520 metres, wet collodion).

quickly, as it were, with giant strides. We didn't have the precious portable accumulators, nor Gaulard's intermediary generators, nor all the other facilities that exist now, and we were reduced to all the awkward inconveniences of the Bunsen battery. No alternative. Thus I had an experienced electrician set up for me, along the glassed-in balcony of my studio frontage on the boulevard des Capucines, fifty medium lights[1] which I hoped would be and which were to be sufficient to give me the illumination I wanted. I got over the problems and difficulties of installation and operation; they were quite trivial in comparison with the obstacles I was to encounter later on – handling portable lights.

Nadar tried some self-portraits indoors first – then:

Indifferent, and even horrible as were these first results, rumours of the experiments spread through our little photographic world where everyone keeps tabs on his neighbor, and I was promptly invited to talk to the *Cercle* and to the newspaper, *la Press scientifique*, then located in the rue Richelieu, on the side of the Pradier fountain – Pradier, that nice but uneven sculptor. Préault said of him, 'He sets off each morning for Athens and comes back each evening via the place Bréda'.

Nadar lugged all his equipment to the offices of the news-paper and there made some trials:

These first plates came out hard, with heightened effects, solid blacks, blocked out without detail on every face. The pupils of the eyes were either like two gimlet holes, crudely blacked in, or bleached out with an excess of light.

In 1861 Nadar spent three excruciating months photo-graphing subterranean Paris, accounting for at least 100 more or less successful negatives:

The possibility of photographing by artificial light was therefore already a fact; it now only remained to apply it to the project I dreamed of.

1 Nadar used these lamps as advertisement as each evening their unac-customed sight drew visitors.

Nadar studio: Model of an experimental steam 'hélicoptère' engine designed by Pontin d'Amecourt, 1863, exhibited by Nadar at a meeting in his studio on 30 July 1863 at which time he advocated 'heavier-than-air' machines as a better solution to the problems of flight than balloons. Wet collodion.

The world underground offered an infinite field of activity no less interesting than that of the top surface. We were going into it, to reveal the mysteries of its deepest, most secret, caverns.

But without going so far at the start, and to begin at the beginning, a primary task was right under our very feet: [to explore] the catacombs of Paris, though they did not have the solemn associations, the pious lessons, of the Roman catacombs, they yet had secrets to tell us, and above all we could show the remarkable achievement, human resourcefulness displayed in the network of the Parisian sewers.

We have passed over the catacombs, only giving up to this point a very summary indication of our working procedure – of which the real difficulties were going to come out above all in the city drain . . .

. . . I cannot tell you how many times our work was interrupted, held up for one reason or another. At one time the weakened acids had been insufficiently brought up to strength and we had to stop with all our gear [literally, with the rifle resting down at the feet, when one is otherwise ready to shoot] in those regions – far from agreeable. Twice I had to change the mechanism which operated our light stands. Must I spell out again how we were let down and angry when after several attempts at a tricky shot, at the moment when all precautions had been taken, all impediments removed or dealt with, the decisive moves being about to take place – all of a sudden, in the last seconds of the exposure[1], a mist arising from the waters would fog the plate – and what oaths were issued against the belle dame or bon monsieur above us, who without suspecting our presence, picked just that moment to renew their bath water!

We might note that Nadar's presence in the Parisian sewers elicited from him some ninteenth-century ecological reflections on the waste of all the muck in the drains, how Victor Hugo wrote about the way the Chinese use it all, while the French are importing chemicals in huge quantities and at great cost from Peru:

As for us, at great expense we send ships to Peru to bring back what we have disdainfully thrown away, eager to be rid of it. We throw it away and yet Barral, in his *Agricultural Trilogy* reckons that our farms lose each year natural fertilisers equivalent to a production of forty million *hectolitres*[2] of wheat. All our agricultural economists, all the specialists, all the Boussingaults, all the Liebigs, the Grandeaus, continually, every day, cry

Nadar: 'Chambre du Pont Notre Dame' one of a series on Paris sewers photographed by electric light. The arc lamps were connected by wires through manhole covers to Bunsen batteries in the streets above. 1861. Wet collodion.

Nadar: The Paris catacombs by electric light, 1861. Wet collodion.

1 Nadar notes that some exposures took up to eighteen minutes: 'Remember that we were still using collodion . . .'
2 One *hectolitre* equals 2·75 bushels.

out against such an incomprehensible madness. But who bothers to listen to them, still less to understand them, and our unfathomable human stupidity persists in losing for us, in Paris alone, hundreds of millions of francs worth of valuable material each year, and it goes to poison our fish . . .

Nadar studio: Interior of 35 Boulevard des Capucines, showing some of Nadar's art collection, including Daumier's 'Washerwoman' and a Corot landscape, c. 1865. Wet collodion.

Nadar's studio 1872–1887, 51 Rue d'Anjou. Balcony and glass wall of studio. Nadar handed over the studio to his son Paul in 1887 and this photograph was probably taken c. 1910.

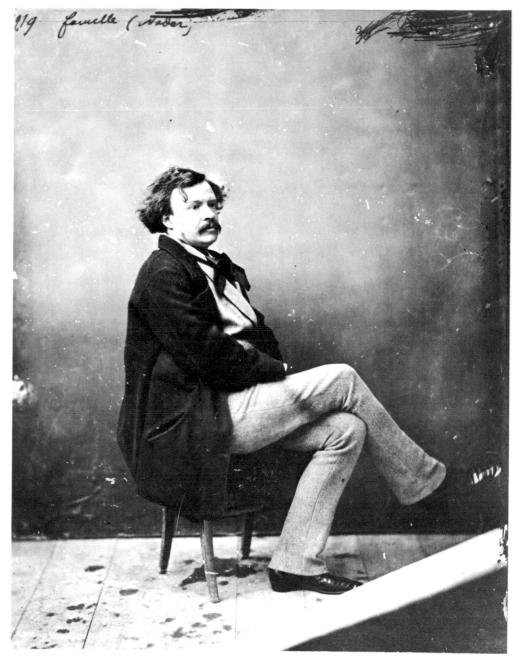

6.1 NADAR: SELF-PORTRAIT

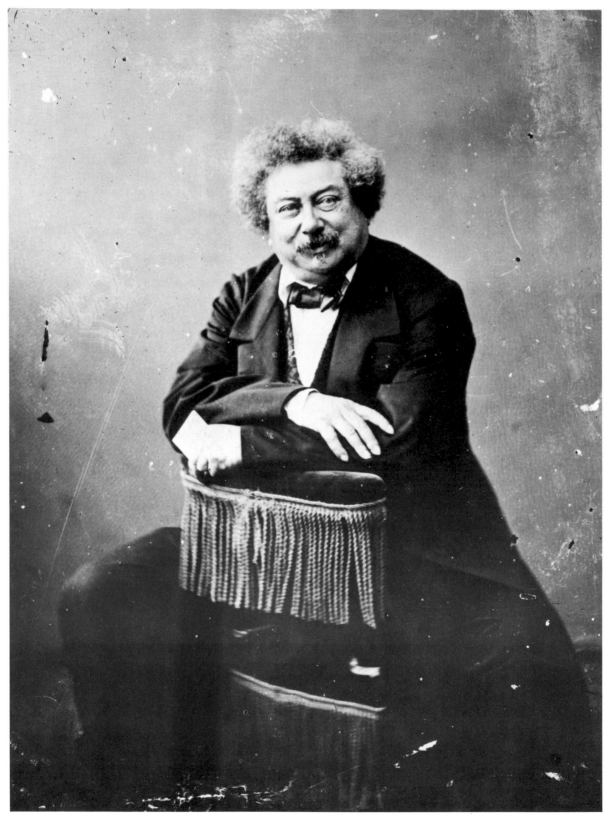

6.2 NADAR: ALEXANDRE DUMAS

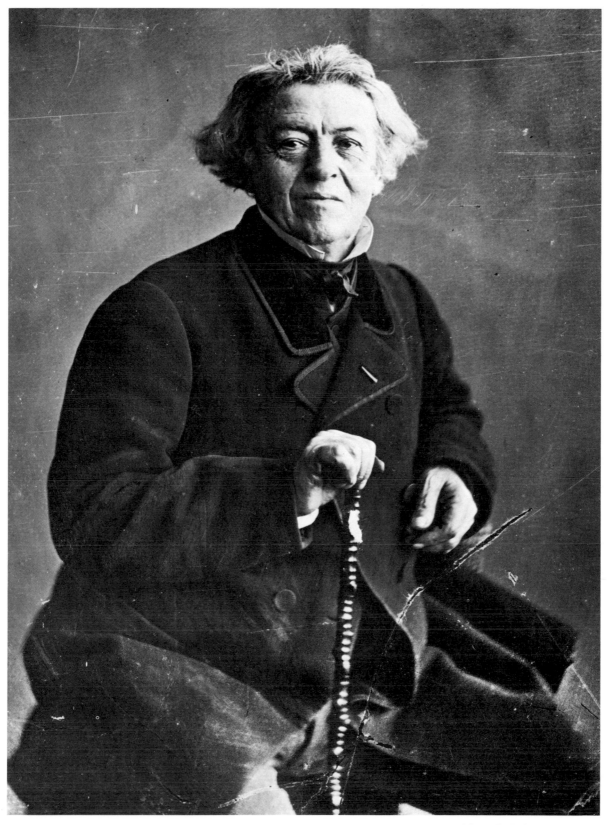

6.3 NADAR: CAMILLE COROT

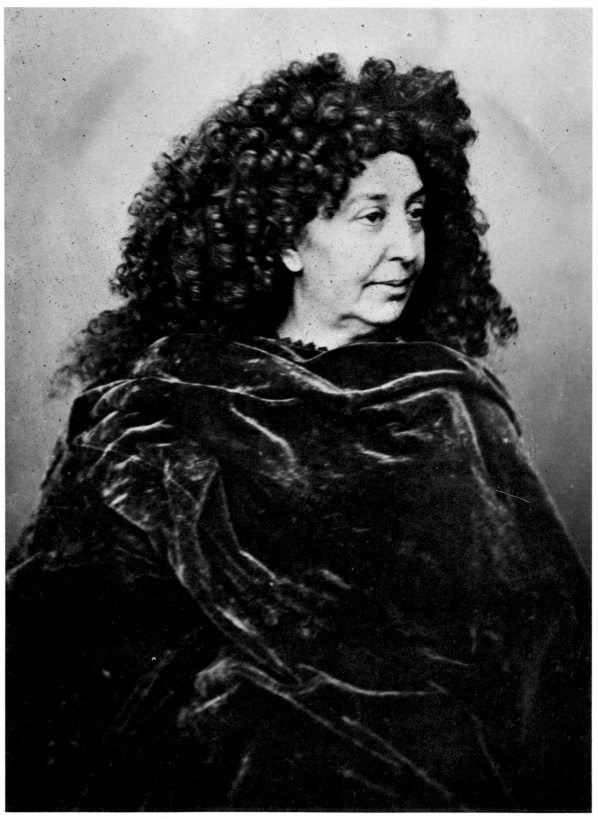

6.4 NADAR: GEORGE SAND AS LOUIS XIV

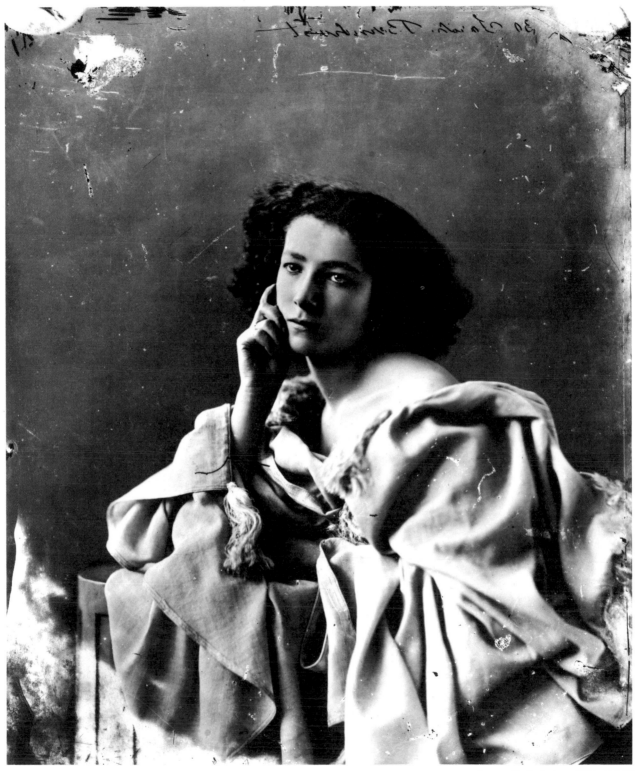

6.5 NADAR: SARAH BERNHARDT

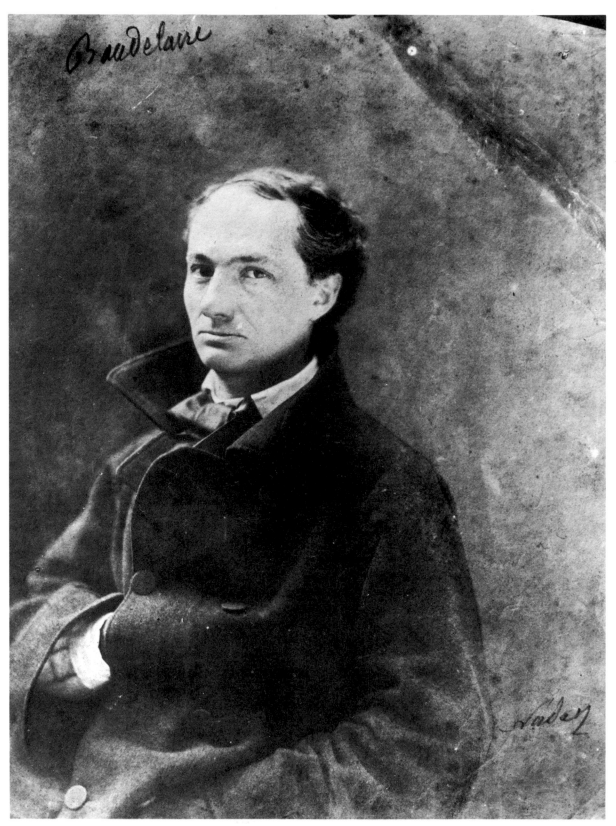

6.6 NADAR: CHARLES BAUDELAIRE

6.7 NADAR: OLD WOMAN

THE INDELIBLE RECORD

"It is a novel experiment to attempt to illustrate a book of travels with photographs, a few years back so perishable, and so difficult to reproduce. But the art is now so far advanced, that we can multiply the copies with the same facility, and print them with the same materials as in the case of woodcuts or engravings."

John Thomson (1873)

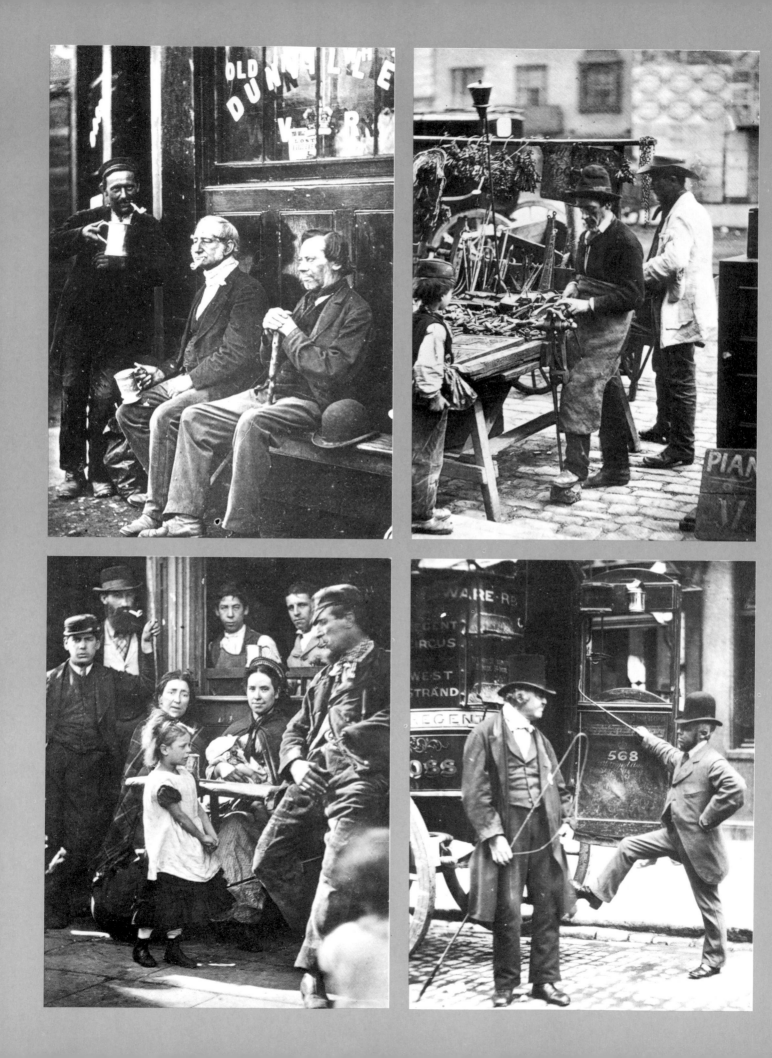

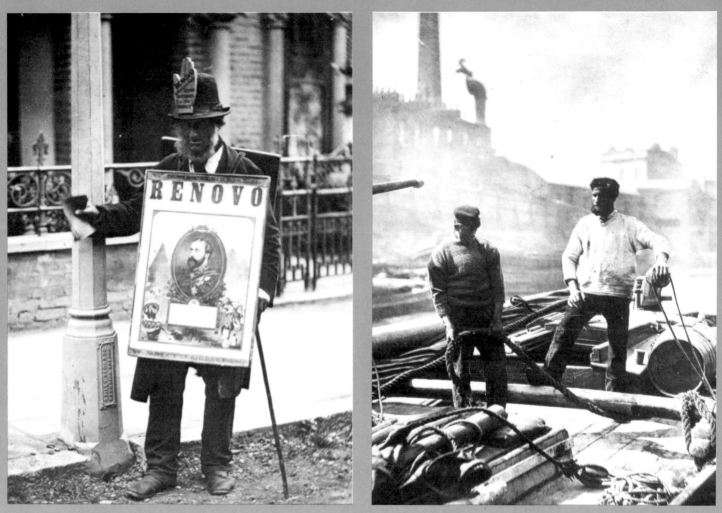

THE INDELIBLE RECORD

Perhaps the most comprehensive assessment in the nineteenth century of the applicability of the photographic medium as a means for producing factual records exists in two articles by the elder Oliver Wendell Holmes, father of the American jurist. They both appeared in the *Atlantic Monthly* magazine: the first in 1857, the other in 1863, at a time when the United States were bitterly divided in the conflict of Civil War. I reproduce here a few excerpts from the two extensive and exquisitely written texts:

Oh, infinite volumes of poems that I treasure in this small library of glass and pasteboard! I creep over the vast features of Rameses, on the face of his rock-hewn Nubian temple; I scale the huge mountain-crystal that calls itself the Pyramid of Cheops. I pace the length of the three Titanic stones of the wall of Baalbec, – mightiest masses of quarried rock that man has lifted into the air; and then I dive into some mass of foliage with my microscope, and trace the veinings of a leaf so delicately wrought in the painting not made with hands, that I can almost see its down and the green aphis that sucks its juices. I look into the eyes of the caged tiger, and on the scaly train of the crocodile, stretched on the sands of the river that has mirrored a hundred dynasties. I stroll through Rhenish vineyards, I sit under Roman arches, I walk the streets of once buried cities, I look into the chasms of Alpine glaciers, and on the rush of wasteful cataracts. I pass, in a moment, from the banks of the Charles to the ford of the Jordan, and leave my outward frame in the arm-chair at my table, while in spirit I am looking down upon Jerusalem from the Mount of Olives.

'Give me the full tide of life at Charing Cross,' said Dr Johnson. Here is Charing Cross, but without the full tide of life. A perpetual stream of figures leaves no definite shapes upon the picture.[1] But on one side of this stereoscopic doublet a little London 'gent' is leaning pensively against a post; on the other side he is seen sitting at the foot of the next post; – what is the matter with the little 'gent'?

1 Because of the lengthy exposure time.

The very things which an artist would leave out, or render imperfectly, the photograph takes infinite care with, and so makes its illusions perfect. What is the picture of a drum without the marks on its head where the beating of the sticks has darkened the parchment? In three pictures of the Ann Hathaway Cottage, before us – the most perfect, perhaps, of all the paper stereographs we have seen – the door at the farther end of the cottage is open, and we see the marks left by the rubbing of hands and shoulders as the good people came through the entry, or leaned against it, or felt for the latch . . . We have got the fruit of creation now, and need not trouble ourselves with the core. Every conceivable object of Nature and Art will soon scale off its surface for us. Men will hunt all curious, beautiful, grand objects, as they hunt the cattle in South America, for their *skins*, and leave the carcasses as of little worth.

The consequences of this will soon be such an enormous collection of forms that they will have to be classified and arranged in vast libraries, as books are now. The time will come when a man who wishes to see any object, natural or artificial, will go to the Imperial, National, or City Stereographic Library and call for its skin or form, as he would for a book at any common library . . .[1]

We should be led on too far, if we develop our belief as to the transformations to be wrought by this greatest of human triumphs over earthly conditions, the

1 By 1856, the London Stereoscopic Company alone sold a half million stereoscopes around the world, and offered 10,000 different views. By 1858, the title list had jumped to 100,000.

Stereo card of Niagara Falls Ice Mountain, late 1860s. Wet collodion.

divorce of form and substance. Let our readers fill out a blank check on the future as they like – we give our indorsement to their imaginations beforehand.[1]

On the Civil War:

The field of photography is extending itself to embrace subjects of strange and sometimes of fearful interest . . . We now have before us a series of photographs showing the field of Antietam and the surrounding country, as they appeared after the great battle of the 17th of September. These terrible mementos of one of the most sanguinary conflicts of the war we owe to the enterprise of Mr Brady of New York . . .

Let him who wishes to know what war is look at this series of illustrations. These wrecks of manhood thrown together in careless heaps or ranged in ghastly rows for burial were alive but yesterday . . . Many people would not look through this series. Many, having seen it and dreamed of its horrors, would lock it up in some secret drawer, that it might not thrill or revolt those whose soul sickens at such sights. It was so nearly like visiting the battlefield to look over these views, that all

1 'The Stereoscope and the Stereograph', loc. cit.

James Wallace Black: Aerial view of Boston taken 13 October 1860 from the balloon of Prof. Samuel Archer King. Black was a partner in the firm of Black & Batchelder which also included Dunmore and Critcherson (5.7) Wet collodion.

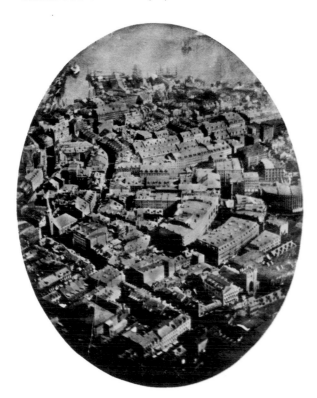

the emotions excited by the actual sight of the stained and sordid scene, strewed with rags and wrecks, came back to us, and we buried them in the recesses of our cabinet as we would have buried the mutilated remains of the dead they too vividly represented . . . The honest sunshine . . . gives us . . . some conception of what a repulsive, brutal, sickening, hideous thing it is, this dashing together of two frantic mobs to which we give the name of armies . . .

It is a relief to soar away from the contemplation of these sad scenes and fly in the balloon which carried Messrs. King and Black in their aerial photographic excursion . . . One of their photographs is lying before us. Boston, as the eagle and the wild goose see it, is a very different object from the same place as the solid citizen looks up at its eaves and chimneys. The Old South and Trinity Church are two landmarks not to be mistaken. Washington Street slants across the picture as a narrow cleft. Milk Street winds as if the cowpath which gave it a name had been followed by the builders of its commercial palaces. Windows, chimneys, and the skylights attract the eye in the central parts of the view, exquisitely defined, bewildering in numbers . . .

While the aëronaut is looking at our planet from the vault of heaven where he hangs suspended, and seizing the image of the scene beneath him as he flies, the astronomer is causing the heavenly bodies to print their images on the sensitive sheet he spreads under the rays concentrated by his telescope. We have formerly taken occasion to speak of the wonderful stereoscopic figures of the moon taken by Mr De la Rue in England, by Mr Rutherford and by Mr Whipple in this country. To these most successful experiments must be added that of Dr Henry Draper, who has constructed a reflecting telescope, with the largest silver reflector in the world, except that of the Imperial Observatory at Paris, for the special purpose of celestial photography . . .

In the last 'Annual of Scientific Discovery' are interesting notices of photographs of the sun, showing the spots on his disk, of Jupiter with his belts, and Saturn with his ring.

While the astronomer has been reducing the heavenly bodies to the dimensions of his stereoscopic slide, the anatomist has been lifting the invisible by the aid of his microscope into palpable dimensions, to remain permanently recorded in the handwriting of the sun himself . . . Of all the microphotographs [photomicrographs] we have seen, those made by Dr John Dean, of Boston, from his own sections of the spinal cord, are the most remarkable for the light they throw on the minute structure of the body . . . When the enlarged image is suffered to delineate itself, as in Dr Dean's views of the *medulla oblongata* [the lowest

part of the brain], there is no room to question the exactness of the portraiture . . . These later achievements of Dr Dean have excited much attention here and in Europe, and point to a new epoch of anatomical and physiological delineation.[1]

The vicissitudes of the war photographer were nicely enunciated when the *American Journal of Photography*, on 1 August 1861, commented on the retreat of the Union troops in the first battle of Bull Run in the early days of the American Civil War:

The irrepressible photographer, like the warhorse, snuffs the battle from afar. We have heard of two photographic parties in the rear of the Federal army, on its advance into Virginia. One of these got so far as the smoke of Bull's Run, and was aiming the never-failing tube at friends and foes alike, when with the rest of our Grand Army they were completely routed and took to their heels, leaving their photographic accoutrements on the ground, which the rebels, no doubt, pounced upon as trophies of victory. Perhaps they considered the camera an infernal machine. The soldiers live to fight another day, our special friends to make again their photographs.

The famous photographer of the Civil War, Mathew Brady (1823–96), no doubt led one of the beleaguered parties referred to. For on that occasion Brady and his assistants not only took the armies in battle and in disarray, but with a journalist's instinct he turned his camera on the stricken carriage crowd who'd come from Washington with picnic lunches to watch, from a high vantage point, their army beat the 'Rebs'. Those particular photographs, sad to say, great social documents as they were, seem no longer to be in existence. But the others of the battle itself were widely distributed.

Brady received the highest praise for his courage and determination, and his pictures were valued for their authenticity far more than the accounts of newspaper correspondents:

The public is indebted to Brady of Broadway for his numerous excellent views of 'grim-visaged war'. He has been in Virginia with his camera, and many and spirited are the pictures he has taken. His are the only reliable records at Bull's Run. The correspondents of the Rebel newspapers are sheer falsifiers; the correspondents of the Northern journals are not to be depended upon, and the correspondents of the English press are altogether worse than either; but Brady never

misrepresents. He is to the campaigns of the republic what Vandermeulen was to the wars of Louis XIV. His pictures. though perhaps not as lasting as the battle pieces on the pyramids, will none the less immortalise those introduced in them.

Brady has shown more pluck than many of the officers and soldiers who were in the fight. He went – not exactly like the 'Sixty-Ninth,' stripped to the pants – but with his sleeves tucked up and his big camera directed upon every point of interest on the field. Some pretend, indeed, that it was the mysterious and formidable-looking instrument that produced the panic! The runaways, it is said, mistook it for the great steam gun discharging 500 balls a minute, and immediately took to their heels when they got within its focus! However this may be, it is certain that they did not get away from Brady as easily as they did from the enemy. He has fixed the cowards beyond the possibility of a doubt.

Foremost among them the observer will perhaps notice the well-known correspondent of the London *Times*;[1] the man who was celebrated for writing graphic letters when there was nobody to contradict him, but who had proved, by his correspondence from this country, that but little confidence can be placed in his accounts. See him as he flies for dear life, with his notes sticking out of his pockets, spurring his wretched-looking steed, his hat gone, and himself the picture of abject despair.

But joking aside, this collection is the most curious and interesting we have ever seen. The groupings of entire regiments and divisions, within a space of a couple of square feet, present some of the most curious effects as yet produced in photography. Considering the circumstances under which they were taken, amidst the excitement, the rapid movements, and the smoke of the battlefield, there is nothing to compare with them in their powerful contrasts of light and shade.[2]

John Thomson (1837–1921) is best known for his part in producing an extraordinary photographic series called *Street Life in London*, published in 1877. His is perhaps the first of such documentary photographs to appear in conjunction with a text (by Adolphe Smith), and is a direct descendant of Henry Mayhew's famous *London Labour and the London Poor* (1851–62). Mayhew himself had contemplated using photographs to illustrate his books but, because of certain drawbacks in the medium and the primitive reproduction techniques at the time, he used

1 'Doings of the Sunbeam', loc. cit.

1 The famous W. H. Russell of *The Times* who earlier had covered the Crimean War.
2 *Humphrey's Journal*, Vol. XII, 1861–2, cited in James D. Horan, *Mathew Brady: Historian with a Camera*, Crown, New York, 1955.

wood-engravings instead, though many of these were actually based on Daguerreotypes. Like Mayhew's text, that of Thomson and Smith is sensitive, sympathetic, and reproduces the fascinating palaver of the urban ghetto without any intention of ridiculing it:

London Nomades
The class of Nomades with which I propose to deal [in this instalment] makes some show of industry. These people attend fairs, markets, and hawk cheap ornaments or useful wares from door to door. At certain seasons this class 'works' regular wards, or sections of the city and suburbs. At other seasons its members migrate to the provinces, to engage in harvesting, hop-picking, or to attend fairs, where they figure as owners of 'Puff and Darts', 'Spin 'em rounds', and other games. Their movements, however, are so uncertain and erratic, as to render them generally unable to name a day when they will shift their camp to a new neighbourhood. Changes of locality with them, are partly caused by caprice, partly by necessity. At times sickness may drive them to seek change of air, or some trouble comes upon them, or a sentimental longing leads them to the green lanes, and budding hedge-rows of the country. As a rule, they are improvident, and, like most Nomades, unable to follow any intelligent plan of life. To them the future is almost as uncertain, and as far beyond their control, as the changes of wind and weather.

London gipsies proper are a distinct class, to which, however, many of the Nomades I am now describing are in some way allied. The traces of kinship may be noted in their appearance as well as in their mode of life, although some of them are as careful to disclaim what they deem a discreditable relationship as are the gipsies to boast of their purity of descent from old Romany stock.

The accompanying photograph, taken on a piece of vacant land at Battersea, represents a friendly group gathered around the caravan of William Hampton, a man who enjoys the reputation among his fellows, of being 'a fair-spoken, honest gentleman.' Nor has subsequent intercourse with the gentleman in question led me to suppose that his character has been unduly overrated. He had never enjoyed the privilege of education, but matured in total ignorance of the arts of reading and writing.

This I found to be the condition of many of his associates, and also of other families of hawkers which I have visited.

William Hampton is, for all that, a man of fair intelligence and good natural ability. But the lack of education other than that picked up in the streets and highways, has impressed upon him a stamp that reminded

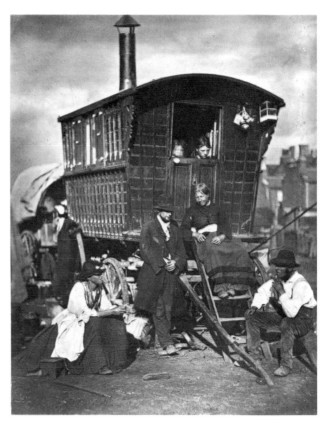

John Thomson: London Nomades, c. 1877. Woodburytype.

me of the Nomades who wander over the Mongolian steppes, drifting about with their flocks and herds, seeking the purest springs and greenest pastures.

He honestly owned his restless love of a roving life, and his inability to settle in any fixed spot. He also held that the progress of education was one of the most dangerous symptoms of the times, and spoke in a tone of deep regret of the manner in which decent children were forced now-a-days to go to school. 'Edication, sir! Why what do I want with edication? Edication to them what has it makes them wusser. They knows tricks what don't b'long to the nat'ral gent. That's my 'pinion. They knows a sight too much, they do! No offence, sir. There's good gents and kind'arted scholards, no doubt. But when a man is bad, and God knows most of us aint wery good, it makes him wuss. Any chaps of my acquaintance what knows how to write and count proper aint much to be trusted at a bargain.'

Happily this dread of education is not generally characteristic of the London poor, although, at the same time, it is shared by many men of the class of which William Hampton is a fair type.

While admitting that his conclusions were probably justified by his experience, I caused a diversion by presenting him with a photograph, which he gleefully

accepted. 'Bless ye!' he exclaimed, 'that's old Mary Pradd, sitting on the steps of the wan, wot was murdered in the Borough, middle of last month.'

This was a revelation so startling, that I at once determined to make myself acquainted with the particulars of the event.

Then follows a bizarre account (too lengthy to recount here) of the fortunes and misfortunes of Mary Pradd.

Thomson's travels in China with the camera afforded him the opportunity of making some unusual ethnological observations:

My design in the accompanying work is to present a series of pictures of China and its people, such as shall convey an accurate impression of the country I traversed as well as of the arts, usages, and manners which prevail in different provinces of the Empire. With this intention I made the camera the constant companion of my wanderings, and to it I am indebted for the faithful reproduction of the scenes I visited, and of the types of race with which I came into contact.

Those familiar with the Chinese and their deeply-rooted superstitions will readily understand that the carrying out of my task involved both difficulty and danger. In some places there were many who had never yet set eyes upon a pale-faced stranger; and the literati, or educated classes, had fostered a notion amongst such as these, that, while evil spirits of every kind were carefully to be shunned, none ought to be so strictly avoided as the 'Fan Qui' or 'Foreign Devil' who assumed human shape, and appeared solely for the furtherance of his own interests, often owing the success of his undertakings to an ocular power, which enabled him to discover the hidden treasures of heaven and earth. I therefore frequently enjoyed the reputation of being a dangerous geomancer, and my camera was held to be a dark mysterious instrument, which, combined with my naturally, or supernaturally, intensified eyesight gave me power to see through rocks and mountains, to pierce the very souls of the natives, and to produce miraculous pictures by some black art, which at the same time bereft the individual depicted of so much of the principle of life as to render his death a certainty within a very short period of years.

Accounted, for these reasons, the forerunner of death, I found portraits of children difficult to obtain, while, strange as it may be thought in a land where filial piety is esteemed the highest of virtues, sons and daughters brought their aged parents to be placed before the foreigner's silent and mysterious instrument of

destruction. The trifling sums that I paid for the privilege of taking such subjects would probably go to help in the purchase of a coffin, which, conveyed ceremoniously to the old man's house, would there be deposited to await the hour of dissolution, and the body of the parent whom his son had honoured with the gift. Let none of my readers suppose that I am speaking in jest. To such an extreme pitch has the notion of honouring ancestors with due mortuary rites been carried in China, that an affectionate parent would regard children who should present him with a cool and comfortable coffin as having begun in good time to display the duty and respect which every well-regulated son and daughter is expected to bestow.

The superstitious influences, such as I have described, rendered me a frequent object of mistrust, and led to my being stoned and roughly handled on more occasions than one. It is, however, in and about large cities that the wide-spread hatred of foreigners is most conspicuously displayed. In many of the country districts, and from officials who have been associated with Europeans, and who therefore appreciate the substantial benefits which foreign intercourse can confer, I have met with numerous tokens of kindness, and a hospitality as genuine as could be shown to a stranger in any part of the world.

It is a novel experiment to attempt to illustrate a book of travels with photographs, a few years back so perishable, and so difficult to reproduce. But the art is now so far advanced, that we can multiply the copies with the same facility, and print them with the same materials as in the case of woodcuts or engravings. I feel somewhat sanguine about the success of the undertaking, and I hope to see the process which I have thus applied adopted by other travellers; for the faithfulness of such pictures affords the nearest approach that can be made towards placing the reader actually before the scene which is represented.[1]

1 John Thomson, *China and its People*, London 1873. In the last paragraph he is referring to the Woodburytype – the process which was used to illustrate the book.

7.1 WOOD AND GIBSON: FEDERAL MORTAR BATTERY, YORKTOWN, VIRGINIA

7.2 TIMOTHY H. O'SULLIVAN: GENERAL ULYSSES S. GRANT'S COUNCIL OF WAR

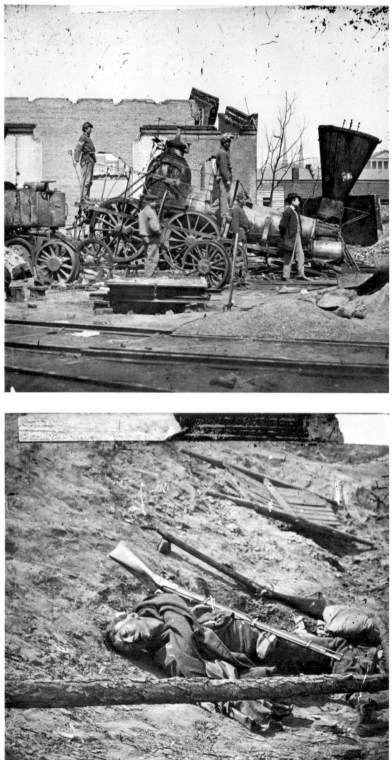

7.5 GALTON AND MOHAMED: AN INQUIRY INTO THE PHYSIOGNOMY OF PHTHISIS BY THE METHOD OF COMPOSITE PORTRAITURE'

7.6 PHOTOGRAPHIC DEPARTMENT, DR BARNARDO'S HOMES

7.7 D. O. HILL AND ROBERT ADAMSON: WOMAN WITH A GOITRE

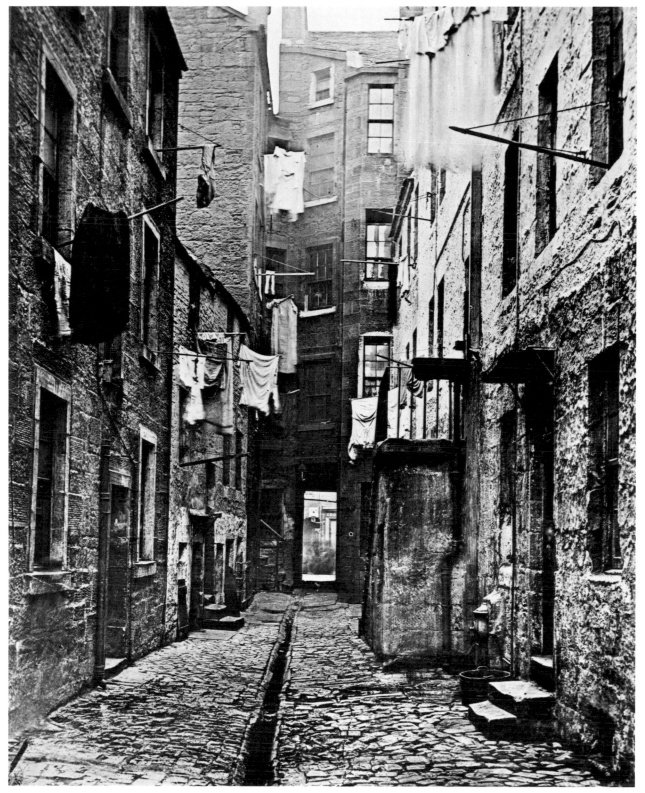

7.8 THOMAS ANNAN: 75 HIGH STREET, GLASGOW

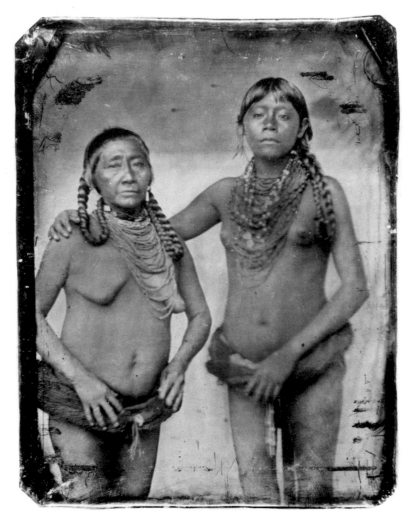

7.9 UNKNOWN PHOTOGRAPHER: TWO AMERINDIAN WOMEN

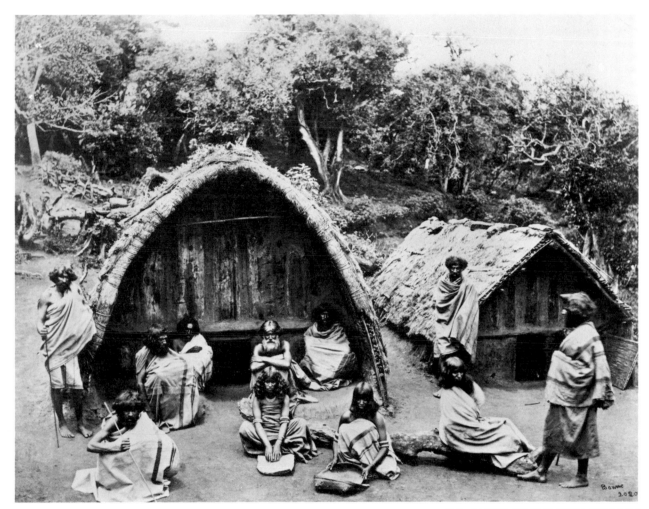

7.10 SAMUEL BOURNE: TODA VILLAGERS

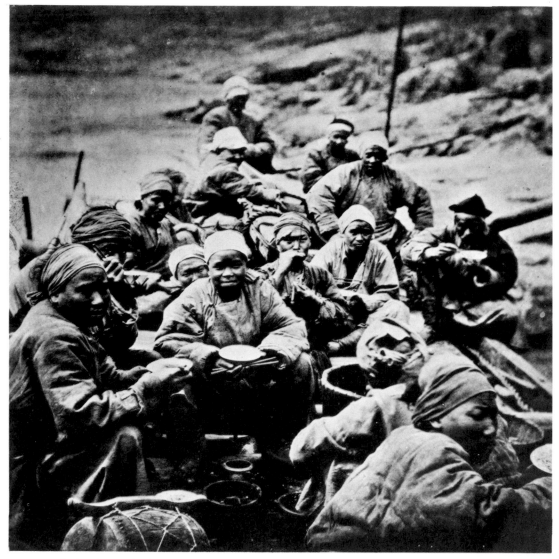

7.11 JOHN THOMSON: INTERIOR OF NATIVE TRAVELLING BOAT

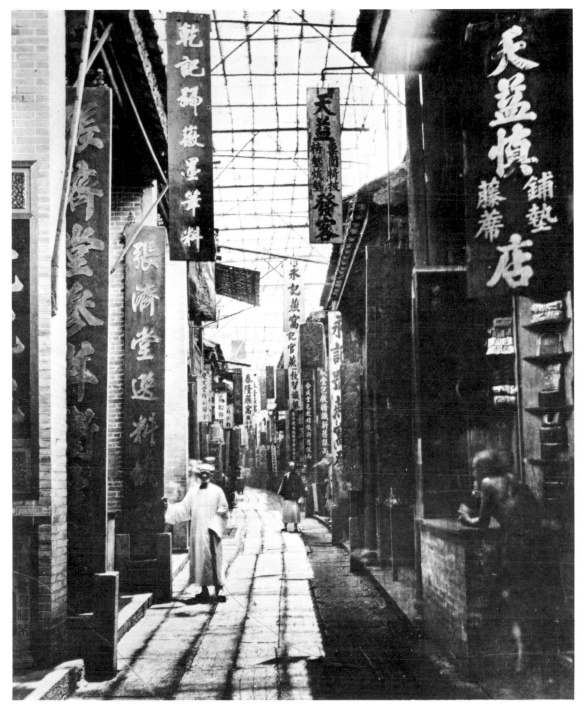

7.12 JOHN THOMSON: PHYSIC STREET, CANTON

ANIMAL LOCOMOTION

"...we have become so accustomed to see [the galloping horse] in art that it has imperceptibly dominated our understanding, and we think the representation to be unimpeachable, until we throw off all our preconceived impressions on one side, and seek the truth by independent observation from Nature herself."
 Eadweard Muybridge (1898)

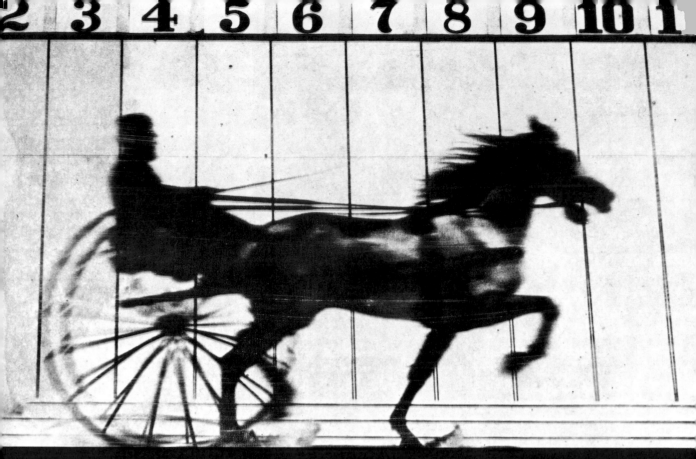

EADWEARD MUYBRIDGE: ABE EDGINGTON DRIVEN BY C. MARVIN

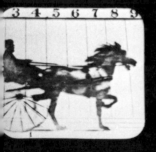 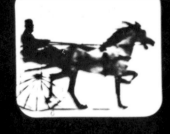 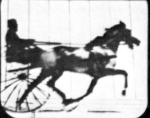 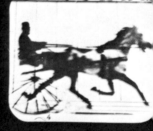

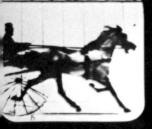 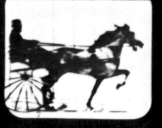 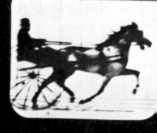

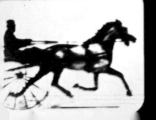 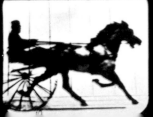 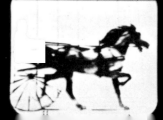 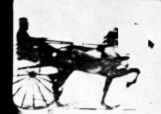

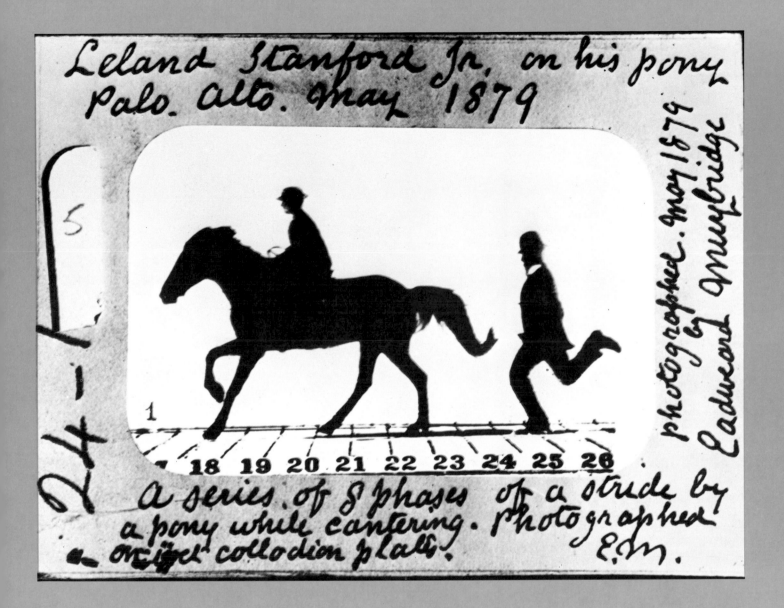

ANIMAL LOCOMOTION

In one of his many publications on animal locomotion deriving from his stupendous collection of sequential photographs produced by 1885, Eadweard Muybridge[1] (1830–1904) describes, at the end of the century, how his photographic procedures nearly led to the invention, not just of the 'movies', but of the 'talking picture' itself:

1 Eadweard Muybridge was born Edward James Muggeridge in Kingston-upon-Thames. After emigrating to America he produced several extensive series of stereo and other photographs of the Far West before being engaged by Leland Stanford, former Governor of California, to undertake the experiment in equestrian locomotion.

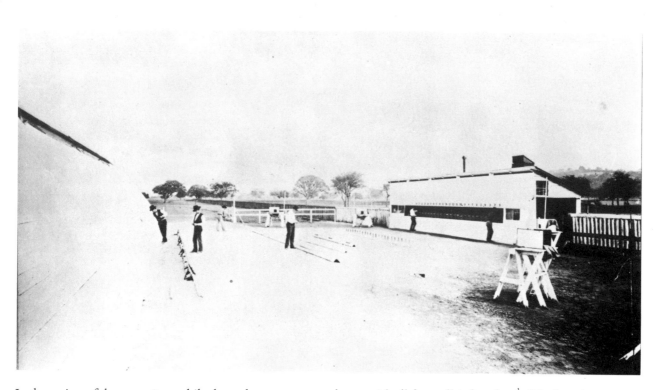

In the spring of the year 1872, while the author was directing the photographic surveys of the United States Government on the Pacific Coast, there was revived in the city of San Francisco a controversy in regard to animal locomotion . . . the principal subject of dispute was the possibility of a horse, while trotting – even at the height of his speed – having all four of his feet, at any portion of his stride, simultaneously free from contact with the ground.

The attention of the author was directed to this controversy, and he immediately resolved to attempt its settlement. The problem before him was, to obtain a sufficiently well-developed and contrasted image on a wet collodion plate, after an exposure of so brief a duration that a horse's foot, moving with a velocity of more than thirty yards [feet?] in a second of time, should be photographed with its outlines practically sharp . . .

Having constructed some special exposing apparatus, and bestowed more than usual care in the preparation of the materials he was accustomed to use for ordinarily quick work, the author commenced his investigation on the race-track at Sacramento, California, in May, 1872, where he in a few days made several negatives of a celebrated horse, named Occident, while trotting, laterally, in front of his camera, at rates of speed varying from two minutes and twenty-five seconds to two minutes and eighteen seconds per mile.

The photographs resulting from this experiment were sufficiently sharp to give a recognisable silhouette portrait of the driver, and some of them exhibited the

horse with all four of his feet clearly lifted, at the same time, above the surface of the ground . . .

Each of the photographs made at this time illustrated a more or less different phase of the trotting action. Selecting a number of these, the author endeavoured to arrange the consecutive phases of a complete stride; this, however, in consequence of the irregularity of their intervals, he was unable to satisfactorily accomplish.

It then occurred to him that a series of photographic images made in rapid succession at properly regulated intervals of time, or of distance, would definitely set at rest the many existing theories and conflicting opinions upon animal movements generally.

Having submitted his plans to Mr Leland Stanford, who owned a number of thorough-breds, and first-class trotting horses, the author secured that gentleman's cooperation for a continuance of the researches at his stock-farm – now the site of the University – at Palo Alto.

His official and other duties, requiring absences from the city on expeditions sometimes extending over several months at a time, prevented continuous attention to the investigation, but in the meanwhile he devised a system for obtaining a succession of automatic exposures at intervals of time, which could be regulated at discretion.

The apparatus used for this initiatory work included a motor-clock for making and breaking electric circuits, which is briefly described in the 'Proceedings of the Royal Institution of Great Britain,' March 13, 1882, and will be, with other arrangements, explained in detail further on.

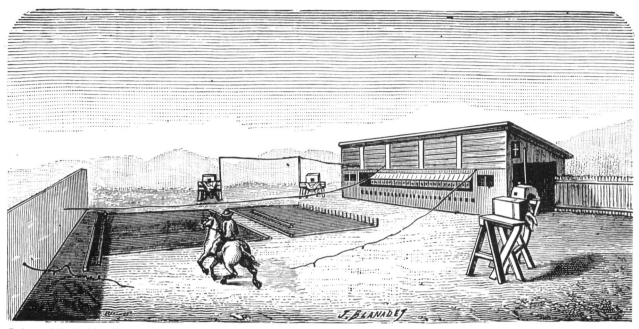

Eadweard Muybridge: General View of the Experimental Track, Palo Alto, 1879. Photo F from his 'Attitudes of Animals in Motion' (left) and track in use (above) from 'Photographie Animée' by Eugene Trutat, Paris, 1899.

Experiments were carried on from time to time as opportunity permitted; they were, however, principally for private or personal use, and it was not until 1878 that the results of any of them were published . . .

Each of the cameras used at this time had two lenses, and made stereoscopic pictures. Selecting from these stereographs a suitable number of phases to reconstitute a full stride, he placed the appropriate halves of each, respectively, in one of the scientific toys called the zoetrope, or the wheel of life an instrument originated by the Belgian physicist Plateau, to demonstrate the persistency of vision. These two zoetropes were geared, and caused to revolve at the same rate of speed; the respective halves of the stereographs were made simultaneously visible, by means of mirrors – arranged on the principle of Wheatstone's reflecting stereoscope – successively and intermittently, through the perforations in the cylinders of the instruments, with the result of a very satisfactory reproduction of an apparently solid miniature horse trotting, and of another galloping.

Pursuing this scheme, the author arranged, in the same consecutive order, on some glass discs, a number of equidistant phases of certain movements; each series, as before, illustrated one or more complete and recurring acts of motion, or a combination of them: for example, an athlete turning a somersault on horseback, while the animal was cantering; a horse making a few strides of the gallop, a leap over a hurdle, another few strides, another leap, and so on; or a group of galloping horses.

Suitable gearing of an apparatus constructed for the

purpose caused one of these glass discs, when attached to a central shaft, to revolve in front of the condensing lens of a projecting lantern, parallel with, and close to another disc fixed to a tubular shaft which encircled the other, and around which it rotated in the contrary direction . . .

To this instrument the author gave the name of Zoöpraxiscope; it is the first apparatus ever used, or constructed, for synthetically demonstrating movements analytically photographed from life, and in its resulting effects is the prototype of all the various instruments which, under a variety of names, are used for a similar purpose at the present day . . .

It may here be parenthetically remarked that on the 27th of February, 1888, the author, having contemplated some improvements of the zoöpraxiscope, consulted with Mr Thomas A. Edison as to the practicability of using that instrument in association with the phonograph so as to combine, and reproduce simultaneously, in the presence of an audience, visible actions and audible words. At that time the phonograph had not been adapted to reach the ears of a large audience, so the scheme was temporarily abandoned.[1]

Not unexpectedly, Muybridge's vast output of sequential photographs, showing humans and animals in each phase of every conceivable movement, were voraciously seized upon, especially by those artists for whom objective truth was a paramount condition in the creation of a

1 Eadweard Muybridge, Kingston-on-Thames, December 1898, published in *Animals in Motion*, London 1899.

work of art. Muybridge was well aware of the signifi-
cance his photographs would have in confounding the
perceptual conventions of art:

If it is impressed on our minds in infancy, that a certain
arbitrary symbol indicates an existing fact; if this same
association of emblem and reality is reiterated at the
preparatory school, insisted upon at college, and
pronounced correct at the university; symbol and fact –
or supposed fact – become so intimately blended that it
is extremely difficult to disassociate them, even when
reason and personal observation teaches us they have
no true relationship. So it is with the conventional
galloping horse; we have become so accustomed to see
it in art that it has imperceptibly dominated our
understanding, and we think the representation to be
unimpeachable, until we throw off all our preconceived
impressions on one side, and seek the truth by
independent observation from Nature herself.[1]

Muybridge's photographs were immediately seen, by the
great French physiologist and medical engineer, Etienne
Jules Marey (1830–1904), as the answer to his own
cumbersome and inconclusive graphic methods for re-
cording objects in motion. He wrote enthusiastically
about them to Gaston Tissandier, editor of the magazine,
La Nature:

18 December 1878

Dear Friend,
 I am impressed with Mr Muybridge's photographs
published in the issue before last of *La Nature*. Could
you put me in touch with the author? I would like his

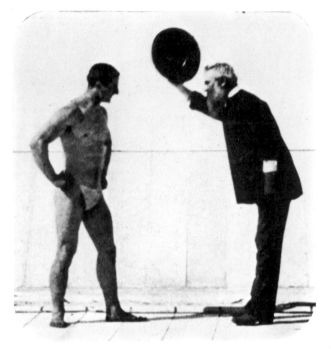

1 Eadweard Muybridge, Kingston-on-Thames, December 1898, pub-
 lished in *Animals in Motion*, London 1899.

Eadweard Muybridge greeting a member of the Olympic Club of
San Francisco, August 1879. From his 'Attitudes of Animals in
Motion', 1881.

Eadweard Muybridge: A woman throwing water, 1887. From
'Animal Locomotion', University of Pennsylvania, 1887.
Photogravure.

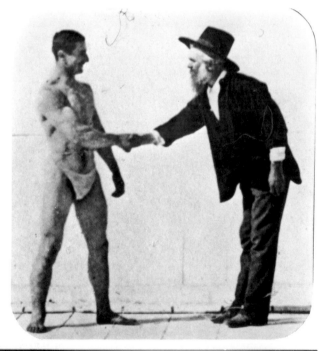

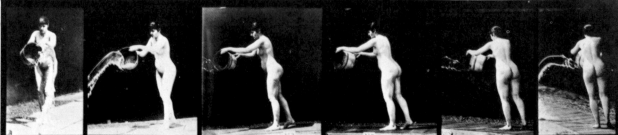

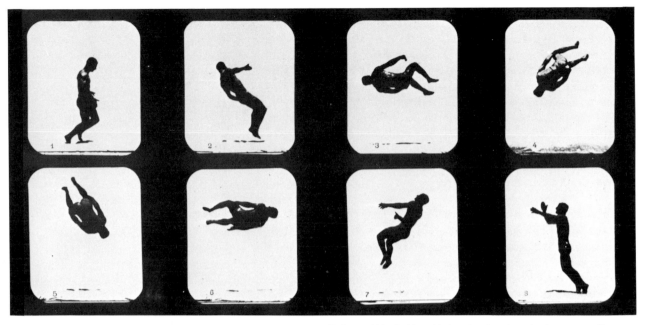

Eadweard Muybridge: Mr Lawton turning a back somersault, August 1879. From 'Attitudes of Animals in Motion', 1881.

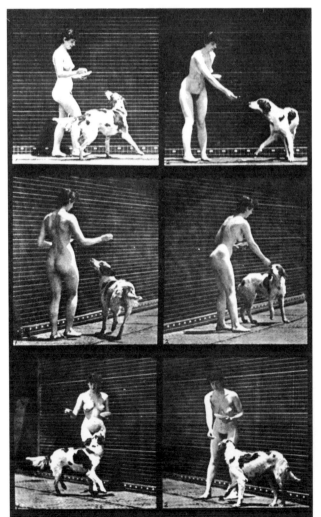

assistance in the solution of certain problems of physiology too difficult to resolve by other methods. For instance, on the question of birds in flight, I have devised a gun-like kind of photography ['*fusil photographique*'] for seizing the bird in an attitude, or better, in a series of attitudes which impart the successive phases of the wing's movement. Cailletet [Louis Cailletet, a French physicist] told me he had tried something analogous in the past with encouraging results. It would clearly be an easy experiment for Mr Muybridge. Then what beautiful zoetropes he could make. One could see all imaginable animals during their true movements; it would be animated zoology. So far as artists are concerned, it would create a revolution for them, since one would furnish them with true attitudes of movement; positions of the body during unstable balances in which a model would find it impossible to pose.

As you see, my dear friend, my enthusiasm is overflowing; please respond quickly. I'm behind you all the way.[1]

1 Cited and translated in *Eadweard Muybridge: The Stanford Years, 1872–1882*, Anita Ventura Mozley, Robert Bartlett Haas and Françoise Forster-Hahn, Stanford University Department of Art, 1972, revised 1973.

Eadweard Muybridge: Woman feeding a dog – from 3 different camera angles, from 'Animal Locomotion', 1887. Photogravure.

In 1881 Muybridge visited Paris where he was warmly received by artists and scientists, and where he consulted with Marey. By 1882 Marey had abandoned the earlier methods and gone over completely to his brilliant modifications of Muybridge's sequential-recording techniques. These he described as chronophotography. In the preface to his best known book, *Le Mouvement*, published in Paris in 1894, Marey describes the predominantly scientific usefulness of chronophotography, unaware that in the twentieth century those strange and beautiful images were to make a profound impression on the poetic sensitivities of a large number of artists:

The graphic method, with its various developments, has been of immense service to almost every branch of science, and consequently many improvements have of late been effected. Laborious statistics have been replaced by diagrams in which the variations of a curve express in a most striking manner the several phases of a patiently observed phenomenon, and, further, a recording apparatus which worked automatically can trace the curve of a physical or physiological event, which by reason of its slowness, its feebleness, or its rapidity, is otherwise inaccessible to observation. Sometimes, however, a curve which represents the phases of a phenomenon is found so misleading that another and more serviceable method, namely, that of chronophotography, has been invented. The development of these new methods of analysing movement could never have proceeded within the confined space of a physiological laboratory. For instance, in comparing the locomotion of various species of animals, it is essential that each should be studied under natural conditions: fish in fresh water or marine aquariums; insects in the open air; and man, quadrupeds, and birds in wide spaces in which their movements are unfettered.

The Physiological Station, endowed by the State and the City of Paris, has afforded in this respect unique opportunities, and there, with the new appliances, the following investigations have been for the most part carried out.

We shall see a variety of instances to what extent the older methods are applicable for the analysis of certain phenomena, and what progress has been achieved by chronophotography.

Each chapter is nothing more than an outline, for any attempt to fill in the details of any section would monopolise the time and attention of a trained specialist.

In a few instances such an attempt has been made, for geometricians, hydraulic engineers, naval and military men as well as artists have all had recourse to this method, and at last naturalists have interested themselves in the

matter. It is more especially to this latter class that we dedicate our work, since it appeals to their particular ambition, namely, that of discovering among the phenomena of life something that has hitherto escaped the most attentive observation.[1]

The great interest in sequential photography generated by Muybridge, and then Marey, was inevitably, it seems, to lead to the perfection, or even the invention, of the cinematograph. The crucial conditions were established not so much as an extension of Marey's chronophotographs on fixed plates, poetically evocative though those images were, but as a result of his concern with chronophotography on moving plates. Marey is universally credited with being among the foremost pioneers in the invention of both the modern cine-camera and projector – if not the originator. The two essential ingredients in the cinematic apparatus were roll film and a means for interrupting momentarily, each film frame. I reproduce here extracts from Marey's discussion in *Le Mouvement*, called 'Principles of Chronophotography on Moving Plates':

The weak point of the photographic gun was principally that the images were taken on a glass plate, the weight

1 Op. cit.

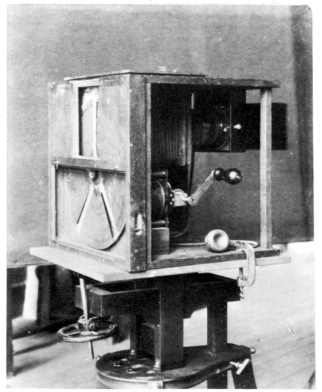

Dr E. J. Marey: Chronophotographic Camera of the early 1880s

Dr E. J. Marey: Man smoking – twenty-one images on a circular plate similar to that used in the photographic gun, c. 1880

of which was exceedingly great. The inertia of such a mass, which continually had to be set in motion and brought to rest, necessarily limited the number of images. The maximum was 12 in the second, and these had to be very small, or else they would have required a disc of larger surface, and consequently of too large a mass.

These difficulties may be overcome by substituting for the glass disc, a continuous film very slightly coated with gelatine and bromide of silver. The film can be made to pass automatically with a rectilinear movement across the focus of the lens, come to rest at each period of exposure, and again advance with a jerk. A series of photographs of fair size can be taken in this way.

The size we chose was 9 centimetres square, exactly the right size to fit the enlarging camera, and by which they could be magnified to convenient proportions. Now, as the continuous film might be several metres

Dr E. J. Marey: Man in a black suit with white stripe down side (left) and the chronophotographic image formed with him walking when photographed against a black wall (above), c. 1884

Dr E. J. Marey: Photographic gun. Devised for photographing birds in flight. When the trigger was pressed, a sensitised glass-plate was rapidly circulated. The inertia of such a heavy object prevented him from taking more than twelve exposures in the time available. The man smoking, a slower moving subject (page 131), has twenty-one images on the plate.

Diagram from 'Photographie Animée' of loading of chronophotographic camera showing lacing of continuous film strip with intermittent action.

in length, the number of photographs that could be taken was practically unlimited.

The necessary elements for taking successive images on a continuous film are united, as we have said, in the apparatus already known to the reader. The back part of this apparatus has a special compartment, the photographic chamber, in which the sensitised film is carried. To admit light, all that is necessary is to substitute for the frame which carried the fixed plate another frame provided with an aperture, the size of which can be varied at pleasure. This is the admission shutter. At each illumination the light passes through

Dr E. J. Marey: Chronophotographic plate showing phases in the movement of a flexible cane. The figure seems to be Marey himself, c. 1884.

this aperture and forms an image on the moving film, which has previously been brought into focus.

The film unrolls itself by a series of intermittent movements, by means of a special mechanical arrangement, which enables it to pass from one bobbin to another . . .

A crank placed behind the chronophotographic apparatus turns all the wheels of the instrument, as well as the circular diaphragms. A movement, so rapid as this must necessarily be, is bound to be continuous, for it would be impossible, as in the case of the photographic gun, to remit or continue the movement of such heavy bodies. The film itself comes to rest at the moment of exposure, arrested by a special mechanism which allows it to continue its movement as soon as the image has been taken . . .

When the chronophotographic apparatus is pointed at the object the movements of which are to be studied, the wheels are put in motion by turning a crank, the different parts acquire a uniform speed, but the film remains stationary until the moment when the observed phenomenon takes place. At this juncture the operator presses the trigger, the film begins to move, and the photographs are taken as long as the pressure is maintained on the trigger; as soon as the pressure is remitted the progress of the film is arrested. The employment of this trigger makes it possible to continue taking photographs until the bobbin is exhausted.

Marey finishes his book with a chapter entitled 'Synthetic Reconstruction of the Elements of an Analysed Movement'. The text amounts to a summary description of a few pre-cinematic techniques, precursors of his own inventions. The chapter ends with a brief description of

Marey's 'Chronophotographic Projector' which he sees mainly as an 'analysing apparatus', an aid to physiological studies. A whole era of scientific investigation into human and animal locomotion seems to draw to a close with the end of the book; a new one to begin. Marey's last words, the matter-of-fact deliberations of a scientist totally preoccupied with his experiment, seem blissfully unaware of the significance of his chronophotographic machines, and of the great changes likely to come in a cinema conscious world. For him chronophotography was a means of analysing, not simulating, movement:

We have therefore constructed a special apparatus, in which an endless length [loop] of film containing forty or sixty figures, or even more, is allowed to pass without cessation under the field of the objective [the lens].

The illumination, which is from behind, and consists either of the electric light or the sun itself, projects these figures upon a screen. This instrument produces very bright images, but it is noisy, and the projected figures do not appear as absolutely motionless[1] as one could wish.

Having arrived at this point in our researches, we learned that our mechanic had discovered an immediate solution of this problem, and by quite a different method; we shall therefore desist from our present account pending further investigations.

1 i.e. the frames flicker, hence 'flicks'.

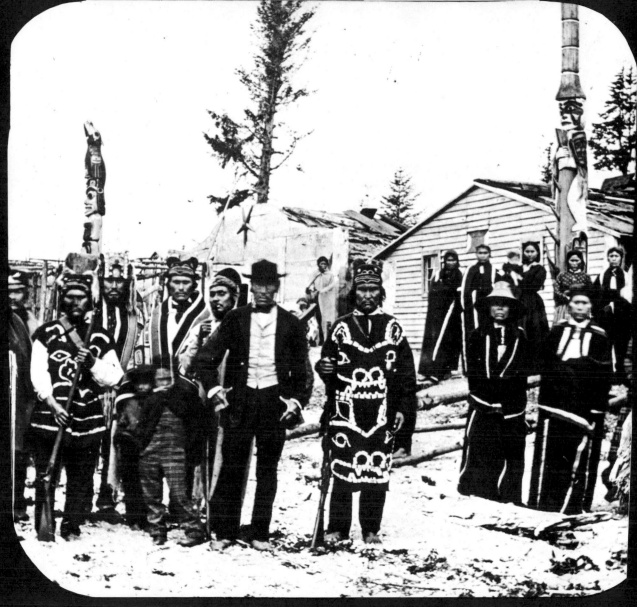

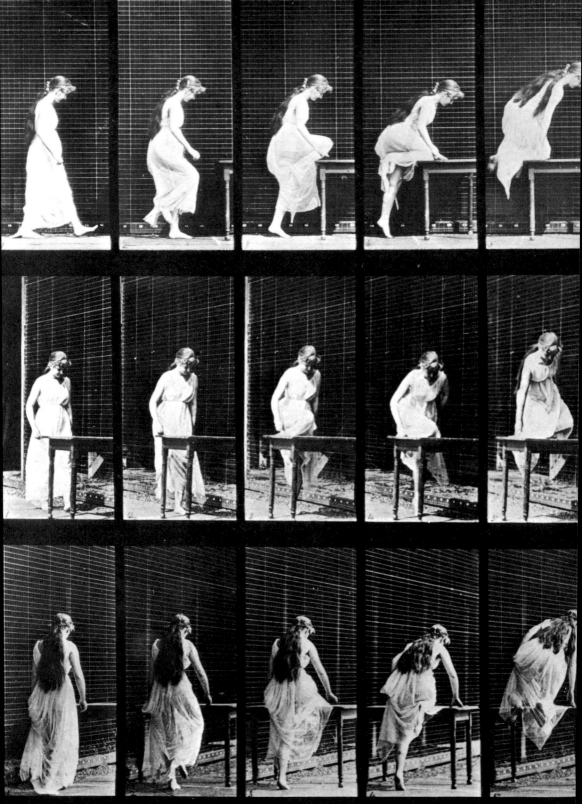

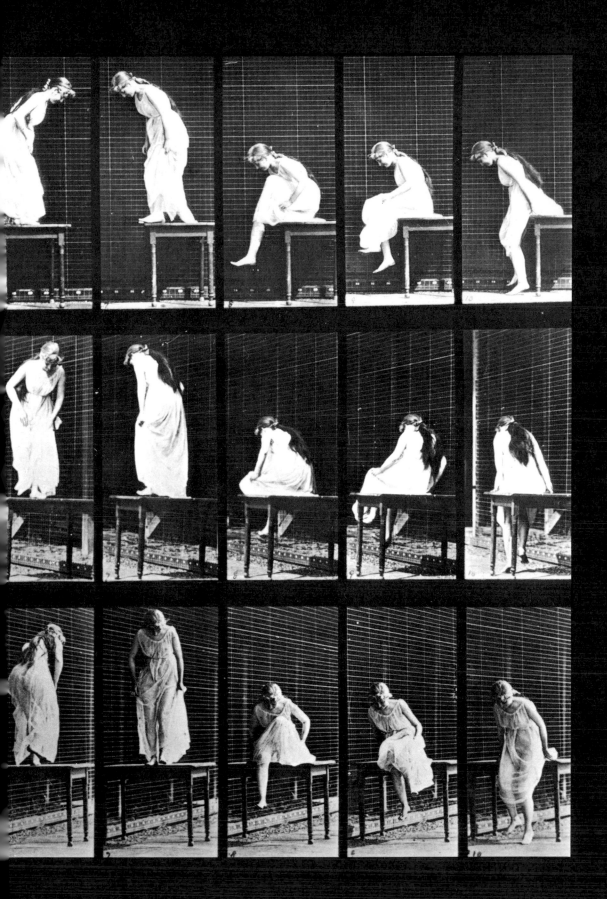

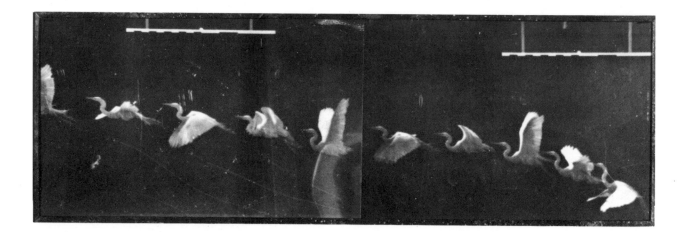

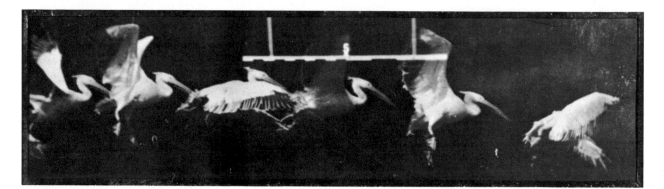

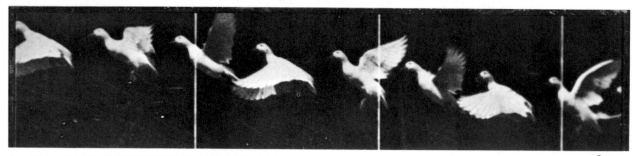

8.4 DR E. J. MAREY: CHRONOPHOTOGRAPHIC PICTURES OF BIRDS IN FLIGHT

8.5 DR E. J. MAREY: AERODYNAMIC STUDIES USING SMOKE FILAMENTS

CAMERA WORK

"My own camera is of the simplest pattern and has never left me in the lurch, although it has had some very tough handling in wind and storm...a shutter working at a speed of one-fourth to one-twenty-fifth of a second will answer all purposes. Microscopic sharpness is of no pictorial value."

Alfred Stieglitz (1897)

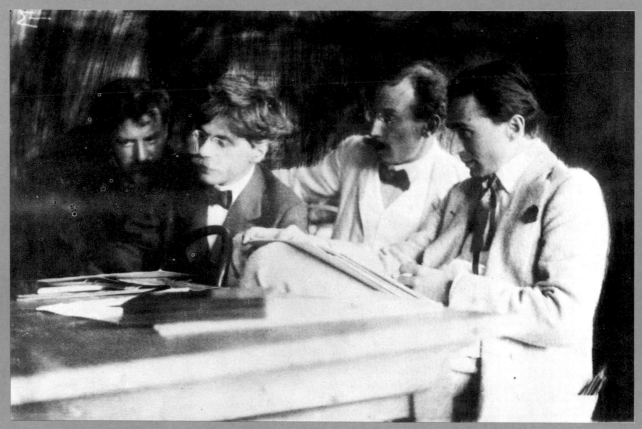

FRANK EUGENE: GROUP (LEFT TO RIGHT) WITH HIMSELF, ALFRED STIEGLITZ, HEINRICH KÜHN AND EDWARD STEICHEN

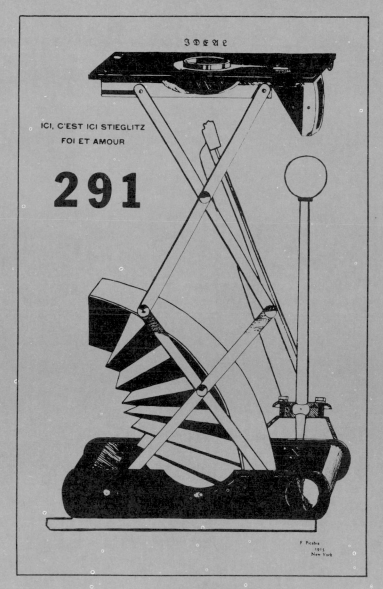

IDEAL

ICI, C'EST ICI STIEGLITZ
FOI ET AMOUR

291

F. Picabia
1915
New York

FRANCIS PICABIA: PORTRAIT OF ALFRED STIEGLITZ

CAMERA WORK

As in the other visual arts towards the end of the century, a great stirring was felt in photography too. For the first time since its inception photographers banded together, not with the complaisance of clubs or photographic societies, but in the spirit of protest with its accompanying sense of outrage and ritual denouncement of all photography which merely tailed after painting. The 'Linked Ring', founded in 1893, engendered 'Photo-Secession', which formed in 1902. The names themselves of these embattled cadres are testimonies of aesthetic camera-

deries forged under the banner of artistic progress. As with Post-Impressionist painting, this union was based not on stylistic similarities but on an opposition to all earlier conventions. Furthermore, these movements were international and thus, as in the other arts, imparted that necessary confirmation of importance so useful in sustaining rebellious convictions.

Studio magazine (London), an extremely important journal concerned with design and the visual arts, and intelligently edited by Charles Holme, published a sumptuously illustrated special number in the summer of 1905 called *Art in Photography*. The following are excerpts from its texts:

Without the natural gift of artistic expression, all the art knowledge in the world will, in nine cases out of ten, when applied to photography prove futile . . .

Innovators have always been terrible to the man in the street. But in art, as in other walks of life, frequently it is not possible to attain a hearing or attract attention to even serious developments without some beating of drums. Another point. Extremists who have let their discoveries in pictorial work run wild, have, nevertheless, often served a useful purpose by challenging antipathetic and severe criticism. Art lives and advances by criticism of the right sort, and much that is valuable in present-day methods of photography has resulted from what has at first been too noisy a revolt from the conventions . . .

It is now, indeed, possible to tell a photograph by almost any leading and well-known worker at a glance, to distinguish the style as easily as to tell a Sargent, a Brangwyn, a Wilson Steer, an Orchardson, a Le Sidaner or an Emile Claus. This fact not only lends dignity to the works themselves, but also forms the strongest possible argument that Photography, like all arts, is evolutionary, and in a word – is an art . . . The limitations of photography as regards the rendering of colour, and the fact that the elimination of the superfluous is not easy of accomplishment, prevent it, at all events at present, being considered on the same plane as painting, or gaining its chief successes in a similar way or by identical methods. In the case of both landscape and portraiture it has been found over and over again that to succumb to the ruse of excessive diffusion of focus and flat low tones in the hope that the resultant photograph may be considered to have been evolved by the same methods as a modern painting by a member of the 'impressionist' school, is but to court ridicule by artists, and invite the stigma of failure at the hands of the less educated.[1]

1 Clive Holland, 'Artistic Photography in Great Britain', op. cit.

The growth of artistic photography in the United States has corresponded in point of time with a remarkable development of American painting, and in no slight measure has been influenced by it . . .

In the early days of the glycerine and gum-bichromate processes, one or two [photographers] were temporarily infatuated by the ease with which they could reproduce the effects of other mediums; but a spirit at once more scientific and more artistic has prevailed; and to-day those photographers who have gone furthest in the pictorial direction are the most jealous supporters of the integrity and independence of their craft.[1]

Less hampered by convention than their *confrères* on the other side of the Channel, much of the best work of the French masters in the art of photography has shown a variety and daring of subject debarred to even the leaders of the English school save as exercises for their own personal gratification. In no particular has the difference of, shall we say convention? been more apparent than in the treatment of sacred subjects, and that of the nude.[2]

Writing in the same publication on pictorial photography in Austria and Germany, the well-known photographer A. Horsley Hinton establishes the fact that it was in Vienna, about 1891, that the first major step was taken in the subsequent appearance of secessionist movements in photography. Hinton, too, is suspicious of the facility with which new, manipulative, photographic techniques can be made to effect the appearance of a genuine work of art but which is essentially superficial. But it is not the fault of the medium he insists:

In England, as in Germany, and in other countries there are some artists and innumerable dilettanti who occupy themselves with pictorial photography, but it should be the aim of all, for the sake of photography, to separate art photography from amateur photography . . .

In the presence of a Gum Bichromate print, where there is abundant evidence of brush development, one often hears it asked, 'Why did not this man paint his picture at first-hand?' The answer is quite simple. 'Because he could not'. There are men who possess a fine artistic perception and knowledge but entirely lack the manipulative skill with either pencil or brush. Photography relieves them of the necessity of acquiring the latter, and in such a process as that now referred to furnishes a medium of personal expression.

1 Charles H. Caffin, 'The Development of Photography in the United States', op. cit.
2 Clive Holland, 'Some Notes upon the Pictorial School and its Leaders in France,' op. cit.

Hinton then supplies us with a lucid description of the much vaunted and much abused gum bichromate process which is well worth reproducing here:

In connection with this mention of the Gum Bichromate process, one may perhaps make brief reference to the not uncommon erroneous notion that the Gum Bichromate worker strives to imitate the effects produced in painting, and that being hand-work it is not legitimate photography – an error arising chiefly from ignorance of how the print is produced. Paper is coated with a mucilage of gum arabic and the desired pigment, and is made light-sensitive by the addition of potassium bichromate, this sensitiveness being shown by the pigment and gum becoming more or less insoluble in proportion as the light has access to it. The paper thus prepared is exposed to daylight under a photographic negative which, being opaque or partly so in those places which should be light in the ultimate picture and relatively transparent where the picture's shadows will be, respectively intercepts and permits the action of the light. No image is visible as the direct result of printing, but the exposed preparation is submitted to the action of water and the film or plaster lightly worked upon with brush or sponge or jet of water, so as to disengage and remove such portions which, having been shielded from the light, are still soluble. But the parts rendered insoluble are not entirely so, and should the photographer desire this or that tone somewhat lighter than the photographic negative has made it, the brush or whatever implement is employed can be used to tease the pigment away from its support in what manner and to such degree as his judgment may direct. Thus we may have brush marks not because the photographer has tried to imitate the brush marks of a painting, but because if they help him to realise his effect they are a legitimate part of his process.[1]

The sixty-year-old polemic about photography's status as an art had now, around the turn of the century, reached a shrill pitch. And we may well suppose that the coincidence of this aesthetic fervour among photographers with the equally vehement declarations of painters and sculptors proclaiming the virtues of art over nature, of art above beauty even, of art for art's sake, was more than merely fortuitous. This radicalism in the photographic arts hardly masks an uneasiness about the availability by that time of the photographic medium to the populace at large. Then, too, the phenomenal growth of cinematography and its obvious relation to still photo-

graphy was bound to have its effect. There were, to be sure, other more obscure, but no less important, social and aesthetic reasons which helped to promote such a great disdain for the mechanically executed work of art and the concomitant apotheosis of human intervention. And with an unparalleled contempt for the trivial, in art as well as in life, the idea of an aesthetic élite producing an exalted art inevitably grew.

And yet the same photographic technology which made it possible for the ordinary man to take up the camera, created the conditions which gave pictorialists the means to manipulate the image. Here is an extract from an essay by Robert Demachy, one of the leading theorists and practitioners of artistic photography in the period. Demachy indignantly and relentlessly echoes the declamations of painters and sculptors. And the perpetrators of the commonplace in reportage and documentary photography, like the descriptive painters of narrative subjects, are pejoratively excommunicated as 'straight' photographers:

On the Straight Print
The old war between straight photography and the other one – call it as you like – has begun over again. It is not, as it ought to be, a question of principle. No, it has become a personal question amongst a good many photographers, because most of them, and especially those who take purely documentary photographs, look to being recognised as artists. It follows that any definition of art that does not fit in with their methods will be violently attacked because the recognition of such a definition would limit pictorial photography to a certain number of men instead of throwing open the doors of the temple to the vast horde of camera carriers . . . for though I believe firmly that a work of art can be evolved under certain circumstances, I am equally convinced that these same circumstances will not perforce engender a work of art. Meddling with a gum print may or may not add the vital spark, though without the meddling there will surely be no spark whatever . . . A straight print may be beautiful, and it may prove superabundantly that its author is an artist; but it cannot be a work of art . . . Now, speaking of graphic methods only, what are the distinctive qualities of a work of art? A work of art must be a transcription, not a copy, of nature. The beauty of the motive in nature has nothing to do with the quality that makes a work of art. This special quality is given by the artist's way of expressing himself. In other words, there is not a particle of art in the most beautiful scene of nature. The art is man's alone, it is subjective not objective. If a man slavishly copies nature, no matter if it is with hand and pencil or through a photographic lens, he may be a

supreme artist all the while, but that particular work of his cannot be called a work of art.

I have so often heard the terms 'artistic' and 'beautiful' employed as if they were synonymous that I believe it is necessary to insist on the radical difference between their meanings. Quite lately I have read in the course of an interesting article on American pictorial photography the following paragraph: 'In nature there is the beautiful, the commonplace and the ugly, and he who has the insight to recognise the one from the other and the cunning to separate and transfix only the beautiful, is the artist.' This would induce us to believe that when Rembrandt painted the 'Lesson in Anatomy' he proved himself no artist. Is there anything uglier in nature than a greenish, half-disemboweled corpse; or anything more commonplace than a score of men dressed in black standing round a table? Nevertheless, the result of this combination of the ugly and the commonplace is one of the greatest masterpieces in painting. Because the artist intervened . . .

Let us change the circumstances and take as an example a beautiful motive such as a sunset. Do you think that Turner's sunsets existed in nature such as he painted them? Do you think that if he had painted them as they were, and not as he felt them, he would have left a name as an artist?

Not once but many times have I heard it said that the choice of the motive is sufficient to turn an otherwise mechanically produced positive into a work of art. This is not true; what is true is that a carefully chosen motive (beautiful, ugly or commonplace, but well composed and properly lighted) is necessary in the subsequent evolution towards art. It is not the same thing. No, you cannot escape the consequences of the mere copying of nature. A copyist may be an artist but his copy is not a work of art; the more accurate it is, the worse art it will be. Please do not unearth the old story about Zeuxis and Apelles, when the bird and then the painter were taken in. I have no faith in sparrows as art critics and I think the mistake of the painter was an insult to his brother artist.

The result of all this argument will be that I shall be taxed with having said that all unmodified prints are detestable productions, fit for the wastepaper basket, and that before locally developed platinotype, gum bichromate, ozotype and oils, there were no artists to be found amongst photographers. I deny all this. I have seen many straight prints that were beautiful and that gave evidence of the artistic nature of their authors, without being, in my private opinion, works of art. For a work of art is a big thing. I have also seen so-called straight prints that struck me as works of art, so much so that I immediately asked for some technical details

about their genesis, and found to my intimate satisfaction that they were not straight prints at all. I have seen brush-developed, multi-modified gum prints that were worse – immeasurably worse – than the vilest tintype in existence, and I have seen and have in my possession straight prints by Miss Cameron and by Salomon, one of our first professionals, just after Daguerre's time, that are undoubtedly the work of artists . . . The conclusion is simple enough, for there is no middle course between the mechanical copy of nature and the personal transcription of nature. The law is there; but there is no sanction to it, and the button-pressers will continue to extol the purity of their intentions and to make a virtue of their incapacity to correct and modify their mechanical copies. And too many pictorialists will meddle with their prints in the fond belief that any alteration, however bungling, is the touchstone of art . . .

Before ending I cannot but confess my astonishment at the necessity of such a profession of faith as the one I have been making. Pictorial photography owes its birth to the universal dissatisfaction of artist photographers in front of the photographic errors of the straight print. Its false values, its lack of accents, its equal delineation of things important and useless, were universally recognised and deplored by a host of malcontents. There was a general cry towards liberty of treatment and liberty of correction. Glycerine-developed platinotype and gum bichromate were soon after hailed with enthusiasm as liberators; today the oil process opens outer and inner doors to personal treatment. And yet, after all this outcry against old-fashioned and narrow-minded methods, after this thankful acceptance of new ones, the men who fought for new ideas are now fighting for old errors. That documentary photographers should hold up the straight print as a model is but natural, they will continue doing so *in æternum* for various personal reasons; but that men like A and B should extol the virtues of mechanical photography *as an art process*, I cannot understand.[1]

Demachy was no doubt referring to Alfred Stieglitz and his followers in New York. Stieglitz had published, from 1897 to 1902, the hard-hitting *Camera Notes*, and he writes in retrospect that it was 'a battlefield as well as a bugle call'. He recalls with glee the intercontinental dimensions of photographic hostilities at the beginning of the century, when he was instrumental in establishing the American version of Photo-Secession, with its head-quarters in the famous New York gallery '291', and at the same time publishing the exceedingly important

1 Robert Demachy, 'On the Straight Print', *Camera Work*, No. 18–19, 1907.

magazine, *Camera Work*, which ran from 1903 to 1917.

Inevitably, the divisions among pictorialists reflect a similar fragmentation in the other arts, and it seems quite in order that the fiery and bellicose Stieglitz should now hold out for an uncompromising and straightforward photography in which the *intrinsic* features of its imagery would provide a sufficiently versatile vocabulary of form to supersede the manufactured niceties of self-consciously creative photographers. The indomitable Stieglitz consequently took an unheard of step in going over to the ordinary, hand-held camera in the 1890s. That was not merely a testimony to his daring, but an expression of faith in the medium and in his own abilities as an artist. Stieglitz understood well that with such an instrument the profound workings of the creative mind may be instantaneously obeyed. Spontaneity was too valuable a gift to fritter away on complicated contraptions and ponderous methods:

Each worker will have his own idea as to which style of camera comes nearest to perfection in this respect, and having made his choice he should study to become so intimate with it that it will become a second nature with his hands to prepare the camera while his mind and eyes are fully occupied with the subject before him ... The writer does not approve of complicated mechanisms, as they are sure to get out of order at important moments, thus causing considerable unnecessary swearing, and often the loss of a precious opportunity. My own camera is of the simplest pattern and has never left me in the lurch, although it has had some very tough handling in wind and storm ... a shutter working at a speed of one-fourth to one-twenty-fifth of a second will answer all purposes. Microscopic sharpness is of no pictorial value. A little blur in a moving subject will often aid in giving the impression of action and motion ... In order to obtain pictures by means of the hand camera it is well to choose your subject, regardless of figures, and carefully study the lines and lighting. After having determined upon these watch the passing figures and await the moment in which everything is in balance; that is, satisfies your eye. This often means hours of patient waiting. My picture, 'Fifth Avenue, Winter,' is the result of a three hours' stand during a fierce snow-storm on February 22nd, 1893, awaiting the proper moment. My patience was duly rewarded. Of course, the result contained an element of chance, as I might have stood there for hours without succeeding in getting the desired picture.[1]

The fountainhead of secessionist movements in photography at the beginning of this century was no doubt Stieglitz's 'Little Galleries of the Photo-Secession', later called '291', its address in Fifth Avenue, New York. Inaugurated in 1905, not only were photographs from international contributors shown there, but the 'Little Galleries' held some of the most important exhibitions in the early history of modern art in the twentieth century. Matisse had his first exhibition in the US there. The galleries introduced Rodin to an American public through his drawings. Manet and other Impressionists were given shows; Cézanne and Toulouse-Lautrec also. Picasso and Braque, Brancusi, Gino Severini, and the modern primitive Henri Rousseau contributed to the exhibitions of the Photo-Secessionists between 1911 and 1914. All the secessionists at the time in American art were represented there: John Marin, Marsden Hartley, Georgia O'Keeffe, Stanton Macdonald-Wright among them. And the photographers belonging to the group included Alvin Langdon Coburn, Frank Eugene, Clarence White and, of course, Stieglitz and Eduard Steichen.

To a considerable extent twentieth-century America was introduced to the photographic might of Hill and Adamson when, in 1906 their works appeared in the Secession galleries in an exhibition of British photographers which included Frederick Evans and J. Craig Annan. And Hill and Adamson were not without influence on the appreciative American photographers. The whole list reads like a roll-call of the 'Greats' in modern art. The Little Galleries also pioneered exhibitions of Negro sculpture, Japanese prints and even works by children. All this in those small and modest rooms at 291 Fifth Avenue. *Camera Work* provides us with a literally colourful description of the gallery:

... One of the larger rooms is kept in dull olive tones, the burlap wall-covering being a warm olive gray; the woodwork and moldings similar in general color, but considerably darker. The hangings are of an olive-sepia sateen, and the ceiling and canopy are of a very deep creamy gray. The small room is designed especially to show prints on very light mounts or in white frames. The walls of this room are covered with a bleached natural burlap; the woodwork and molding are pure white; the hangings, a dull ecru. The third room is decorated in gray-blue, dull salmon, and olive-gray. In all the rooms the lampshades match the wall-coverings.[1]

George Bernard Shaw was an ebullient photographic enthusiast. His own photographs were nothing special,

1 Extracted from Stieglitz, 'The Hand Camera – its Present Importance', *The American Annual of Photography*, 1897. Reprinted in *Photographers on Photography*, ed. Nathan Lyons, Prentice-Hall, 1966.

1 Op. cit., No. 14, April 1906.

and his lofty utterances about photography and the death of art made up in bombast what they lacked in perception. Nevertheless, Shaw was very important in galvanising the photo-pictorialists of the time, confirming in them a greater sense of their own importance. In a letter to Alvin Langdon Coburn, sent from the Hotel Palais d'Orsay in Paris on 17 April 1906, Shaw wrote:

Come along any time you like.

Rodin, seeing that I had a camera, invited me to photograph his place if I liked. I took the opportunity to press your claims, and he said certainly. I guaranteed you a good workman. The sculpting sittings are at Meudon 25 minutes train from Paris, where he has a lot of beautiful things. No photograph yet taken has touched him. Steichen was right to give him up and silhouette him. He is by a million chalks the biggest man you ever saw; all your other sitters are only fit to make gelatin to emulsify for his negative.

G.B.S.[1]

And to Archibald Henderson, from Hafod y Llanbedr, 29 July 1907:

My dear Henderson,

You must restrain your enthusiasm for photogravure, unless you propose to issue a Bernard Shaw album at $25. Each photogravure has to be separately printed on separate paper at a cost of about two-pence. The three in Three Plays for Puritans knock about sixpence a copy off the profits, and probably don't increase the sales a bit.

I am glad you like Coburn. He is a specially white youth, and, on the whole, the best photographer in the world. He is quite right in saying that he could do no better with the Rodin than he has already done. You see, that was what he meant to do, and if you don't like it (says Master Alvin) there is always the trade photographer to fall back on. He is quite an eligible subject for an article. He has carried photography clean beyond the Käsebier-Stieglitz boom. The best workman that movement produced was, perhaps, Demachy; but Demachy does not aim at making an art of photography, but at producing the effects of the painters – notably the Barbizon School and the Impressionists – by photographic methods and artistic manipulation of the print. Mrs Käsebier's work is most charming, her lucky negatives are first rate, but though she knew what to try for, and valued it when she got it, she had to make merits of glaring deficiencies in the photographic process, and use her power of appeal to the imagination to

make us swallow huge blotches of shadow which were not merely under-exposed but actually not effectively photographed at all. Coburn, though even he cannot get the whole scale of natural light out of his plates (or rather his Christoid films) any more than Turner could get it out of his paints, nevertheless never exhibits a print that does not owe much of its value to great skill in developing and printing, or that is not an artistic photograph sui generis, and not an imitation of Corot landscape, or a charcoal drawing. I consider that the only living photographer within London ken who has kept pace with him technically is Baron de Meyer. When his work and de Meyer's appeared in London with a miscellaneous collection of the masterpieces of the Stieglitz boom, these latter were visibly beaten hollow: some which delighted us all a few years ago, now proclaimed themselves simply as Straight Prints from Spoiled Negatives. In Short, Coburn is a good workman, and whenever his work does not please you, watch and pray for a while and you will find that your opinion will change.

Haven't seen any of Steichen's results except the color plate which you saw . . .

G.B.S.

1 George Bernard Shaw. Collected Letters 1898–1910. Ed. Daniel H. Laurence. Max Reinhardt 1972.

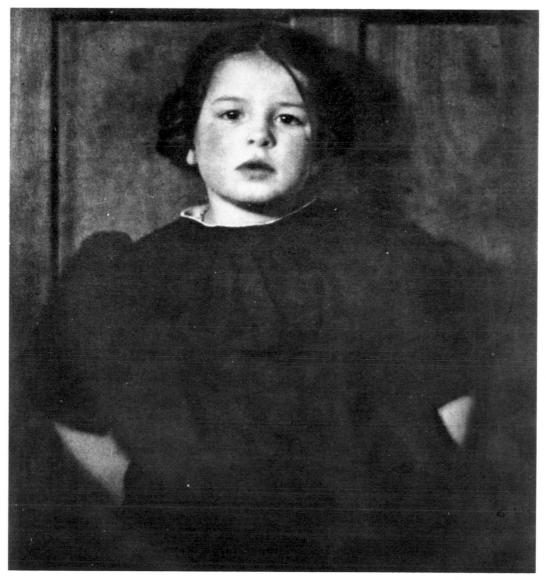

9.1 HEINRICH KÜHN: SMALL GIRL

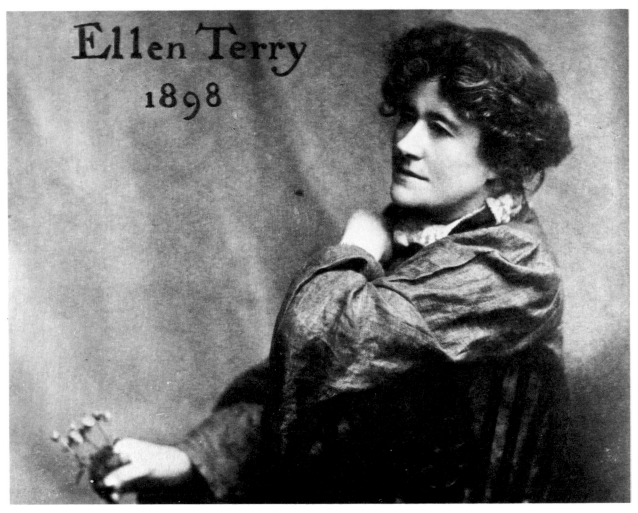

9.2 JAMES CRAIG ANNAN: ELLEN TERRY

9.3 ROBERT DEMACHY: FIGURE STUDY

9.4 CLARENCE WHITE: THE MIRROR

9.5 ALVIN LANGDON COBURN: LUDGATE CIRCUS WITH ST PAUL'S

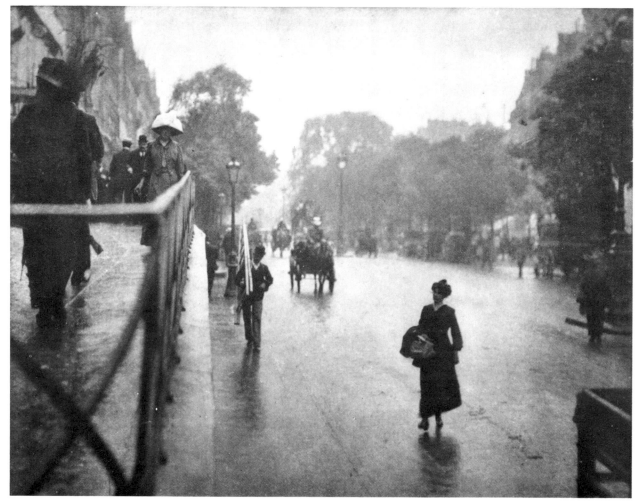

9.6 ALFRED STIEGLITZ: PARIS II

9.7 ALFRED STIEGLITZ: WINTER, NEW YORK, 1892

COLOUR NOTES

"Steichen arrived breathlessly at my hotel to show me his first two pictures. Although comparative failures, they convinced me at a glance that the color problem for practical work had been solved, and that even the most fastidious must be satisfied."

Alfred Stieglitz (1907)

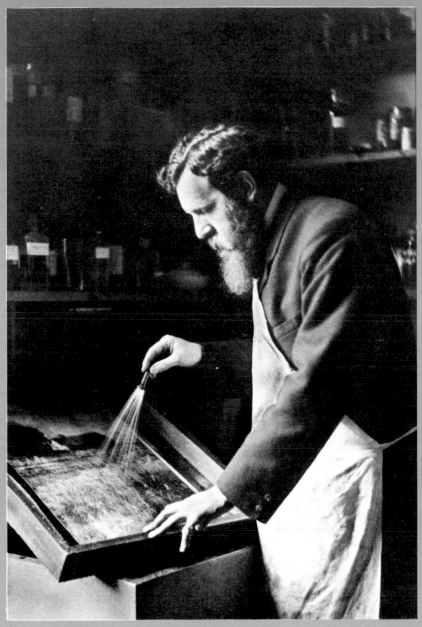

J. C. WARBURG IN HIS DARKROOM WORKING ON A GUM PRINT

COLOUR NOTES

Alfred Stieglitz was rapturous over the arrival of a practicable natural-colour photographic process after more than half a century of inconclusive experiment. In an enthusiastic letter to the editor of *Photography* (London), reprinted in *Camera Work*, he describes those thrilling days in Paris when he and Eduard Steichen first saw evidence of the new miracle. His letter is particularly interesting as it demonstrates the optimism of a photographer of unquestionable brilliance who sees in the ease of execution and chromatic truthfulness of the new tech-

nology not a threat to his profession but a means for yet greater triumphs in the art of photography:

Sir, – Your enthusiasm about the Lumière Autochrome plates and the results to be obtained with them is well founded. I have read every word *Photography* has published on the subject. Nothing you have written is an exaggeration. No matter what you or anyone else may write on the subject and in praise of the results, the pictures themselves are so startlingly true that they surpass anyone's keenest expectations.

I fear that those of your contemporaries who are decrying and belittling what they have not seen, and seem to know nothing about, will in the near future, have to do some crawling. For upwards of twenty years I have been closely identified with color photography. I paid much good coin before I came to the conclusion that color, so far as practical purposes were concerned, would ever remain the *perpetual motion* problem of photography.

Over eighteen months ago I was informed from inside sources that Lumière's [sic] had actually solved the problem; that in a short time everyone could make color pictures as readily as he could snap films. I smiled incredulously, although the name Lumière gave that smile an awkwardness, Lumière and success and science thus far always having been intimately identified. Good fortune willed it that early this June I was in Paris when the first results were to be shown at the Photo-Club. Steichen and I were to go there together. Steichen went; illness kept me at home. Anxiously I awaited Steichen's report. His 'pretty good only' satisfied my vanity of knowing it all.

Steichen nevertheless bought some plates that morning, as he wished to see what results he could obtain. Don't we all know that in photography the manufacturer rarely gets all there is in his own invention? Steichen arrived breathlessly at my hotel to show me his first two pictures. Although comparative failures, they convinced me at a glance that the color problem for practical work had been solved, and that even the most fastidious must be satisfied. These experiments were hastily followed up by others, and in less than a week Steichen had a series of pictures which outdid anything that Lumière had had to show. I wrote to you about that time, and told you what I had seen and thought, and you remember what you replied. His trip to London, his looking you up and showing you his work, how it took you literally off your feet, how a glance (like with myself) was sufficient to show you that the day had come, your enthusiasm, your own experiments, etc., etc. – all that is history, and is for the most part recorded in your weekly. While in London

Steichen did Shaw and Lady Hamilton in color; also a group of four on Davison's houseboat. The pictures are artistically far in advance of anything he had to show you.

The possibilities of the process seem to be unlimited. Steichen's pictures are with me here in Munich; he himself is now in Venice working. It is a positive pleasure to watch the faces of the doubting Thomases – the painters and art critics especially – as they listen interestedly about what the process can do. You feel their cynical smile. Then, showing them the transparencies, one and all faces look positively paralysed, stunned. A color kinematographic record of them would be priceless in many respects. Then enthusiasm, delighted, unbound, breaks loose, like yours and mine and everyone's who sees decent results. All are amazed at the remarkably truthful color rendering; the wonderful luminosity of the shadows, that bugbear of the photographer in monochrome; the endless range of grays; the richness of the deep colors. In short, soon the world will be color-mad, and Lumière will be responsible.

It is perhaps fortunate that temporarily the plates are out of the market. The difference between the results that will be obtained between the artistic fine feeling and the everyday blind will even be greater in color than in monochrome. Heaven have pity on us. But the good will eventually outweigh the evil, as in all things. I for one have learned above all that no problem seems to be beyond the reach of science.

Yours truly, Alfred Stieglitz
Tutzing, Munich, July 31st, 1907

In the following year Steichen, in Paris, wrote a long and thoroughgoing article drawing out the technical distinctions between the Lumière Autochrome process and several others, both earlier and contemporary. Interestingly, Steichen finds, in what might have been considered an imperfection in the irregularity of the granulation on the Lumière plate, a photographic means equivalent to Impressionist painting technique, by which a sense of shimmering luminous particles of colour could be conveyed. He even states a preference for a plate with a yet coarser emulsion so that the chromatic nuances would become more easily visible.

This article appeared in *Camera Work* in April 1909. That number carried only three illustrations: colour prints of Lumière Autochromes made from original transparencies by Steichen. A small section of the article is reproduced here:

Color Photography
During the last twenty years we have been periodically informed by the daily press that color photography was

an accomplished fact. Every time some excitable individual got a little chemical discoloration on his photographic plate or paper, the news was sent sizzling over the globe and color photography was announced in big type, corporations were formed, and good friends were given another chance to invest in a sure thing. As usual, the public soon yawned at this perpetual cry of 'wolf', but somehow capital kept up its faith. It was only a year ago that a very prominent French financier came to me, breathless with excitement over a few very good three-color carbon prints – a clever English shark was trying to interest capital in his 'discovery'. Millions have surely been buried in fake schemes, to say nothing of the millions spent in earnest, but commercially fruitless, research.

When the Lumière brothers published the description of their process, several years ago, it was naturally duly recorded by the photographic press, and it even got into some of the big dailies – at least as padding; but those of us that were puttering along with the various three-color methods watched for results with much interest, especially when we heard that a special plant was being put up to manufacture the plates. From time to time one heard rumors of a man that had seen one of the results, and the report was · 'true coloring, green grass, red tie,' and so on. The first specimens the makers showed us would have been as discouraging as such rumors had been, did one not remember the results that makers of plates and papers generally exhibit as 'samples'; but the working process seemed so fascinatingly simple that the very next day I tried them myself, and the first results brought the conviction that color photography had come to stay.

Of course the Autochrome process is not a discovery in the science of color photography, for the principles of the process were described by Ducos du Hauron, in 1868; in fact the development of the fundamental theories of three-color photography are ascribed to Maxwell, as far back as 1861. Other inventors have been and are still working on polychrome screen-processes – amongst the better-known are Joly, MacDonough, Powrie-Warner, Krayn, Brasseur, Mees, and Smith. The Société Jougla, in Paris, is soon to market a polychrome plate, made under the supervision and according to the patents of Ducos du Hauron and Raymond Bergecol; and a number of other plates will probably soon be available, which promise to do even better than the Lumière plates – but that remains to be demonstrated. In any case, from a pictorial standpoint, the Lumière plate for the present holds a unique field. The fine, irregular grain of this plate gives a beautiful, vibrant quality to the light, that I do not think any of the mosaic or line screen-plates, with their absolute

regularity, can give. I am, however, very anxious to try some plate that has a coarser screen, for it should, apparently, be more luminous in color rendering. . . .

As regards the printing of Autochromes, the three-color process affords no end of possibilities, such as Gum, Carbon and Pinatype. But other simpler processes are under way, and the practical solutions of the problem are nearer at hand. I shall leave any more definite reference to the printing process for another article, when my own experiments have been more complete. But one thing we must not lose sight of: it is futile ever to expect any process on paper, or other substance that presents the picture by reflected light, to give an exact reproduction of a color transparency, any more than a painting on canvas can represent the effects of a painting on glass. In this way the screen plate will always possess value and beauty that are not to be copied – and color that cannot exist on paper. Furthermore and of particular interest pictorially is this fact: that what may appear very beautiful as a transparency, may when transferred to paper be absolutely horrible, for the richness and purity of color produced by transmitted light admits of color arrangements that would be impossible, if attempted in the dull tones that reflected light would make of them.

There are color harmonies which can only be indulged in when colors as luminous as in enamel or stained glass are available – such combinations are possible on Autochrome plates. This is one of the direct facts that point to color harmony as the vital element to strive for in Autochromy. Personally I have no medium that can give me color of such wonderful luminosity as the Autochrome plate. One must go to stained glass for such color resonance, as the palette and canvas are a dull and lifeless medium in comparison. As I write these notes prints of the color plates from the edition of those appearing with these pages in CAMERA WORK, are before me. The originals have not yet arrived, so I can not compare. The engravings are remarkable; they are technically by far the best reproductions that have been made from Autochromes up to the present; but their relationship to the originals, as regards color, vitality, and harmony, as I remember them, is as – well, comparison fails completely! There is no relationship. They are a thing apart. To-day, in making plates intended for prints in any form, one will consider the final result, and work accordingly – so the accompanying color pictures go into CAMERA WORK merely as an expression of good will. They are neither representative of Autochrome photography, nor of color photography: they are a compromise – an experiment.

Paris, 1908 Eduard J. Steichen

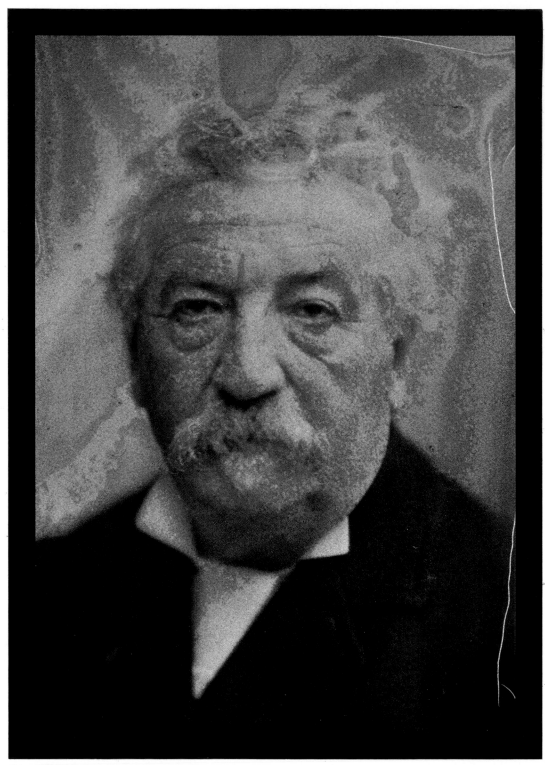

10.1 LOUIS LUMIERE: HIS FATHER ANTOINE

10.2 LOUIS LUMIÈRE: LYONS IN THE SNOW

10.3 LOUIS LUMIERE: YOUNG LADY WITH AN UMBRELLA

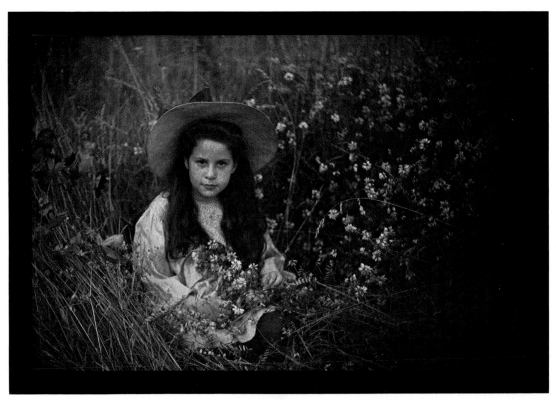

10.4 FRANK EUGENE: KITTY STIEGLITZ

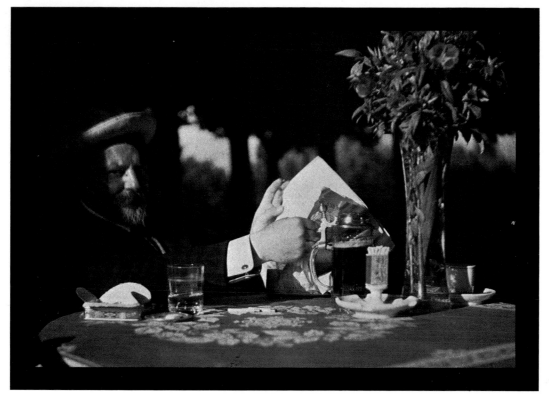

10.5 ALFRED STIEGLITZ: FRANK EUGENE

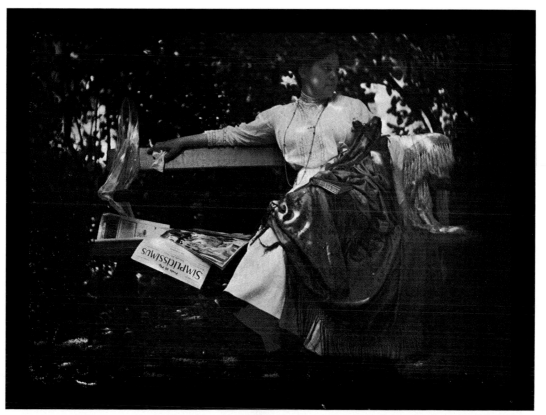

10.6 PROBABLY FRANK EUGENE: EMMELINE STIEGLITZ

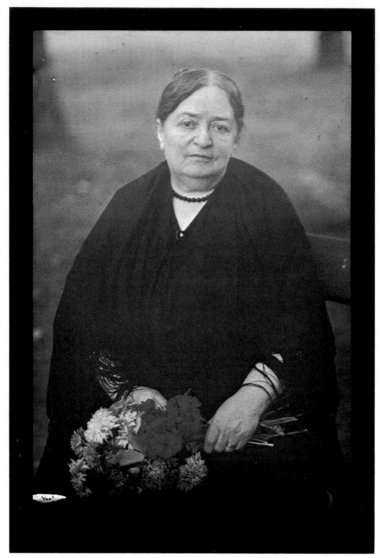

10.7 ALFRED STIEGLITZ: HIS MOTHER

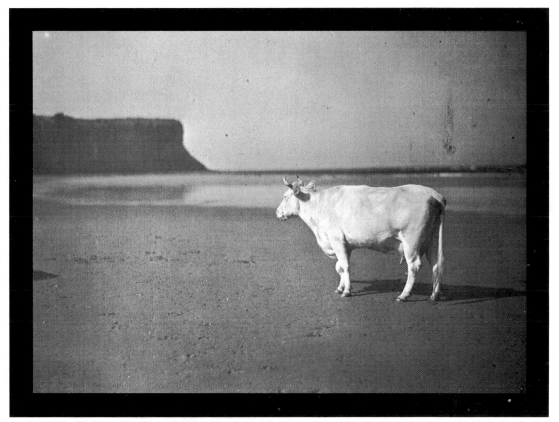

10.8 J. C. WARBURG: COW AT SALTBURN SANDS, YORKSHIRE

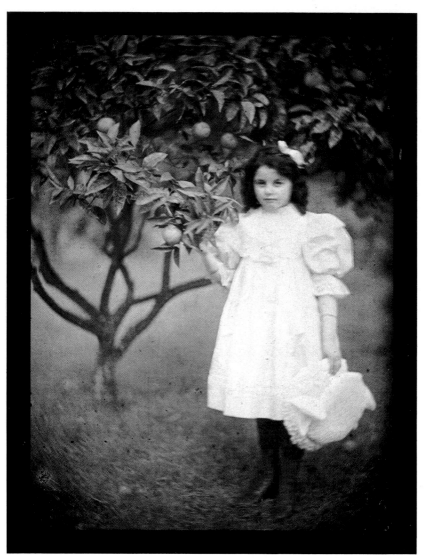

10.9 J. C. WARBURG: PEGGY WARBURG

10.10 GEORGE BERNARD SHAW: BEATRICE WEBB

LIST OF ILLUSTRATIONS

7.3 Probably Alexander Gardner: Crippled locomotive of the Richmond and Petersburg Railroad, Richmond Depot, Virginia, 1865. (Library of Congress)

7.4 Unknown photographer: Dead Confederate, in trenches at Fort Mohane, Virginia, April 1865. (Library of Congress)

7.5 F. Galton, FRS, and Dr F. A. Mahomed, with G. Turner and Mr Mackie, photographer to Pentonville Convict Prison: Plate II of 'An Inquiry into the Physiognomy of Phthisis by the Method of "Composite Portraiture"', 1881. An early attempt (like 7.7) to use photographs as medical evidence. Autotype (Guy's Hospital Report 1881)

7.6 Photographic Department, Dr Barnardo's Homes, c. 1875. Each child would have its photograph taken on arrival at Dr Barnardo's. (Barnardo Photo Library)

7.7 D. O. Hill and Robert Adamson: Woman with a goitre. Calotype (Scottish National Portrait Gallery)

7.8 Thomas Annan: Old Glasgow Close – 75 High Street, c. 1865. Modern print from the original negative, c. 1845. Wet collodion (Thomas Annan & Sons, Glasgow)

7.9 Unknown photographer: Two Amerindian women, c. 1850. Daguerreotype (International Museum of Photography, George Eastman House)

7.10 Samuel Bourne: Toda Villagers, c. 1868. Wet collodion (Royal Photographic Society)

7.11 John Thomson: 'Interior of Native Travelling Boat' Woodburytype from his book China and Its People, London 1873. (Royal Photographic Society)

7.12 John Thomson: Physic Street, Canton. Woodburytype from his book China and Its People, London 1873. (Royal Photographic Society)

Other illustrations in this chapter are from the Library of Congress (109), Private collection, London (108), Royal Photographic Society (111)

Chapter 8

OPENING PAGE Eadweard Muybridge: Abe Edginton driven by C. Marvin 15 June 1878. From his book The Attitudes of Animals in Motion, Palo Alto, 1881. The negatives of the photographs were made at intervals of about 1/25 second, the exposure about 2,000th second. (Kingston-upon-Thames Museum and Art Gallery)

Eadweard Muybridge. 'Leland Stanford Jr. on his pony. Palo Alto. May 1879' Lantern slide inscribed by Muybridge. (Stanford University)

8.1 Eadweard Muybridge: San Francisco, c. 1870. (Kingston-upon-Thames Museum and Art Gallery)

8.2 Eadweard Muybridge: Group of indians, Nanaimo district of Vancouver Island, c. 1868. (Kingston-upon-Thames Museum and Art Gallery)

8.3 Eadweard Muybridge: Woman climbing on and off a table. From Animal Locomotion, 1887. Photogravure (Royal Photographic Society)

8.4 Dr E. J. Marey: Chronophotographic pictures of birds in flight, c. 1882. (Musée des Beaux Arts, Beaune-photo Ellebé, Rouen)

8.5 Dr E. J. Marey: Aerodynamic studies using fine streams of smoke, c. 1884. (Musée des Beaux Arts, Beaune – photo-Ellebé, Rouen)

Other illustrations in the chapter are from Kingston-upon-Thames Museum and Art Gallery (126, 128 top, 129 top), Marey Institute, Paris (130, 131, 132, 133), Royal Photographic Society (128 bottom, 129 bottom)

Chapter 9

OPENING PAGE Frank Eugene: Group (left to right) shows Eugene, Alfred Stieglitz, Heinrich Kühn, and Edward Steichen, c. 1905. (Royal Photographic Society)

Francis Picabia: Portrait of Alfred Stieglitz (291, 1916)

9.1 Heinrich Kühn: Small girl, c. 1900. (Royal Photographic Society)

9.2 James Craig Annan: Ellen Terry, 1898. (Royal Photographic Society)

9.3 Robert Demachy: Figure Study. From etched negative gum bichromate, 1906. (Royal Photographic Society)

9.4 Clarence White: 'The Mirror', 1912. (Royal Photographic Society)

9.5 Alvin Langdon Coburn: Ludgate Circus with St Paul's, 1904–6. Photogravure (Royal Photographic Society)

9.6 Alfred Stieglitz: Paris II, 1911. (Royal Photographic Society)

9.7 Alfred Stieglitz: Winter, New York, 1892. From Camera Work no. 12, 1905. (Royal Photographic Society)

Chapter 10

OPENING PAGE John Cimon Warburg in his darkroom working on a gum print, c. 1910. (Private collection, London)

10.1 Louis Lumière: experimental autochrome of his father Antoine. This shows the problems the Lumière brothers had with the even distribution of the coloured starch granules which acted as filters, c. 1905. (Dr Paul Gènard)

10.2 Louis Lumière: Lyons in the snow. Early autochrome, c. 1908. (Dr Paul Gènard)

10.3 Louis Lumière: Young Lady with an umbrella, c. 1907. (Time–Life Publications, photo Société Lumière)

10.4 Frank Eugene: Kitty Stieglitz, daughter of Alfred Stieglitz, probably taken at Tutzing, Germany, 1907. Autochrome (Alfred Stieglitz collection, Art Institute of Chicago.)

10.5 Alfred Stieglitz: Frank Eugene, Tutzing, 1907. Autochrome (Alfred Stieglitz collection, Art Institute of Chicago)

10.6 Probably Frank Eugene: Emmeline Stieglitz, first wife of Alfred Stieglitz, Tutzing 1907. Autochrome (Alfred Stieglitz collection, Art Institute of Chicago)

10.7 Alfred Stieglitz: His mother, c. 1907. Autochrome (Alfred Stieglitz collection, Art Institute of Chicago)

10.8 J. C. Warburg: Cow at Saltburn Sands, Yorkshire, c. 1909. Autochrome (Royal Photographic Society)

10.9 J. C. Warburg: Peggy Warburg (probably south of France) c. 1909. Autochrome (Royal Photographic Society)

10.10 George Bernard Shaw: Beatrice Webb. Autochrome (National Trust)

Other illustrations

FRONT COVER Nadar: self-portrait in a balloon basket taken in his studio, c. 1860. Wet collodion (Nadar collection, Bibliothèque Nationale, Paris)

TITLE PAGE Herman Krone: Self-portrait with his photographic equipment. (Staatliche Landesbildstelle Hamburg)

CONTENTS PAGE Samuel A. Cooley, 'US Photographer, Department of the South', his assistants and photographic waggons. Wet collodion (Library of Congress)

PAGE 8 Henry Fox Talbot: The family coach and footman at Lacock Abbey, 1840. A calotype made soon after the discovery of the process. 'Done in 3 minutes'. (Science Museum)

BIBLIOGRAPHY

General
Art and photography, AARON SCHARF, Allen Lane, The Penguin Press, 1968.
Histoire de la découverte de la photographie, GEORGES POTONNIÉE, Paris: Maitel, 1925 (French). English translation by Edward Epstean, New York, 1936.
Histoire de la photographie, RAYMOND LÉCUYER, Paris: Baschet, 1945 (French).
The history of photography, HELMUT AND ALISON GERNSHEIM, Thames and Hudson, rev. edn. 1969.
Image of America 1839–1900, a catalogue of an exhibition, Washington D.C.: Library of Congress, 1957.
Masters of photography, BEAUMONT AND NANCY NEWHALL, New York: George Braziller Inc., 1958.
Photography and the American scene – a social history, 1839–1889, ROBERT TAFT, New York: 1936; Dover Publications, 2nd edn. 1964.
Pioneers of science and discovery – George Eastman and the early photographers, BRIAN COE, Priory Press, 1973.
The Science Museum Photography Collection: a catalogue with sections on processes, D. B. THOMAS, HMSO, 1969.

Fox Talbot
The first negatives, D. B. THOMAS, Science Museum Monograph, HMSO, 1965.
Guide to Lacock Abbey, The National Trust, 1974.
Photography: men and movements Vol. 2 – William H. Fox Talbot, inventor of the negative–positive process, ANDRÉ JAMMES, New York: Macmillan Publishing Co. Inc., 1974.
William Henry Fox Talbot: father of photography, ARTHUR BOOTH, Pub. Arthur Barker, 1965.
William Henry Fox Talbot, F.R.S. – material towards a biography, collected by J. DUDLEY JOHNSTON. Part I in *The Photographic Journal*, January 1947, pages 3–13; Part II in *The Photographic Journal* no. 10, December 1968, pages 361–371.

Niépce and Daguerre
Daguerre, 1787–1851: catalogue of exhibition, Bibliothèque Nationale and George Eastman House, 1961.
L. J. M. Daguerre: the history of the diorama and the daguerreotype, HELMUT AND ALISON GERNSHEIM, Secker and Warburg, 1956. New York: Dover Publications, 1969.
Joseph Nicéphore Niépce: Lettres 1816–1817 Correspondance conservée à Châlon-sur-Saône, Association du 'Pavillon de la Photographie' du Parc Naturel Régional de Brotonne 1973 (French).

Bayard
Bayard, Paris: Lo. Duca Editions Prisma, 1943.
French primitive photography, ANDRÉ JAMMES AND ROBERT SOBIESZEK, New York: Aperture, 1970.
Hippolyte Bayard – catalogue of exhibition, Essen: Folkwang Museum, 1959.

Hill and Adamson
A centenary exhibition of the work of David Octavius Hill, 1802–70, and Robert Adamson, 1821–48, KATHERINE MICHAELSON, Scottish Arts Council, 1971.

An Early Victorian Album (the Hill/Adamson collection), COLIN FORD AND DR ROY STRONG, Jonathan Cape, 1974.
Sun Pictures, the Hill–Adamson calotypes, DAVID BRUCE, Studio Vista, 1973.

Julia Margaret Cameron
Julia Margaret Cameron, ALISON AND HELMUT GERNSHEIM, the Fountain Press, 1948, New York: Aperture, rev. edn. 1974.
Victorian photographs of famous men and fair women by Julia Margaret Cameron, VIRGINIA WOOLF AND ROGER FRY, Hogarth Press, 1926. New edn. with preface by TRISTAM POWELL, 1973.

Nadar
Nadar, JEAN PRINET AND ANTOINETTE DILLASSER, Paris: Armand Colin, 1966 (French).
Nadar: catalogue of exhibition of his life's work. Paris: Bibliothèque Nationale, 1965.

Documentary photography
Gardner's photographic sketch book of the Civil War, Washington, 1865; New York: Dover Publications, 1959.
Mathew Brady: historian with a camera, JAMES D. HORAN, New York: Crown, 1955.
Reality recorded, GAIL BUCKLAND, David and Charles, 1974.
Street life in London, JOHN THOMSON AND ADOLPHE SMITH, Wakefield, Yorks: E. P. Publishing Ltd, 1973 (facsim. of 1877 edn.)

Moving pictures
Animals in motion, EADWEARD MUYBRIDGE, Chapman and Hall, 1889. Dover Publications, 1957.
The human figure in motion, EADWEARD MUYBRIDGE, Chapman and Hall, 1901, Dover Publications, 1955.
Eadweard Muybridge: the Stanford years 1872–1882, ANITA VENTURA MOZLEY, et al. catalogue of exhibition, California: Stanford University Press, 1972.
Louis Lumière – Cinema d'Aujourd'hui, GEORGES SADOUL, Editions Seghers, Paris 1964 (French).
La photographie Animée, EUGÈNE TRUTAT, Paris: Gauthier-Villars, 1899 (French).

Photo Secession
Photo Secession, photography as a fine art, ROBERT DOTY, monograph no. 1, Rochester, New York: George Eastman House, 1960.
Alfred Stieglitz: photographer, Boston, USA: Museum of Fine Art, 1965 (Catalogue of Museum's collection with introduction by Dorothy Bry).
Camera Work: a critical anthology, 1903–1917, ed. JONATHAN GREEN, New York: Aperture, 1973.
America and Alfred Stieglitz, a collective portrait, WALDO FRANK et al. New York: Doubleday, 1934.
Steichen the photographer, CARL SANDBURG, New York: Museum of Modern Art, 1961.

Colour photography
Lumière: Les premiers photographes en couleurs, introduction by PAUL GÉNARD and ANDRÉ BARRET, Paris: André Barret, 1974.

For more detailed information, consult the sources provided in the text.

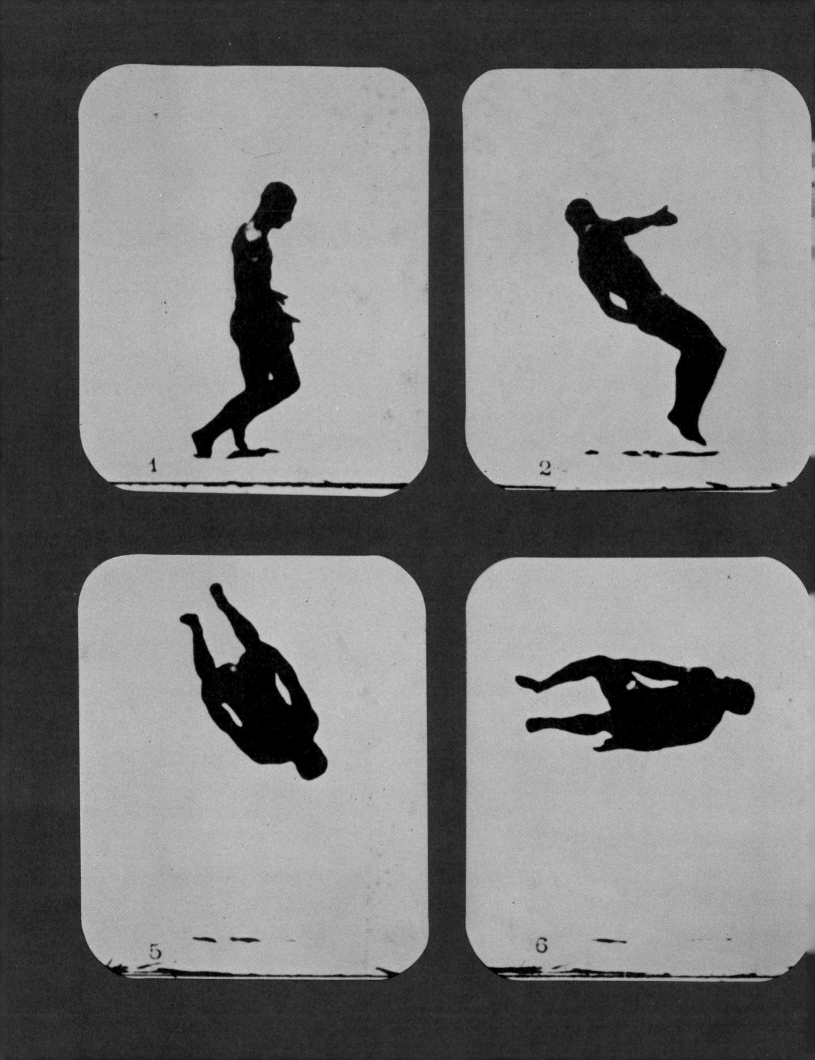